ENGLISH RUINS

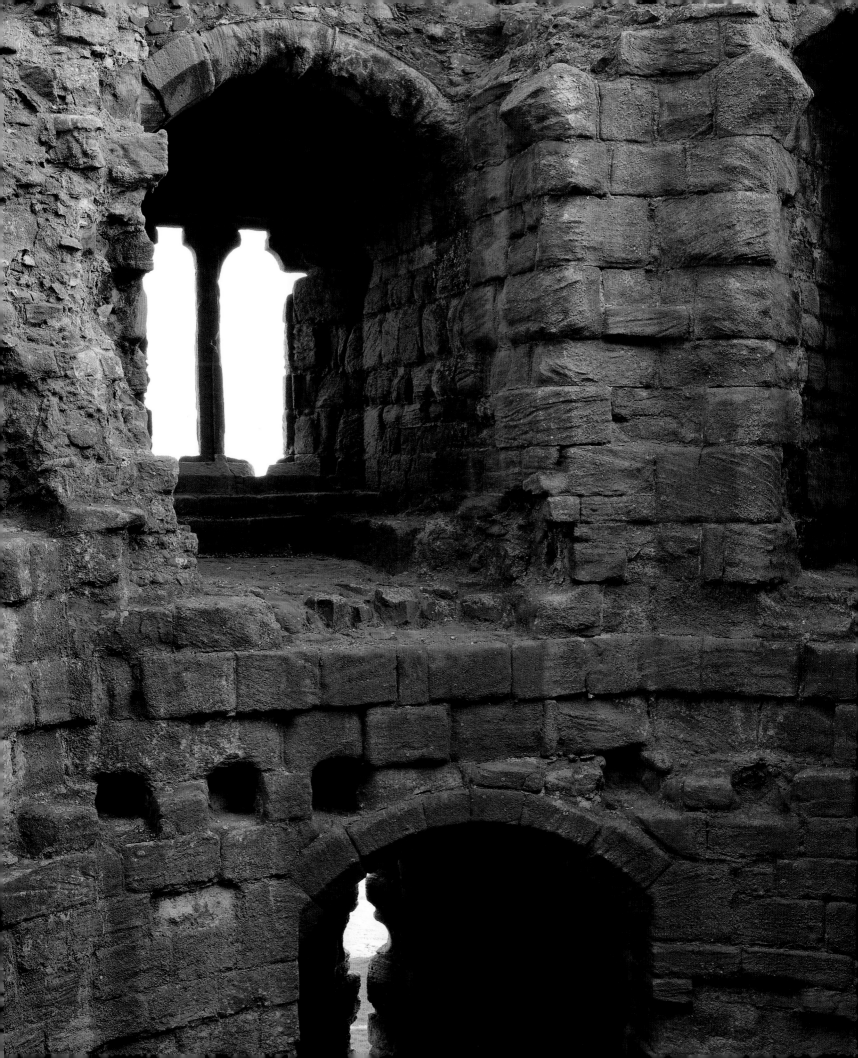

ENGLISH RUINS

Jeremy Musson
Photographs by Paul Barker

MERRELL

LONDON · NEW YORK

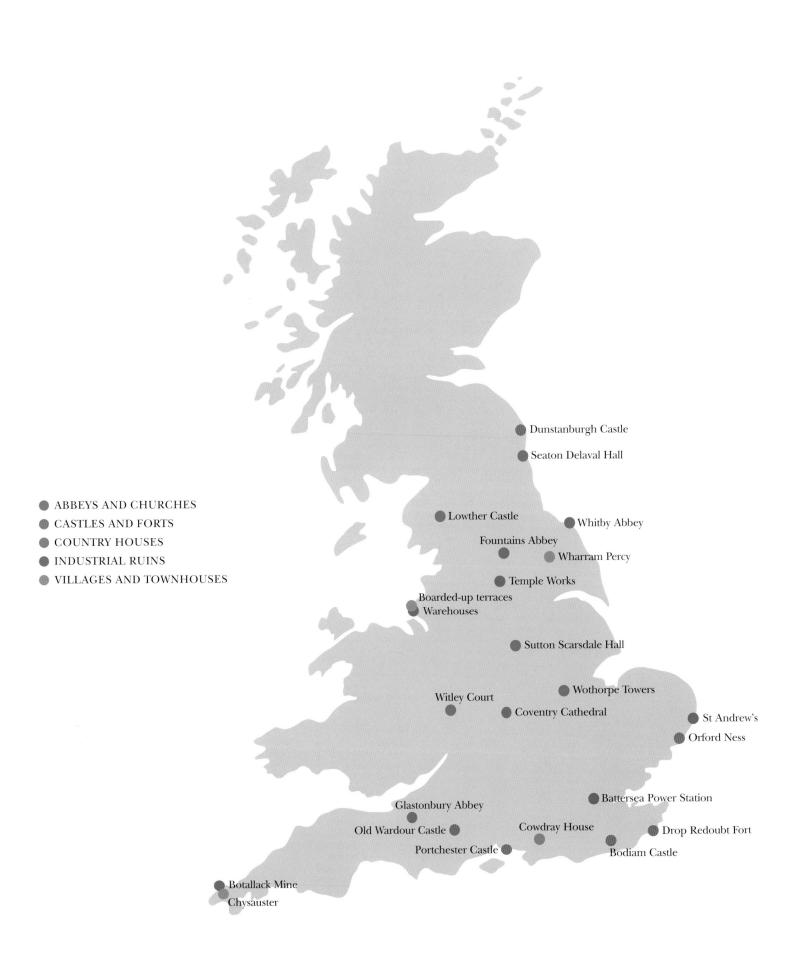

ABBEYS AND CHURCHES

CASTLES AND FORTS

COUNTRY HOUSES

INDUSTRIAL RUINS

VILLAGES AND TOWNHOUSES

Dunstanburgh Castle

Seaton Delaval Hall

Lowther Castle

Whitby Abbey

Fountains Abbey

Wharram Percy

Temple Works

Boarded-up terraces
Warehouses

Sutton Scarsdale Hall

Wothorpe Towers

Witley Court

Coventry Cathedral

St Andrew's

Orford Ness

Battersea Power Station

Glastonbury Abbey

Old Wardour Castle

Cowdray House

Drop Redoubt Fort

Portchester Castle

Bodiam Castle

Botallack Mine
Chysauster

CONTENTS

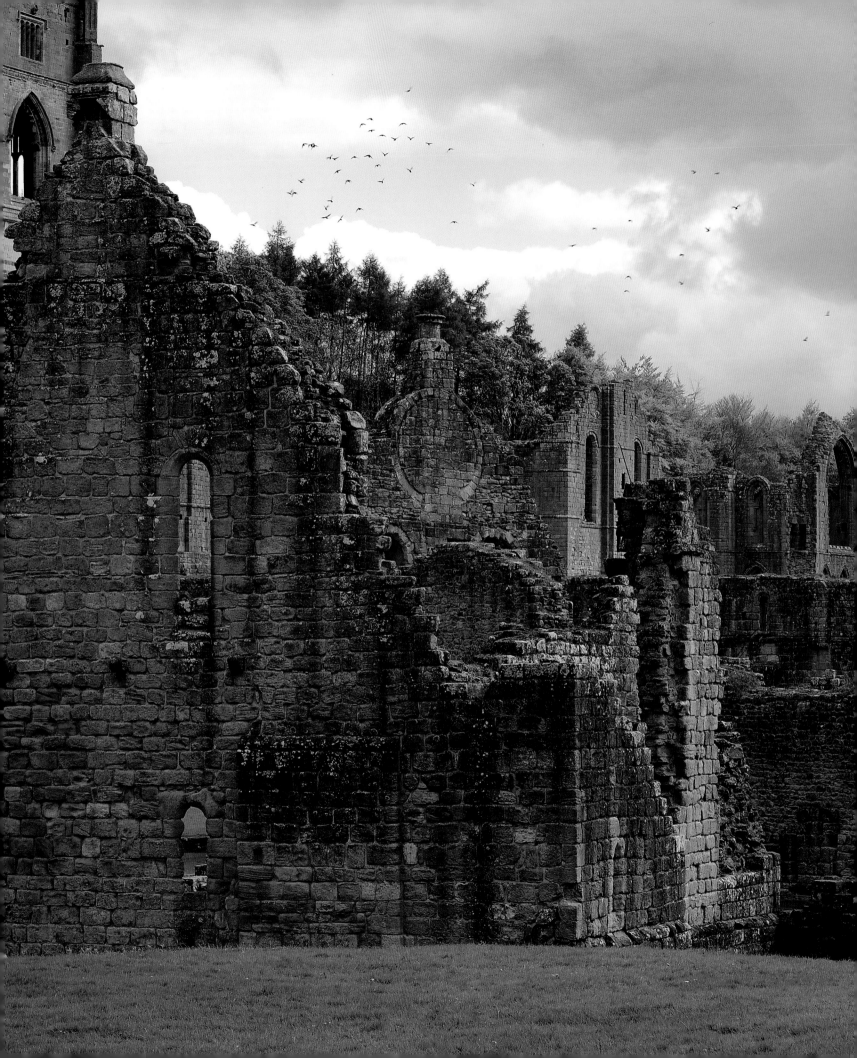

ENGLISH RUINS:
A PERSONAL ODYSSEY IN ENGLISH HISTORY

Glance at any Ordnance Survey or tourist map and you will see that the English landscape is a landscape of ruins. Map-makers often treat ruins with a distinctive Gothic script, marking them out as landmarks of historical interest. Justly so, because, whether fragmentary or only roofless, ruins symbolize England's national history in a number of different ways: they speak of the rising and falling of dynasties, of the power of the church, of the tides of industry and war – of the mutability of human experience.

Quite simply, the ruins of England speak of the passing of time and, perhaps most poignantly, of the presence of the past, of 'living in an old country'. They provide a kind of historic scenery for the nation's journeys, physical and imagined, and can be glimpsed from motorways or approached at arduous length on foot across distant fields. In fact, one hardly has to venture beyond the nearest town, for few such places do not have some fragmentary castle in a corner of a well-kept park, often looking as much like an abstract modern sculpture as an old building.

In this book of images of ruined buildings I wanted to explore ruins as an aspect of the English cultural landscape and, through this, perhaps trace something of how the English see themselves and their past. As a nation, the English are usually very conscious that they live in an old country with well-defined boundaries; somehow, to paraphrase T.S. Eliot, the past is always pressing on their future.

The whole process of an encounter with ruins is, of course, deeply personal. Perhaps it is fair to say that, for most of us, it is an almost artistic experience, subjective and emotional, for which we instinctively draw on our imaginations, memories and instincts to seek out the human story in a place. Our sensations and responses are formed and shaped by a whole series of personal and impersonal forces, including opposing political and cultural inheritances; these tensions are creative, too.

Most of the cherished, and indeed overlooked, ancient ruins that we encounter are away from towns, and their relationships with the landscape, with nature or with the wider countryside are often uppermost in our responses to them. Christopher Woodward, in his book *In Ruins* (2001), about the way in which ruins have shaped the European imagination, stresses this link: 'No ruin can be suggestive to the visitor's imagination, I believe, unless its dialogue with the forces of nature is visibly alive and dynamic.'

Certainly, what appeals to me and, I think, to so many visitors to historic ruins is the very openness of the 'undone' or 'deconstructed' building to the skies, fields and woods around it: nature pierces the man-made. The relationship between the building and the landscape also provides an important contrast to the bustling museum, art gallery or historic house, however relaxed, intimate or entertaining these places might be.

In our modern, 'image-rich' culture, the relatively static and unadorned historic ruins of England still remain curiously potent canvases of the nation's history, visual records of the hopes and dreams of the past, of great follies and long-forgotten certainties, of the accidents and the strokes of good fortune that shape the destinies of both individuals and peoples. This is as true for the carefully preserved monuments as it is for the untended, unprotected results of accident and decay, ruins that may yet have a future of revival and new purpose. The very changeableness of the fortunes of some ruins is part of their mystery.

For my part, I have been obsessed with historic buildings from early childhood, and some of my most lasting memories are of my first imaginative engagements with the past during visits to such ruins as Cowdray House, West Sussex (page 104), which I explored with my mother and grandmother; and Waverley Abbey, Surrey, where I walked our dog with my father (often in the rain, dodging the grazing cattle). But I also recall the abandoned pillboxes encountered on bridleways, collapsing barns and a burnt-out warehouse on the edge of our village. Even at the age of six I think I had a notion of the mournful beauty in such things.

In adulthood, the ruin has been a landmark in my life as an architectural historian investigating how buildings are put together (so many historians of buildings have been partly inspired by how they come apart). Personally, I am deeply interested in how people react to old buildings, what they think, what they say, and what stories move them; I am also interested in how writers and artists respond to ruins, judging their purpose, beauty and history, and often creating significant new mythologies of their own.

When I worked for the Victorian Society in the early 1990s, I often found myself touring abandoned buildings in advanced states of ruination, including a number of churches, warehouses, factories and former hospitals. I especially remember clambering through the extraordinary Holloway Sanatorium in Virginia Water, Surrey, a great palace of a building, with roofs fallen in and panelling spattered with rain. It has since been restored and converted into houses and apartments, but many of the other buildings I visited were demolished and have gone forever.

When confronted with the rotting warehouses and factories of the Victorian industrial and commercial world, it was difficult not to admire the sheer energy that went into their construction. In the post-war period such buildings fell out of use, emphasizing England's status as not only a post-imperial nation but also a

post-industrial one. It was difficult, too, not to admire the public-spiritedness of the Victorians, for many of the buildings the Society was trying to save from demolition in the 1990s were actually built for the public's benefit, for health, recreation, religion or education. The fact that it was these particular buildings that were being abandoned and left to decay – usually for economic reasons – said much about those free market-orientated days.

When I worked as a curator for the National Trust, all the frenetic work of conservation and restoration at various of the historic country houses with which I was involved was contrasted with the even more challenging work of trying to understand the great hulks of ruined military and defence-testing buildings on a newly accessioned National Trust site, Orford Ness in Suffolk (page 93). The buildings ranged in age from those constructed during the First World War to those built in the 1950s for the Atomic Weapons Research Establishment. It was a huge philosophical challenge, for the undoubted significance of the site had to be weighed against the inhospitability of the coastal situation and the state of advanced decay that the buildings had already reached. Revisiting the site for this book fifteen years later was a profound experience.

The sea-weathered and half-collapsed buildings on Orford Ness still feel to me to be some of the most evocative ruins of the twentieth century, symbols of the war to end all wars, and the Cold War that followed some thirty years later. Yet one recent scholar has argued that the visitor route, as laid out by the National Trust, follows, unconsciously no doubt, all the principles of the Picturesque landscape of the late eighteenth century: intimacy and surprise, variety of perspective, and the stimulation of awe.

The English, if I may be permitted to generalize in this way, have for the last few centuries exhibited a distinct interest in the past. It was the English who, in the late 1600s, set the vogue for visiting the major ruins of the Classical world, a rite of passage for the wealthy that became known as the Grand Tour. It was also the English who, in the eighteenth century, created the fashion for making false ruins of castles and abbeys in great parklands, while at the same time embracing real ruins as a key feature in a contrived but ostensibly wild landscape. The latter can be seen in Studley Royal's relationship with Fountains Abbey in North Yorkshire (page 31), and in Alnwick Castle's with Hulne Priory in Northumberland.

A lively sense of the impact of a ruinous building can be seen in the late sixteenth century, in the poetry of Shakespeare, the rise of the antiquary and the birth of the study of history as we understand it today. However, the first recorded written appeal to save a ruined building on account of its historic associations and aesthetic character was that made by Sir John Vanbrugh, dramatist and architect of Blenheim Palace in Oxfordshire, in 1709. In an impassioned letter to Sarah, Duchess of Marlborough, Vanbrugh tried to persuade the duchess not to pull down the old manor house at Woodstock:

> There is perhaps no One thing, which the most Polite part of Mankind have more universally agreed in; than the Vallue thay have ever set upon the Remains of distant Times. Nor amongst the Severall kinds of those Antiquitys, are there any so much regarded, as those of Buildings; Some for the Magnificence, or Curious Workmanship; And others; as they move more lively and pleasing Reflections (than History without their aid can do) on the Persons who have Inhabited them; On the remarkable things which have been transacted in them, Or the extraordinary Occasions of Erecting them.

The historical and royal associations of the physically very old manor were rich indeed, as this was the place where Henry II was

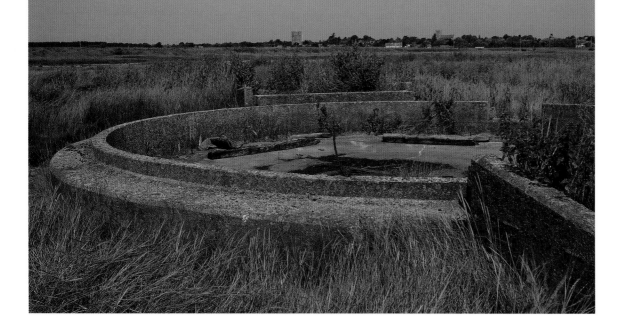

Page 6
The ruins of Fountains Abbey in North Yorkshire are a potent reminder of the faith of ages past.

Left
Centuries of defence: remnants of the twentieth-century bomb-testing site on Orford Ness, Suffolk, with the twelfth-century keep of Orford Castle on the horizon.

said to have met with the 'Fair Rosamond', one of his mistresses. But Vanbrugh also argued that it could become a feature in the landscape, and improve the view from the great house then being built. He claimed that, if the manor were planted up to appear amid the trees, 'it wou'd make One of the Most Agreable Objects that the Best of Landskip painters can invent', by which he meant Nicolas Poussin, Claude Lorrain and Salvator Rosa, for whom ruins were an essential ingredient in their landscape painting.

Ruins for such late seventeenth-century painters were important motifs, providing dramatic and subtle interplays of light and shade. The relationship of the ruined buildings to the trees and flowers around them gave the artists opportunities to explore interesting contrasts in texture and colour that were not offered by the undamaged buildings in their pristine state.

In many ways, the same remains true for photography – and, indeed, is part of the inspiration for this very book. I have collaborated with Paul Barker as a photographer for some fifteen years, and admire his ability to capture the unique spirit of the ancient building and ruin, his feeling for light, stone and the whole form of a view. To me, he has something of the Romantic eye of John Piper or Edwin Smith that comes from many years of looking at and photographing such buildings.

Working with Paul I have found that, while we often see things in different ways, we somehow speak the same language. We always instinctively want to explore the historical truth of a building and capture its romanticism at the same time – to render up a faithful account of a place while celebrating its beauty and the joy of looking into the philosophical landscape of the past.

This introduction is followed by five themed chapters – illustrated with Paul's photographs – on ecclesiastical ruins (abbeys and churches); military ruins (castles and forts); ruins of country houses; industrial ruins; and the curious remains of human settlements, rural and urban. These are English ruins, since the ruins of Scotland and Wales have their own, albeit related stories to tell, of ownership, religion and politics. I wish to explore these buildings not only for their own stories but also for the part they play in the story of England and the English attitude to the past.

In total I have selected twenty-four ruins, the locations of which stretch from close to the Scottish border down to the south coast at Dover, and then across to the tip of Cornwall. Naturally, there will be many beloved ruins that I will not have chosen; forgive me. The ruins featured in this book have been selected by me from thousands to be representative of key themes. Many are nationally famous (even world famous), but a number have been chosen specifically because they are relatively unknown, creating a contrast with the obviously loved and cherished. Some of the ruins date from the late twentieth century, while others are about to be restored; after all, restoration in itself is one of the most fruitful indicators of our attitude to the past, the drive to recapture or regenerate.

The romance of the Gothic form: Woodbridge Lodge in Suffolk, built in 1790.

The old castle at Scotney, Kent, depicted by John Piper in a watercolour of 1976. In the 1830s the castle was part-dismantled to become a feature in the landscaped grounds of a new house.

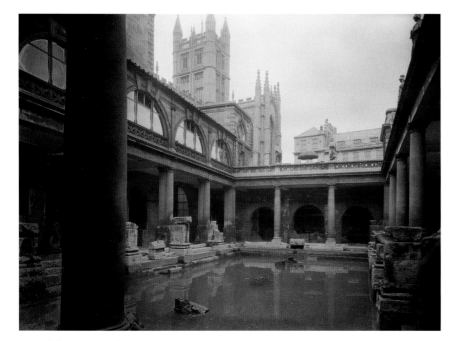

Part of the remains of the Roman
bathing complex in Bath, Somerset.

The artificial castle ruins of the 1740s
at Hagley Hall, Worcestershire.

But just what is a ruin? It must surely be a building in a state that renders it useless for most practical purposes. We usually see a ruin as a building that is part fallen down, perhaps roofless. Just take a glimpse at those 'official' preserved ruins that are cared for by English Heritage on behalf of the state, and therefore the nation.

Although it is obvious that a ruin can be a fragment or a series of fragments, height, scale, material and even date do not matter at all in terms of a definition. Moreover, a ruin can be ancient or modern, and can be of many different periods in one. Indeed, part of the charm of some ruins is that they reveal the older structure that had been covered by later accretions.

Intriguingly, the dictionary definition of a ruin, as given in the *Concise Oxford Dictionary*, puts the active sense of 'Downfall or fallen or wrecked or impaired state' before the meaning that most people would more immediately think of: 'What remains of a building, town, structure … that has suffered.' In his book *Poetic Diction: A Study in Meaning* (1928), literary critic Owen Barfield devoted an entire chapter to explaining the process he called 'poetic diction', or the change and emergence of new metaphorical meaning. He wrote: 'English schoolboys are generally taught to translate the Latin verb *ruo* [from which 'ruin' is derived] by one of two words, "rush" or "fall"', and that, in Classical contexts, *ruo* 'always carries with it a larger sense of swift, disastrous movement'.

The origins of the poetic appreciation of the ruins of former empires, so familiar to our modern imaginations, can be traced to an eighth-century Anglo-Saxon poem that describes the Roman ruins in Bath, quoted here as translated by S.A.J. Bradley in *Anglo-Saxon Poetry* (1982):

Wondrously ornate is the stone of this wall, shattered by fate; the precincts of the city have crumbled and the work of giants is rotting away … There are tumbled roofs, towers in ruins, high towers rime-frosted, rime on the limy mortar, storm-shielding tiling scarred, scored, collapsed, undermined by age … There were bright city buildings, many bath houses, a wealth of lofty gables, much clamour of the multitude, many a mead hall filled with human revelry – until mighty Fate changed that.

The anonymous poet refers back to the obvious glories of this vanished world, imagining the richness and joy of its halls, and contrasts them with the state of desolation before him. The poem offers a very vivid evocation of the influence of the ruin, of what it is like to be living among the remains of former empires. This is how ruins speak to us; the durability of the great building, even in fragments, tells of the greatness of a former age.

In the late fifteenth century, the ideal of the Classical past associated with the humanist revival of interest in Classical literature and art gave the Classical ruin a particularly important resonance. The Renaissance, as it is known, began in Italy, a country well aware of its history as the cradle of the Roman Empire, and of the potential for applying the lessons provided by Classical literature and buildings.

In England, the actual physical presence of the Classical past was less dominant, although visible in certain structures, including Hadrian's Wall and various other fortifications, as well as remnants of villas and roadways. But the cultural idea of England having been Roman was nonetheless potent. For the most stirring survivals of the Classical world, the English gentleman, scholar or artist travelled to Europe, especially Italy, on the Grand Tour. The

pattern for this journey of discovery was set in the early seventeenth century, when the architect Inigo Jones travelled to Italy with the Earl of Arundel to see the important sights.

By that time, however, England's own past had begun to seem significant. In the first half of the sixteenth century the dissolution of the monasteries had caused one of the biggest upheavals in the architectural story of England, leaving the country with its own great monuments to consider. Travels in Europe to admire the scale of Classical remains also clearly fed an increasingly imaginative response to England's own Gothic and medieval past.

The dissolution of the monasteries in the late 1530s (the result of laws passed in 1536 and 1539) was part of a process of redefining the church in England, an emphatically political rejection of the influence of the 'international' papacy over English Christianity. Cultural and political tensions between England and Rome had been evident for centuries, but it was Henry VIII (famously seeking to divorce his first wife, Catherine of Aragon, so that he could marry Anne Boleyn) who gave them legal form.

The process began in 1531, when Henry declared himself the Supreme Head of the Church in England. Seizing on theological criticism of the monastic orders, he closed down thousands of monastic houses and appropriated their income. Many were stripped of their roofs, and often their masonry too, and simply left to fall into ruins. Comfortable abbots' lodgings were sometimes turned into equally comfortable dwellings for the gentry; some of these can be seen today, such as Lacock Abbey in Wiltshire, whereas others have long been hidden under later rebuildings. Several of the converted abbots' lodgings remained surrounded by the slowly decaying abbey or priory church and cloister, as at Battle Abbey in East Sussex and Wenlock Priory in Shropshire.

Those buildings that were not to be occupied were almost always stripped of their most valuable asset: the lead that protected the timber roof below. Ask any architect or builder with knowledge of such materials and you will learn that, without their lead protection, such roofs might last only a decade, although sometimes longer.

While masonry was also sold and transported for reuse, it is interesting to note how much of it was often left in situ. Perhaps this is simply because the ruins in question were originally well constructed, or perhaps because a degree of superstition hung around them. Or maybe it was because of a lasting affection for what they symbolized, which might explain why there seem to be so many more monastic ruins in the traditionally more Catholic north. One wonders how often in the late sixteenth century such places seemed as dangerous as an abandoned factory site seems to many of us today.

Referring to the dissolution of the monasteries in his book *In Ruins*, Christopher Woodward writes: 'There was not to be such change in the architectural landscape of Britain until the Second World War.' It is the dissolution, more than any other period in England's history, that surely created the peculiarly English

inheritance of ruined Gothic grandeur on a vast scale. The awareness of the aesthetic and emotional impact of the monastic ruin set in surprisingly quickly, within fifty years if Shakespeare's sonnet referring to 'Bare ruin'd choirs, where late the sweet birds sang' is anything to go by.

My favourite illustration of the sensations stirred by walking through a ruin is found in John Webster's play *The Duchess of Malfi* (1623), which, although purporting to be set in Italy, certainly evokes some monastic remains in England. The ability of ruins to communicate the cycle of human fortune is shown in the speech of Antonio, who says:

> I do love these ancient ruins. / We never tread upon them but we set / Our foot upon some reverend history; / And, questionless, here in this open court, / Which now lies naked to the injuries / Of stormy weather, some men lie interr'd / Lov'd the church so well, and gave so largely to 't, / They thought it should have canopied their bones / Till dooms-day. But all things have their end; / Churches and cities, which have diseases like to men, / Must have like death that we have.

The dramatic tension is heightened by an echo within the ruins' walls, creating a mournful dialogue with the characters.

In Britain's first topographical poem, 'Cooper's Hill', written by John Denham in 1642 at the outbreak of the Civil War, the poet reflects on the view from the hill, and on the ruins of an abbey on a nearby rise. His words illustrate how the destruction of the monasteries was seen one hundred years later: 'But my fixt thoughts my wandring eye betrays, / Viewing a neighbouring hill, whose top of late / A Chappel crown'd, till in the Common Fate, / The adjoyning Abby fell: (may no such storm / Fall on our times, where ruine must reforme.)' He asks the muse to explain what crime had brought about this destruction, and decides that it was the greed of Henry VIII, 'Who having spent the Treasures of his Crown / Condemns their Luxury to feed his own.' Later in the poem, he wonders: 'Who sees these dismal heaps, but would demand / What barbarous Invader sackt the land? / But when he hears, no Goth, no Turk did bring / This desolation, but a Christian king; / When nothing, but the Name of Zeal, appears / 'Twixt our best actions and the worst of theirs, / What does he think our Sacriledge would spare'.

The upheavals of the English Civil War (1642–51) and the subsequent period of the Commonwealth government (1651–60) led to the creation of another series of great English ruins. These buildings, including castles and fortified houses, either suffered directly from their role in the conflict or, more usually, were deliberately dismantled or destroyed after the end of the war to render them useless for combat, a process known as 'sleighting'. However, some of the ruined castles we see today are more often the result of later disuse or decay than is commonly thought.

As in the case of the dissolution of the monasteries, the Civil War brought about a sudden fall of ancient symbols of authority.

Curiously, such destruction seems to have inspired a kind of tender curiosity about the very buildings being lost. As Denham's poem quoted above demonstrates, this interest also embraced the long-ruined monasteries, in a way that had not happened at the time of their dissolution. John Aubrey, for example, the late seventeenth-century antiquary and author of that humorous volume of English biography *Brief Lives*, observed of monastic ruins that 'the eie and mind is no less affected with these stately ruines than they would be if they were standing and entire. They breed in generous mindes a kind of pittie; and set the thoughts aworke to make out their magnificence as they were in perfection.'

Walk through any major house built in the eighteenth century, with anything of its original collections still in situ, and the ruin is visible in painting after painting, and then echoed in the Classical temples of the park. The phenomenon of creating artificial Gothic or Classical ruins as features in the landscape, of which the English do seem to be pioneers, belongs to this period, and while the earliest garden temples seem to be Classical, the contrivance of designing 'ruined' structures took most of its inspiration from England's own Gothic past.

Horace Walpole, the eighteenth-century diarist who designed his own Gothic-style 'plaything' house, Strawberry Hill in Twickenham, deeply admired the work of Sanderson Miller. Miller created a ruined castle in the grounds of Hagley Hall in Worcestershire (also one of his designs), which Walpole rather teasingly described as having 'the true rust of the Barons' Wars', referring to the Wars of the Roses (1455–85). This oft-quoted phrase shows precisely how people in the eighteenth century were looking back to the Middle Ages with a sense of awe and romance, as reflected in the novels and paintings of the era.

The story of Netley Abbey in Hampshire is especially revealing. Walpole wrote to his friend Richard Bentley in 1755,

It is the spot in the world for which Mr Chute [a fellow admirer of the Gothic style] and I wish. The ruins are vast, and retain fragments of beautiful fretted roofs pendant in the air, with all variety of Gothic patterns of windows wrapped round and round with ivy – many trees are sprouted up against the walls, and only want to be increased by cypresses [a type of tree often found in Italian ruins] ... In short they are not the ruins of Netley, but of Paradise. Oh! the purple abbots, what a spot had they chosen to slumber in.

After the dissolution of the monasteries, the Marquis of Winchester had turned part of the abbey into a house. Some years later the property came into the hands of the Earl of Huntingdon, who, rather indecorously, put a tennis court in the nave, among other alterations. Early in the eighteenth century a Southampton carpenter bought the ruins as a source of building materials, but died while dismantling them when a stone fell on his head. In 1765 Thomas Dummer, an English MP, bought a part of the north transept and erected it as an eye-catcher in his home at Cranbury Park near Winchester, where it still stands. The south transept is still in its original location, and now in the care of English Heritage, but the fate of the rest of the abbey is illustrative of the allure of the ruin to the English landowner and park designer.

The sentiments expressed by Walpole were perhaps also reflected in the growth of the Picturesque school, in which the nature of beauty, especially in landscape, was furiously debated. In the 1780s, in several accounts of his travels on the River Wye and in the Lake District, the watercolourist and author Reverend William Gilpin encouraged the well-off English to 'examine the face of the country by the rules of picturesque beauty', referring to the way in which the old masters composed their landscapes. Gilpin undoubtedly engaged a wide audience with his attitude to looking at the landscape, in which drama, variety and distant surprises played a critical part – and in which the ruin was especially emotive. In his *Essay on Picturesque Beauty* (1792), Gilpin wrote:

A piece of Palladian architecture may be elegant in the last degree. ... But if we introduce it in a picture, it immediately becomes a formal object and ceases to please. Should we wish to give it picturesque beauty, we must use the mallet, instead of the chissell: we must beat down one half of it, deface the other, and throw the mutilated members around in heaps. In short, from a *smooth* building we must turn it into a *rough* ruin.

The great ruin in the landscape can be seen to stimulate contrasting sensations. In his treatise on aesthetics, the eighteenth-century philosopher and politician Edmund Burke held that our response to the sublime – as perceived, for example, in a dramatic, awe-inspiring landscape – is born out of fear, terror and an innate desire for self-preservation. By contrast, our response to beauty is derived from sensations of pleasure. In the ruin in the landscape, we find both unease and pleasure.

Another influential book on the effect of ruins on the European imagination was the comte de Volney's *Les Ruines, ou méditations sur les révolutions des empires* (1791), a long meditation on the lessons of history that opens with a description of the ruins of Palmyra in Syria. In particular, the book asserted that all empires will eventually fall, as suggested by the ruins of the past. It was also an argument for the future unity of all religions, based on the common truths that unite them.

Also inspired by the evidence of long-vanished empires, and the fall of tyranny that it often symbolizes, was Percy Bysshe Shelley's famous poem 'Ozymandias' (1818). The speaker encounters the remnants of a massive Egyptian statue, 'Two vast and trunkless legs of stone', close to which 'a shattered visage lies'. The inscription reads: '"My name is Ozymandias, king of kings: / Look on my works, ye Mighty, and despair!"' But all the works have gone: 'Round the decay / Of that colossal wreck, boundless

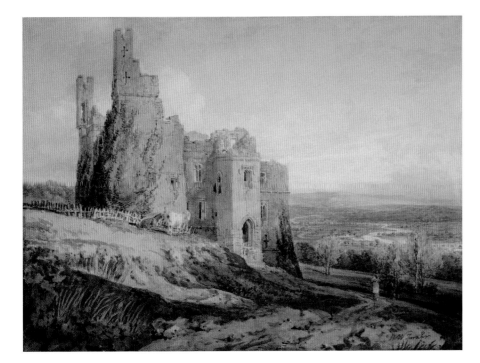

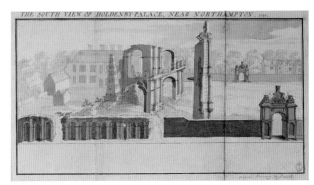

Ruins as subject for the English artist:
(left) Harewood Castle in West Yorkshire,
as painted by J.M.W. Turner in about 1798;
(above) fragmentary remains of an
Elizabethan palace at Holdenby,
Northamptonshire, in an engraving
of 1729 by Nathaniel Buck.

and bare / The lone and level sands stretch far away.' There can be few more eloquent demonstrations of what the remains of former great civilizations can communicate.

In England there were no vast statues towering above the traveller, but often a haunting castle or abbey dominating a town or harbour. By the late eighteenth century these undone buildings were being perceived with growing interest, and visited by an increasing number of curious sightseers. They were of particular interest to artists searching out the best in English landscape. By the early 1800s, one of England's greatest painters, J.M.W. Turner, had made the evocative power of the ruin a central feature of his work, although we more naturally think of him as a painter of landscapes and skies.

Turner's early career as an architectural draughtsman actually included work colouring engravings of the ruins of castles and abbeys. In the last years of the eighteenth century he exhibited numerous studies of famous historical ruins in landscapes, appealing to the Romantic spirit of his audience; characteristically, they were often visual foils for dramatic expositions of sea or sky.

Throughout his career, Turner continued to make studies of ancient ruins, including castles and abbeys, on tours around the whole of England. Some were featured in his ambitious *Liber Studiorum* project (1806–19), while many were published in different histories, especially Charles Heath's *Picturesque Views in England and Wales* (1827–38). Turner used his studies of ruins for aesthetic drama, to represent the glories of English civilization and to communicate his belief in the inevitable end of empires, part of his Romantic vision of the vanity of human achievement.

Turner's work caught the spirit of the age. The long, drawn-out wars with France had inspired a nationalistic interest in the monuments of the home nation, and in some ways broke the dominance of the European Grand Tour over the educated Englishman's attitude to history. Such national romanticism also played its part in the Gothic Revival, the rise in interest in the architecture of the medieval age as a template for the new. Augustus Charles Pugin, like Turner a student of the Royal Academy of Arts, was one of a number of artists who specialized in the study of the Gothic past, illustrating such works as *Specimens of Gothic Architecture* (1821–23) and *Architectural Antiquities of Great Britain* (1826). Pugin's own son, Augustus Welby Northmore Pugin, who had been trained as an architectural draughtsman by his father, became one of the great champions of the Gothic Revival. In 1836, in a volume titled *Contrasts*, he attacked the predominance of the Classical style in contemporary architecture, contrasting the glories of the medieval Christian past – a good part of it imagined from the evidence of glorious abbey ruins – with the thinness of modern classicism.

The novels of Sir Walter Scott contributed considerably to the interest of the English in their medieval past. *Kenilworth*, published in 1821, is based on the story of one of the most romantic ruins in Warwickshire:

We cannot but add, that of this lordly palace, where princes feasted and heroes fought, now in the bloody earnest of storm and siege, and now in the games of chivalry, where beauty dealt the prize which valour won, all is now desolate. The bed of the lake is but a rushy swamp; and the massy ruins of the Castle only serve to show what their splendour once was, and to impress on the musing visitor the transitory value of human possessions, and the happiness of those who enjoy a humble lot in virtuous contentment.

Two other nineteenth-century writers helped to shape the English response to all surviving buildings from the past, ruins included. John Ruskin, artist, author and patron, wrote some of the most influential texts on the importance of recognizing the beauty and moral value of authentically old buildings, touchstones of periods when the crafts were properly valued. The very survival of masons' work in the great ecclesiastical ruins of England, for example, was evidence of the quality of the original craftsmanship.

In his *Seven Lamps of Architecture* (1849), Ruskin appealed to contemporary architects to build like the ancients:

> when we build, let us think that we build for ever. Let it not be for present delight, nor for present use alone; let it be such work as our descendants will thank us for, and let us think, as we lay stone on stone, that a time is to come when those stones will be held sacred because our hands have touched them, and that men will say as they look upon the labour and wrought substance of them, 'See! this our fathers did for us.'

In short, he regarded all surviving buildings of the past as jewels, a 'precious inheritance' to be jealously guarded and protected.

Ruskin's call was echoed in different ways by William Morris, who, together with the architect Philip Webb and others, founded the Society for the Protection of Ancient Buildings in 1877. This group played a critical role in defining the English attitude to restoration. Morris feared that increasing interest in old buildings and monuments had actually produced a negative result, and, as he wrote in the Society's manifesto, had 'done more for their destruction than all the foregoing centuries of revolution, violence and contempt'. The Society opposed restorations that recreated a fantasy of what had been there before, and argued for careful preservation or 'conservation' with modest necessary repairs. This philosophy is still influential today.

It is interesting to note that all listed-building legislation, everything that defines and protects the historic environment today, derives from legislation introduced to protect ruins: the Ancient Monuments Protection Act of 1882. It was an Act introduced rather bravely (and doggedly, every year from 1873 to 1879) by Sir John Lubbock, the Liberal MP for Maidstone in Kent. Lubbock, who had been tutored in his youth by Charles Darwin, believed that the idea of progress and natural selection could be applied to archaeology. His Act was the first piece of legislation to protect man-made structures in England.

Sixty-eight sites were listed as 'ancient monuments', all of them prehistoric, and the commissioner of the Board of Public Works could take any of them into care. Britain's first inspector of ancient monuments was General Pitt Rivers (whose collection forms the remarkable museum of the same name in Oxford), and by 1890 all the designated sites had come under his protection. An additional Act in the year of his death, also 1890, broadened the definition of an ancient monument to include 'any structure ... of historical or architectural interest' (except churches and occupied buildings). This opened the way for ruined abbeys and castles.

The early years of the twentieth century saw the great furore over the sale of fifteenth-century Tattershall Castle in Lincolnshire to a group of American businessmen. In 1911 the castle's new owners began to strip it of its fireplaces, packaging them ready for shipping to the United States. Lord Curzon intervened, buying the castle and triumphantly returning the fireplaces in an open cart draped in a Union Jack. The rescue of Tattershall contributed to the passing, in 1913, of a third Act of Parliament to protect historic buildings at risk of demolition.

In 1900 a new inspector of ancient monuments had been appointed, Charles Reed Peers, an architect and former secretary of the Society of Antiquaries. Peers believed in repair not restoration, but, as quoted in the Joint Royal Historical Society/Gresham College Annual Lecture of 2007, he also believed that the aim must be to preserve, 'with as little change as possible, what the lapse of Time has spared', and that 'What remains must be set off to best advantage, if only for the mere pleasure of doing so and for the revelation of the beauties long hidden in their own ruins.' Peers's approach led to much tidying up, not only the stripping away of post-medieval structures but also (invisible) mending; at Rievaulx Abbey in North Yorkshire, some 5 metres (16 feet) of earth were excavated. By 1910 there were eighty-nine monuments in care; by Peers's death in 1952, this number had risen to 400. In both practical and philosophical terms, the state became one of the principal guardians of the past, although its acquisition of sites was not conducted in a particularly scientific manner.

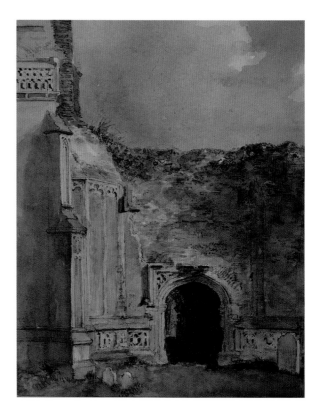

During Peers's lifetime England and the world had experienced one of the greatest upheavals in history: the Second World War. This conflict, which affected so many, brought devastation to Europe on an unprecedented scale. Although terrible destruction had been wrought in France and Flanders in the First World War, aerial bombardments in the Second World War changed the range and magnitude of destruction.

It is difficult today to imagine the effect of the Blitz on London and other parts of the United Kingdom. However, in 1942 the Architectural Press published *The Bombed Buildings of Britain: A Record of Architectural Casualties: 1940–41* to document the buildings of historic importance that had been damaged or destroyed in those years alone. As well as being a record of architectural losses, the book also serves as a poignant reminder of both the drama and the human experience of wartime destruction, with all its attendant emotions.

The book's editor, James Richards, wrote that 'It has always been the role of the ruin to compress into the same picture both the embodiment of the experience and the form and colour of the architecture itself. Hence its romantic appeal.' But he also understood what such images meant to those who had lived through the bombings,

> with our memories of that peculiar air-raid smell of wet charred wood, of the blundering gait with which we picked our way over puddle streets criss-crossed with hoses on dark winter mornings and of the familiar houses we saw splintered with impressive thoroughness into a spillikins heap of dusty timbers

> ... a background of smells, sights and sounds sufficient to evoke for us the whole strange aftermath of bombing.

There are a few ruins that still stand to remind us of the bombing. The English artist and writer Barbara Jones argued that more of the bombed churches in London should be kept as memorials to the awfulness of war; in fact, many were carefully rebuilt as an act of cultural defiance. One in the very shadow of St Paul's Cathedral, Christ Church Greyfriars, was left roofless, and is now a place where City workers can eat their sandwiches (bomb-damaged churches outside the capital include St Peter's in Bristol and the Royal Garrison Church in Portsmouth). But just think of the streets around them that were totally destroyed by bombing. The churches were just one building type; homes, shops, hotels and factories were also consumed.

The economic and political aftermath of the war at first saw a huge shift in attitude towards history and the past, with a desire to open a new egalitarian age of opportunity for all. But the cycle of empires discussed above began to take its toll on a series of different aspects of England's national architecture. In the countryside, for example, hundreds of country houses, used for institutional purposes during the war, were never reoccupied. Some were abandoned altogether, and many demolished.

In the towns, the great physical legacy of the Industrial Revolution was beginning to fall into decay. During the 1950s and 1960s many of the industrial buildings of the late nineteenth and early twentieth centuries were beginning to be seen as outdated and unusable for modern industrial purposes; by the 1980s they

Opposite
The ruined north archway of the unfinished tower of St Mary's Church in East Bergholt, Suffolk, as painted by John Constable in the early 1800s. Ruins have always provided artists with an opportunity to depict light and shade, the natural and the man-made together.

Right
During the Second World War, life continued as normal in many English cities, as here in Blitz-hit London, despite the grim backdrop of bombed streets.

Far right
The interior of this abandoned warehouse in Sussex reminds us just how quickly unused buildings can decay.

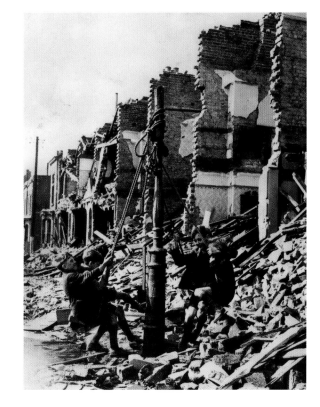

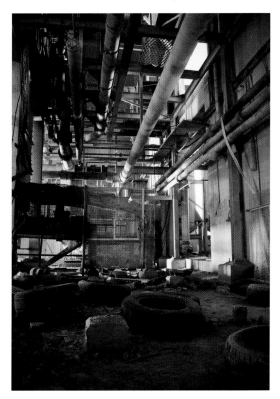

were being replaced with prefabricated, mass-produced units. The pre-First World War culture of construction, in which factories were designed with traditional architectural values, and built with an idea of greater permanence, had passed into history.

An understandable desire to modernize left other aspects of the nation's infrastructure exposed. The extraordinary network of canals that had been used for freight transport since the late eighteenth century was more or less abandoned in the 1960s. At about the same time, the massive reduction of the railway network, under the infamous Dr Beeching, left its own series of ruins, including stations, bridges and lines (many of these lines are now footpaths). And as some towns expanded with dense modern housing and new road systems in the 1960s and 1970s, semi-wastelands of former industry were left on their fringes: whole landscapes of urban ruins, evocative of the potency of the nineteenth-century industrial world and its eventual decline.

In the 1970s there was a vivid and visible reaction to all this abandonment and dereliction, and the modern idea of 'heritage' was born: stations and canals, among other ruins, were rescued by enthusiasts and those local authorities that could see the value of heritage tourism. Marcus Binney, a champion of conservation and founder of Save Britain's Heritage, believes deeply in the role that restored and renewed former industrial buildings can play in modern life, as he explained in an interview for this book:

Our campaigns only work when local people take them to heart and want to preserve and renew. Preserved ruins can only ever represent a small number of the historic buildings that can be maintained, and where they are capable of use, it makes sense to give them a use and prolong their life. The rescue of historic houses and industrial complexes alike contributes to local pride in a place.

There can be no doubt that the ruin, too, is an important source of local and national pride. The ruins cared for by English Heritage, the National Trust and countless private owners and organizations play a vital part in England's heritage tourism, and in the education of the nation's children. At the official, 'preserved' ruins visited for this book, it is rare not to encounter whole families treating these places as a happy playground, or to find school parties of children dressed as knights and maidens or garbed as monks. The rest of us walk around the ruins as day trippers, admiring, enjoying, reading a little of the history, perhaps just glad to be away from our desks.

The current chief executive of English Heritage, Simon Thurley, who has some 400 ruins in his care, believes strongly in the power of ruins to affect the modern imagination. In conversation with me, he argued that a visit to a preserved ruin, as to any historical site, is the chance to indulge in a moment of fantasy: 'It is an opportunity to sink yourself into a kind of dream of the past, especially when visiting the great abbeys and castles that have played an important role in our national story.'

In an interview for this book, Anna Keay, the properties presentation director for English Heritage, observed of the Ministry of Works' treatment of ruins in its care during the interwar period:

They aimed at creating an authentic version of the great building period, demolishing everything of later dates. Therefore, at Rievaulx, for example, they removed all the post-Reformation buildings, so that a visitor could read the plan. At that date they also thought nothing of dismantling and rebuilding ruins to ensure their stability. Charles Peers was also keen on gardening, and really believed in the aesthetic effect of the cleaned ruin seen from a mowed lawn.

She added:

People's reactions to ruins are very personal and emotional, but it's interesting how people tend to see monastic ruins as haunting, and ruined country houses as sad. It is also interesting to note that in the middle of the twentieth century, the Ministry of Works often decided to remove a roof to make something easier to manage as a ruin – as, for instance, at bomb-damaged Appuldurcombe House on the Isle of Wight.

English Heritage's responsibility is not only to protect ruins but also to provide visitors with the facilities and the freedom to enjoy them. As Keay noted, 'It is a conundrum how to get the balance right: visitors need to be free to enjoy ruins as well as to be given pointers to understand the story of the place. It is worth remembering that Cistercian abbeys were deliberately built in out-of-the-way places – which is actually why those ruins are such a perfect cocktail for visitors today.'

In her role at English Heritage, Keay is sensitive to the full aesthetic experience of visiting ruins: 'We do explore in current practice a greater awareness of the aesthetics of ruins, and are reintroducing sheep grazing in some sites, or grass cultivation to stimulate wild flowers. In some places, such as Hailes Abbey in Gloucestershire, rubble walls have been capped with turf rather than concrete, as turf has its own ecology and can draw moisture out of the stone.'

The National Trust has a number of English ruins of national significance in its care, from Bodiam Castle in East Sussex (page 75) to Fountains Abbey in North Yorkshire and Corfe Castle in Dorset. Simon Jenkins, journalist and current chairman of the National Trust, celebrates such ruins as an important part of what the Trust is for. When asked for his thoughts on ruins for this book, however, he did admit to a degree of ambivalence about the twentieth century's elevation of the ruin:

My parents' generation really believed in the importance of ruins, and my mother saw them as having Romantic significance. A ruin creates a certain sense of the past and of the passage of time. Ruskin started the pathological respect

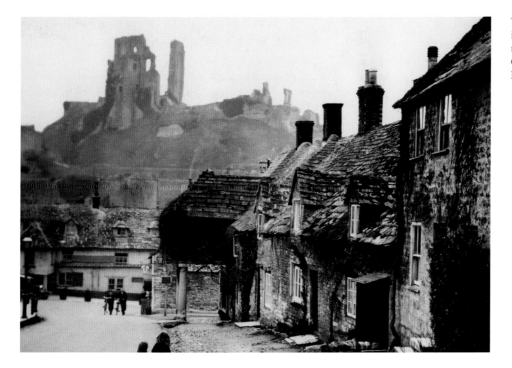

for ruins that gripped the twentieth century, but what he was really talking about was the respect for the old building itself. What Ruskin hated was the lack of the respect for the old.

Jenkins's own opinion is:

> Most ruins are almost meaningless to the layman – just mounds of masonry. If the question is how to bring such buildings to life, the answer must be to restore them, unless you regard them as like Henry Moore's sculptures. Some castles I visit were of such importance, I cry out for a Viollet-le-Duc figure [the nineteenth-century French architect famous for restoring many great medieval buildings] who can put them back together. In the nineteenth and early twentieth centuries in England, it was quite usual to restore castles, and, indeed, to restore churches that had had roofs open to the sky.

Many such castles were indeed restored, including Allington in Kent, now a private residence. Jenkins concedes that there might not be the funds to rebuild many others, but passionately believes that usefulness and stimulation to the imagination derive from a fuller understanding of ruins, and that, in some cases, the re-creation of parts of a ruined building can help the modern visitor to attain a fuller appreciation of the original.

It is certainly true that things need to be loved in order to survive. The artist David Hockney once remarked that the great art that has survived from earlier times tends to be made of very durable materials or to have been loved by someone. I believe that while it is important to have things understood, protected and explained, we must also encourage the conditions in which a ruin may be loved, recognizing its role as a canvas for the imagination, a place of freedom in which to engage with both the past and the present. Of course, none of this would be possible without the invaluable work of archaeologists, on whom we all depend to reveal more and more of these sites.

This book presents a deliberately selective tour of some of the most evocative ruins within England's national boundaries. They include some of the best-known national icons, and also some that will be completely new to a general audience. All of them, I believe, tell a different part of the story of the English people's relationship with the past, and are places that feed our modern curiosity about what has gone before us. They are slices of the same pie, but the flavour of each is subtly different, the result of its own story, its own topographical context and its treatment either as a monument or as a ruin awaiting a new life.

Whether they are abandoned and forgotten, neatly trimmed and prepared for family picnics, or awaiting scaffolding and builders, ruins offer us a vivid and personal encounter with the past. They always offer us history, of course; but they give us theatre, too, food for our imaginations. For whatever the historic reasons for the state of the building we see before us as a ruin, as philosopher Robert Ginsberg punningly writes, 'The ruin remains to be scene.'

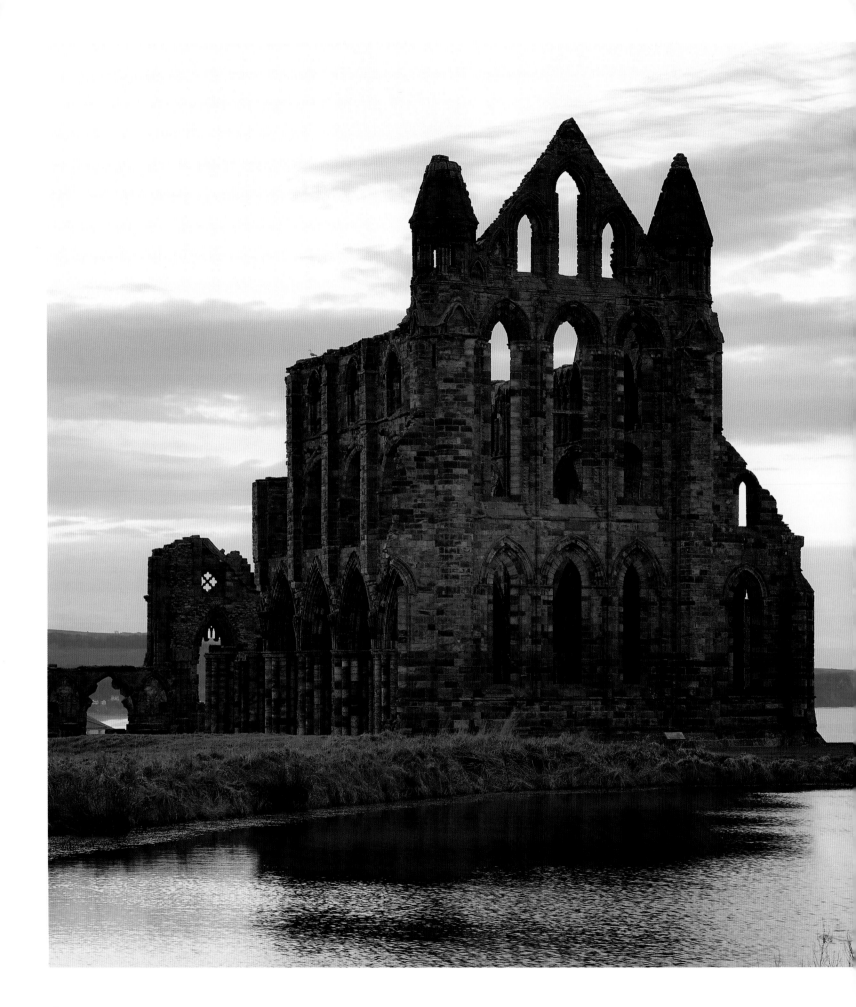

ABBEYS AND CHURCHES

There is perhaps nothing so elusive of proper definition, and yet so obviously part of the defining character of the English nation, as the Anglican Church. Yet it must be seen as a descendant of the international Catholic tradition, which defined pre-Reformation European history for a millennium.

From early Christian times, an essential part of that tradition was the monastic settlement, the abbey and the priory, which were not only important architectural complexes but also repositories of learning, hospitality and healing. The rules of English monasticism were defined by two traditions: that of Celtic Christianity, which was actually derived from Near Eastern traditions; and the Rule of St Benedict, brought from Rome to England by Augustine of Canterbury in 597. The famous Synod of Whitby eventually conceded the primacy of the Roman Church in 664.

A century later, and English Christianity was devastated by the Viking invasions. It was eventually revived under the influence of such figures as St Dunstan, a tenth-century Benedictine monk from Glastonbury who became an Archbishop of Canterbury. The Norman invasion led to the establishment of a large number of new monastic settlements in England, founded under the influence of Lanfranc, a Benedictine and Archbishop of Canterbury from 1070 to 1089, who had come over from Normandy with William the Conqueror.

While the Benedictines remained the major monastic order in England, a number of others also helped to shape the country's history. In the twelfth

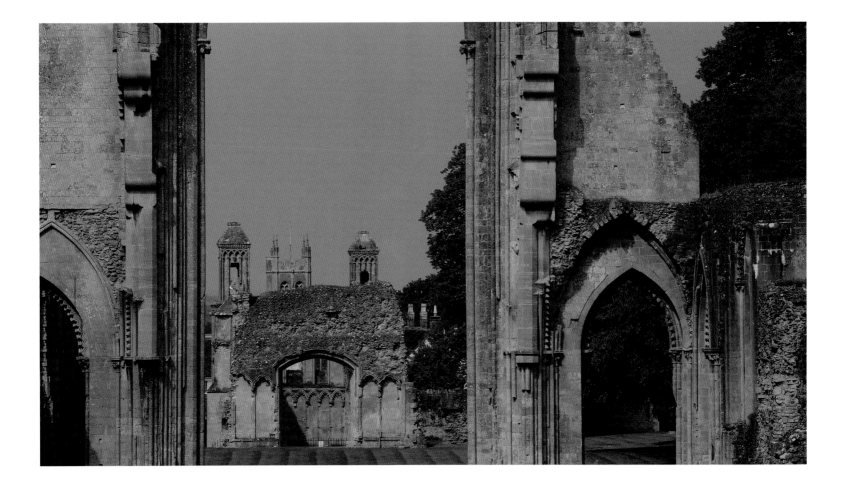

Pages 18–19
Whitby Abbey in
North Yorkshire: the
ruins of the former
abbey church have
long served as a
coastal landmark.

Above
The view along the
nave at Glastonbury
Abbey in Somerset,
a place of legend,
myth and continuing
spirituality.

century, St Bernard of Cîteaux introduced a new, more austere interpretation
of the Benedictine tradition, the Order of Cistercians, which placed a greater
emphasis on agricultural work, created settlements for hundreds of lay
brethren (or farm workers) as well as monks, and preferred remote sites.

There were yet more orders. The Augustinians (also known as the Black
Canons) established themselves in England in the early twelfth century, as
did the Friars: the Franciscans (Grey Friars) and the Carmelites (White Friars).
The Dominicans came to England in the thirteenth century.

As noted above, monasteries were centres of learning, healing and
hospitality, most having guest houses. As abbeys grew in landownership
through endowment, their heads – the abbots and abbesses – became figures
of considerable patronage and political influence. A priory was a small
monastery dependent on a larger monastic house or a cathedral church.

The dissolution, or closure, of the monasteries by Henry VIII in the 1530s
included what amounted to a major architectural revolution, in that it saw the
destruction of some of the finest buildings of the nation and the dispersal of
their estates to new ownership. Some of the churches that had once belonged
to monastic settlements became either cathedrals or parish churches,
including what is now Peterborough Cathedral and Binham Priory, a parish
church in Norfolk, both of which are surrounded by the ruins of their former
monasteries. Seven of the great English cathedrals were originally abbey

churches of Benedictine houses. Hundreds of monastic churches were simply abandoned, their lead roofs stripped, and other materials removed for sale or reuse, including the very stones with which they had been built (the remoter the site, however, the more difficult they were to remove).

The ruins that remained became such dramatic and familiar landmarks that, in some areas of England (North Yorkshire, for example), they can now be said to be some of the defining features of the landscape. Their importance was especially recognized in the eighteenth century by the painters and garden designers of the Picturesque school. In the nineteenth century, changes in attitude towards the medieval past were central to the Gothic Revival, which was associated with a widespread religious revival.

Thousands of churches were restored in the mid- to late nineteenth century, and some ruined churches were even re-roofed and reconsecrated. In 1875, inspired by childhood memories of the ruins of Glastonbury Abbey, Charlotte Boyd, a wealthy Anglo-Catholic, established the English Abbey Restoration Trust. The trust restored a fragment of the old Malling Abbey in Kent, giving it to a newly established order of Anglican nuns in 1893. More famously, perhaps, it paid for the restoration of the Slipper Chapel in Walsingham, Norfolk.

Many hundreds of urban churches were destroyed by bombing during the Second World War, and while some were defiantly rebuilt, others were not. A few are maintained as ruins, symbolizing the loss of so much more. The decline in religious attendance has thrown the future of many older churches into doubt, and hundreds have passed into different uses; the very best have been preserved by the Churches Conservation Trust. Today, there is a wide consensus on the significance of these buildings to our cultural landscape, and it is unlikely that many more will be allowed to fall into ruins.

A fifteenth-century window from the preserved ruins of the old, bombed-out Coventry Cathedral. The window affords a glimpse of another memorial to the upheaval of war: *Reconciliation*, a statue by Josefina de Vasconcellos presented to the cathedral in 1995 to mark the fiftieth anniversary of Japan's surrender at the end of the Second World War.

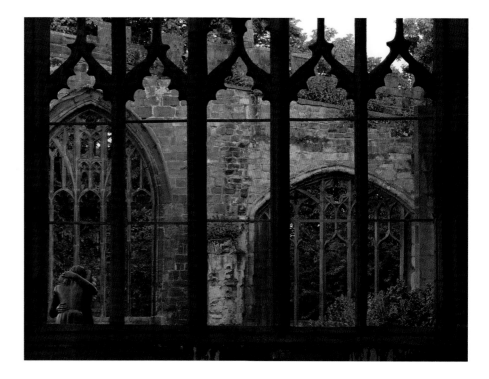

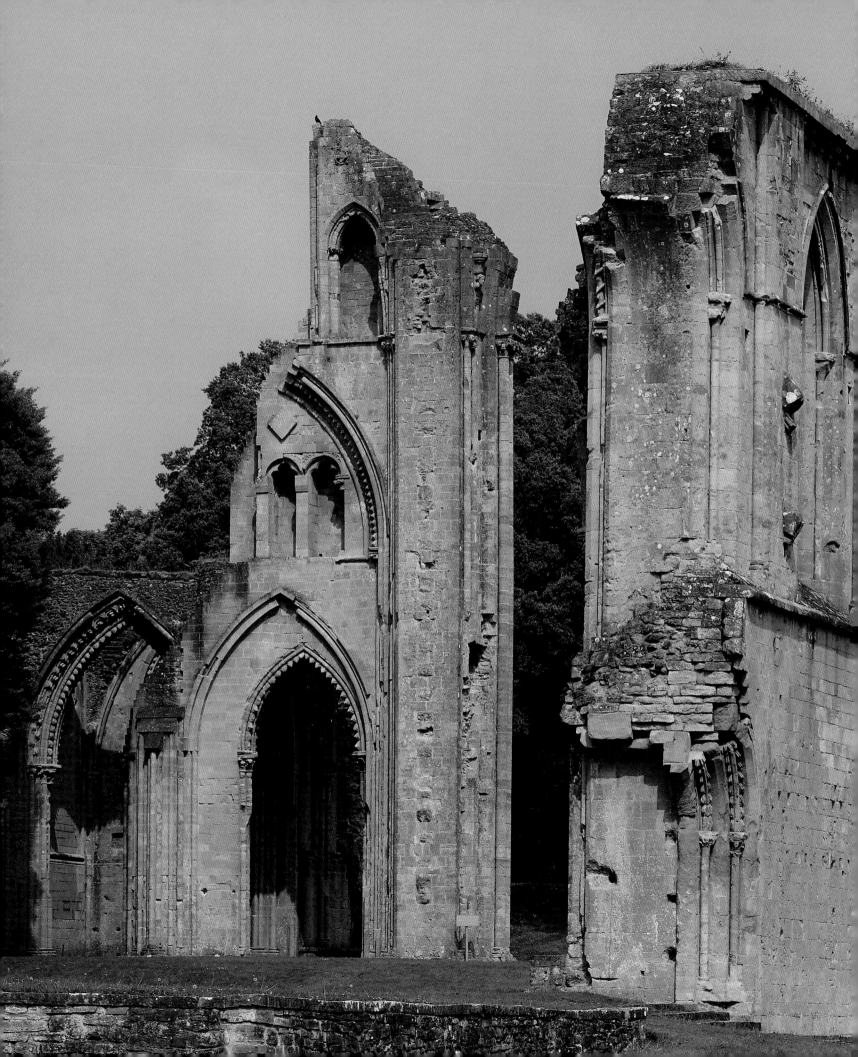

GLASTONBURY ABBEY
Somerset

Many of the great abbey remains can be found in spectacular landscape settings; in other important cases, they are sited at the centre of towns that arose on the foundations of their patronage. One such is Glastonbury Abbey in Somerset, around which the town huddles. There is an extraordinarily rich atmosphere here, since the picturesque Somerset market town is a centre for alternative spirituality, and the shops seethe with everything from Tibetan Buddhism to witchcraft.

The pale stone ruins of the abbey were bought by the Church of England in 1907. Today, they are open to the public as a gently manicured tourist attraction complete with costumed monks and women, who allow themselves to speak only in sixteenth-century English. But it is still regarded as a sacred site, and Roman Catholics and Anglicans alike continue to view Glastonbury as a deeply holy place. Large processions and open-air masses are held here at certain times of the year.

According to medieval legend, the first simple church at Glastonbury was built by Joseph of Arimathea with the assistance of the boy Jesus. This same legend – which is not authenticated in any way by modern scholarship – states that Joseph later returned to Glastonbury with the chalice used to catch Christ's blood at the Crucifixion. The site has a further connection with the legend of the Holy Grail, being the reputed burial place of Arthur and Guinevere. In the early eighteenth century Daniel Defoe described being escorted around Glastonbury to see these same attractions.

What is certain is that the abbey is a very ancient site, although it is difficult to determine its exact origin. It was refounded in the seventh century by King Ine of Wessex. Ine built a stone church, which was then extended by St Dunstan, the abbot of Glastonbury from 940 to 956 (and later Archbishop of Canterbury). More than a century later, at the time of the Domesday Book, the abbey was the richest in England. It was again rebuilt after a major fire in 1184; the restored Lady Chapel, much of which survives today, was consecrated in 1186. The vast nave appeared next,

completed in the 1250s. In the fourteenth century a series of chapels was added to the choir, and at the same time a great kitchen was built for the abbot's lodgings, which survives almost intact.

The abbey was dissolved in 1536, and was one of the few places where an abbot was executed for opposing the closure of his monastic house; in this case, Abbot Whiting, an old and frail man, was hanged with two other monks on Glastonbury Tor. His head was displayed on the abbey gateway. The Tor itself rises above both the abbey and the town, and the tower of the former church of St Michael's stands dramatically on its crest. The view from the Tor is at once surreal and awe-inspiring, with the Somerset Levels spreading far around.

When I visited the abbey early one spring morning, there were relatively few visitors, and I had the full attention of one of the costumed guides, dressed as a monk. I was amused to discover that he was also an ordained priest of the Church of England. The richness of the spiritual world here is potent, and it was intriguing to note that Frederick Bligh Bond, the first official Director of Excavations at the abbey, was dismissed in 1922 for his apparently excessive interest in psychic phenomena.

Opposite
The remains of the crossing tower at Glastonbury Abbey, once one of England's most important Christian shrines.

Right
The tower of St Michael's on Glastonbury Tor, beside which the last abbot of Glastonbury was executed in 1539 for his refusal to surrender the abbey to the Crown.

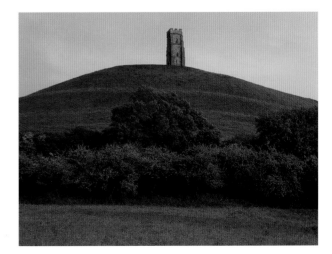

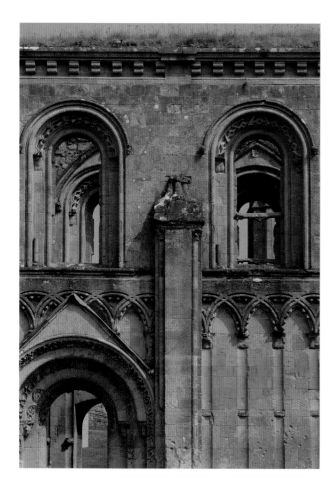

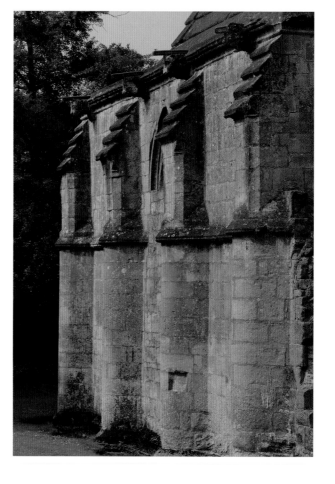

Left
Romanesque and Gothic details at Glastonbury Abbey: (top left) the distinctive windows of the late twelfth-century Lady Chapel; (top right) the buttresses of the fourteenth-century abbot's kitchen; (bottom, left and right) fragments of the north and south side of the main crossing, complete with distinctive 'dog-tooth' detailing.

Opposite
A corner of the Lady Chapel showing the richness of the interior carved detail. Originally, the carvings would have been brightly painted.

Pages 26–27
The ornate fifteenth-century tower of the nearby church of St John's seen across the ruins of the Lady Chapel. The presence of the church highlights the continuing life of the parish after the suppression of the monasteries.

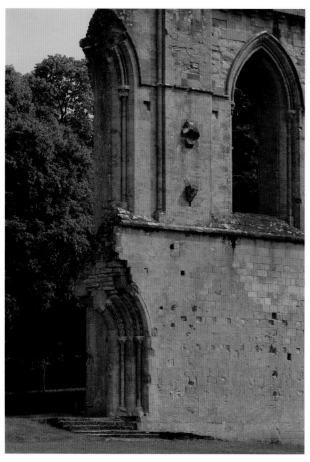

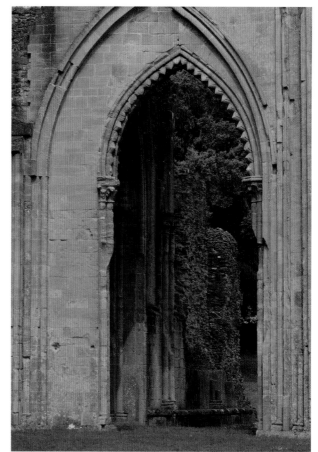

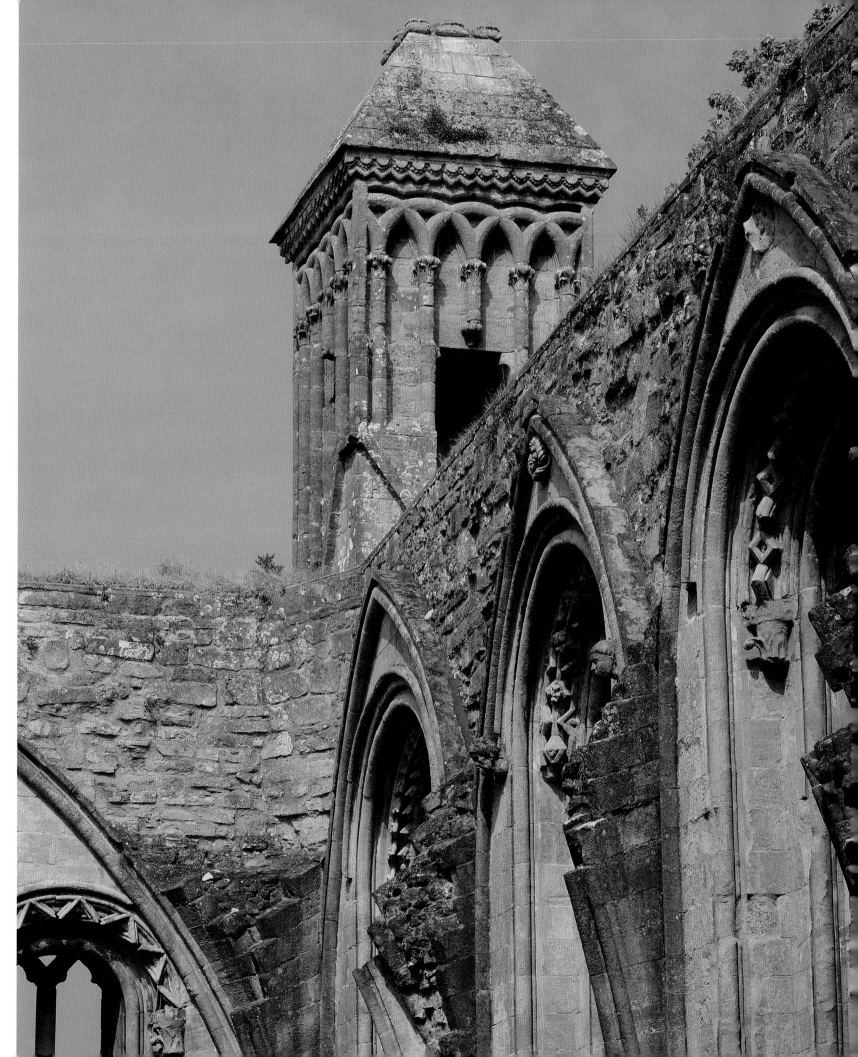

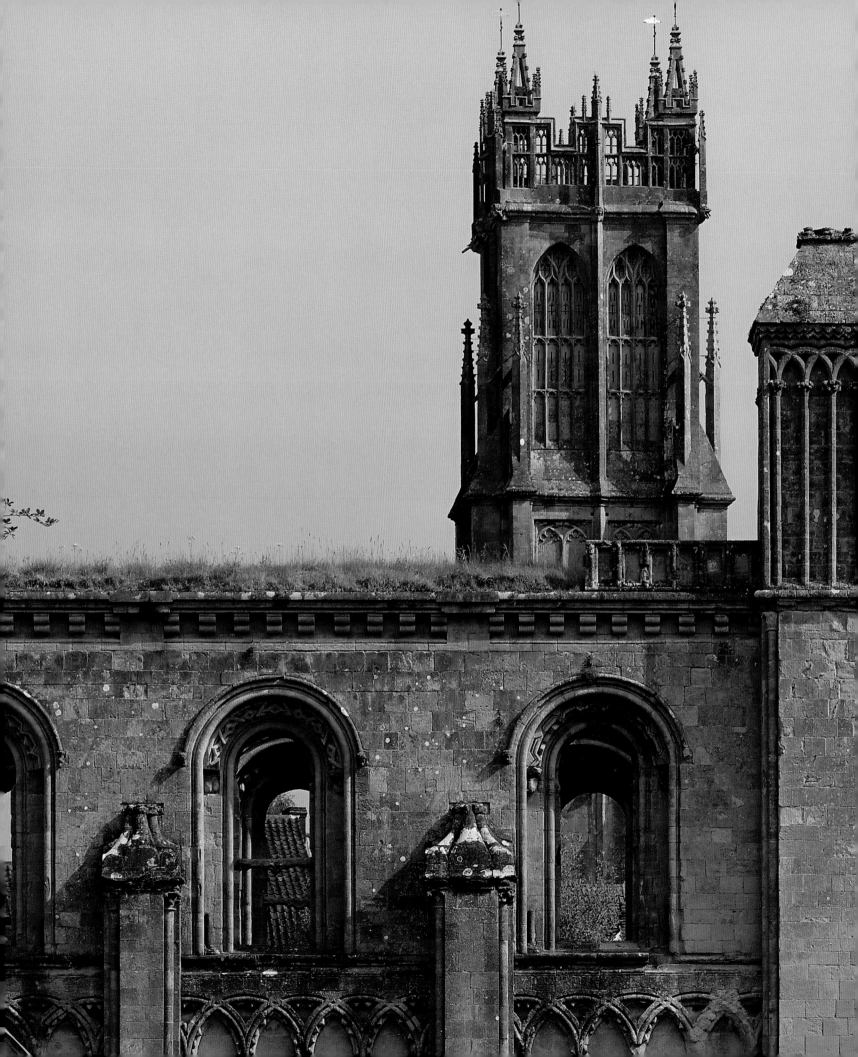

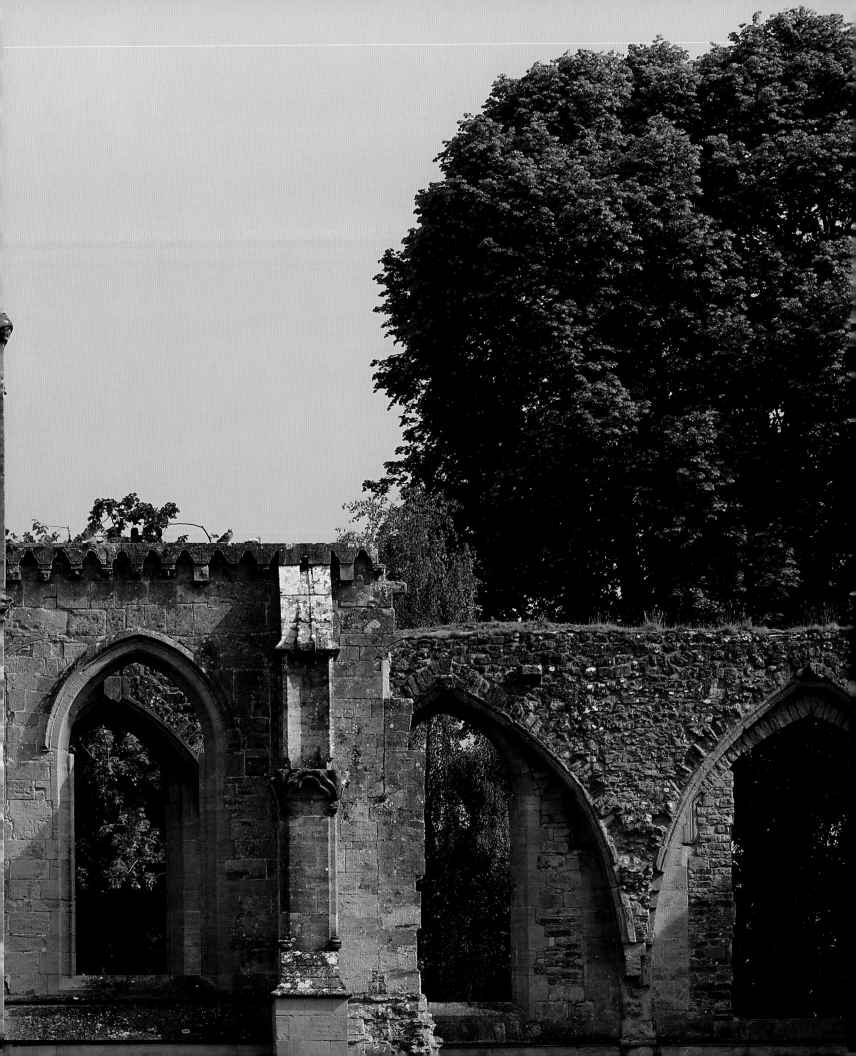

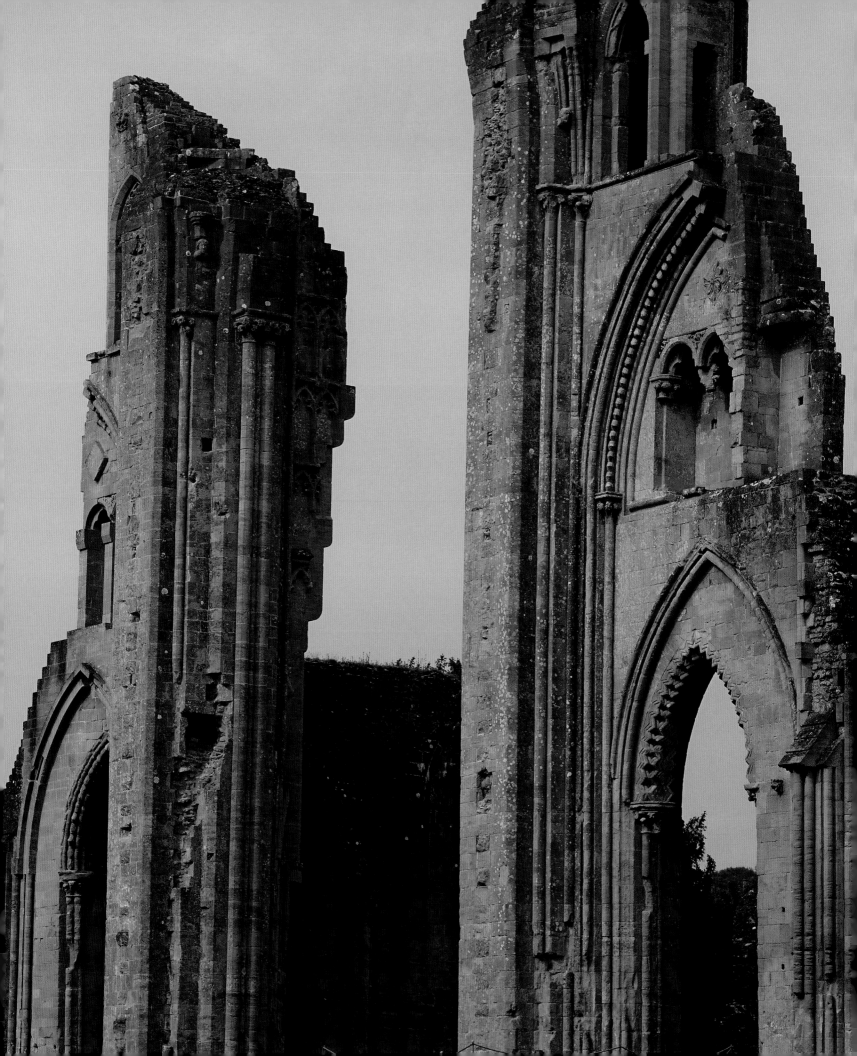

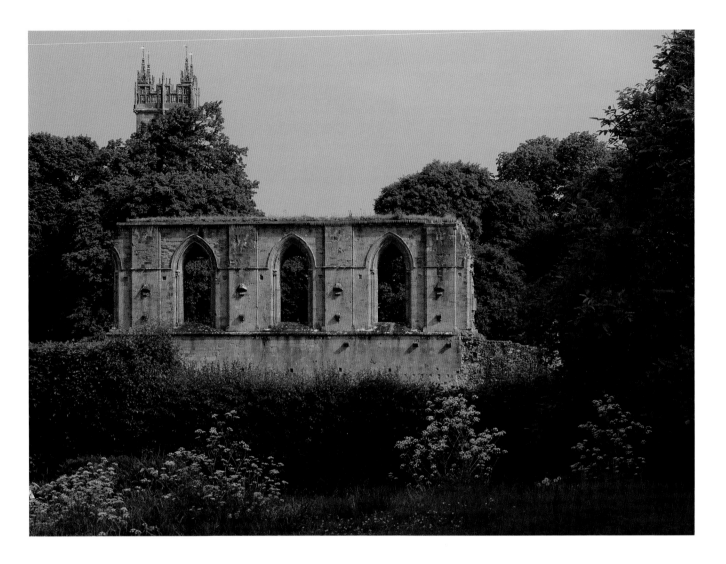

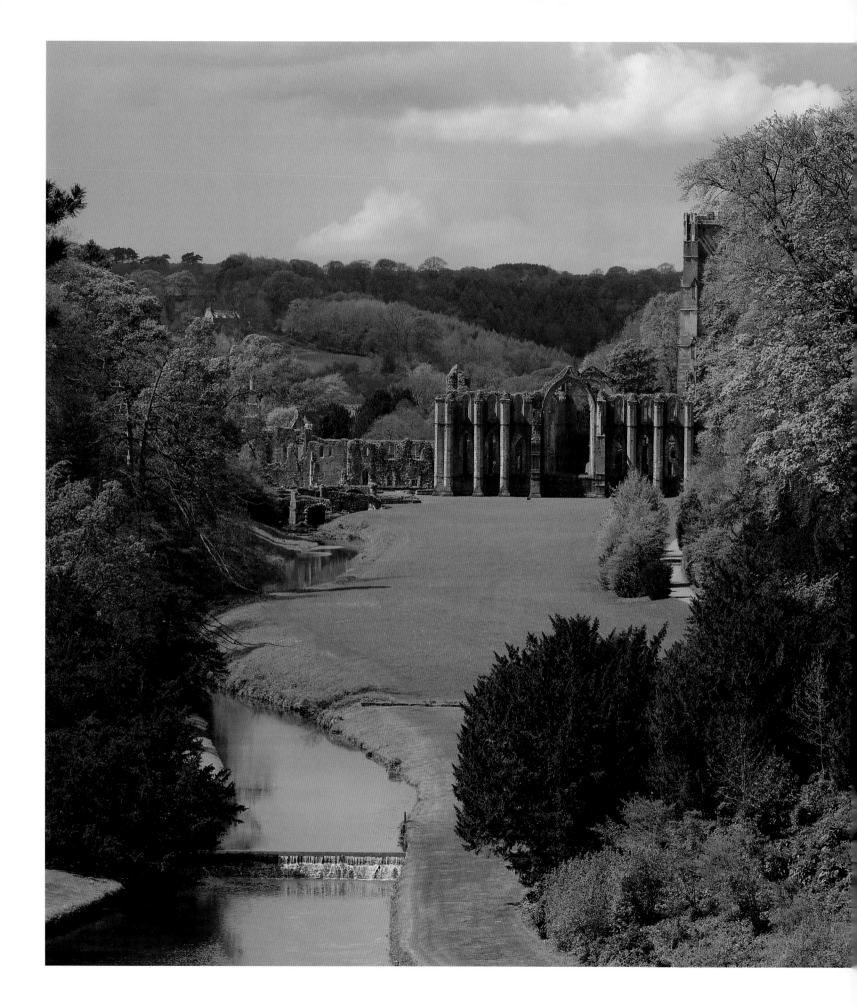

FOUNTAINS ABBEY
North Yorkshire

Fountains Abbey is the most famous of the great ruined abbeys of England. It is simply one of the wonders of English architectural history, set in a 'secret' valley not far from Thirsk in North Yorkshire (and now cared for by the National Trust). Today's visitors approach the abbey by a path that winds its way through a wood before revealing below them a vast complex of grey stone buildings of breathtaking grandeur – almost like a small town in extent.

To one side are the towering remains of the roof-less, glass-less, grass-floored church. In the centre stands the core of the original abbey: the cloister, refectory and dormitory. One of the most intact interior spaces is the cellarium (or storehouse), which was built on the west side of the cloister. There is also a pair of guest houses and, just beyond them, a twelfth-century mill, which remained in working use until 1929.

Fountains Abbey was first settled in 1132 by a group of monks originally from St Mary's Abbey in York. The monks had been given this wild site on the River Skell by Thurstan, Archbishop of York from 1114 to 1140. In 1135 their first abbot, Richard, was permitted to become part of the Cistercian Order (known as the White Monks). The main abbey church was built in the 1150s, and, at first, two-thirds of the nave was used by the land-working lay brothers, allowing the 'choir monks' to concentrate on prayer and meditation.

In the early 1200s the original east end of the church was replaced with a new choir and a transept known as the Chapel of the Nine Altars. Three centuries later a large bell-tower was added to the north transept by Abbot Huby, under whom Fountains became the richest Cistercian abbey in England. It was also Huby who surrendered Fountains to the Crown.

The abbey's setting was originally chosen for its remoteness, a quality appropriate to the austerity of the order. Yet to a modern visitor it feels peaceful and hidden, made more beautiful by the surrounding Studley Royal estate. The estate's parklands, which include such Classical features as the Temple of Piety, were landscaped for William Aislabie in the eighteenth century, and the remains of Fountains Abbey were treated as an important focal point.

A large proportion of the monastic complex can still easily be traced, including the remains of the great cloister and, to the west of the cloister, the remains of the large accommodation range for the lay brothers. In addition, it is possible to locate the lay brothers' reredorter (or communal latrine) and infirmary, built over the river; the two guest houses mentioned above; a malt house; and a wool house.

Also clearly discernible today are the choir monks' chapter house, the monks' refectory and dormitory, kitchens, and the vaulted muniments room over a warming chamber (where monks affected by the cold could revive themselves beside the always-burning fire). Beyond this lay the monks' infirmary built by Abbot John, as well as the once-extensive abbot's lodgings. The walled precinct of the abbey was some 30 hectares (74 acres) in extent, and the awesome scale of what remains today serves to underline what has been lost.

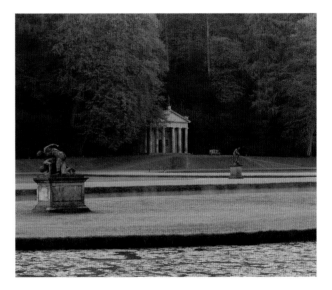

Opposite
Fountains Abbey, once one of the richest monasteries in England, lies in the valley of the River Skell. The domestic ranges stood to the south of the great abbey church.

Above
The Temple of Piety, built in the eigthteenth century as part of the landscaping of the Studley Royal estate's parklands.

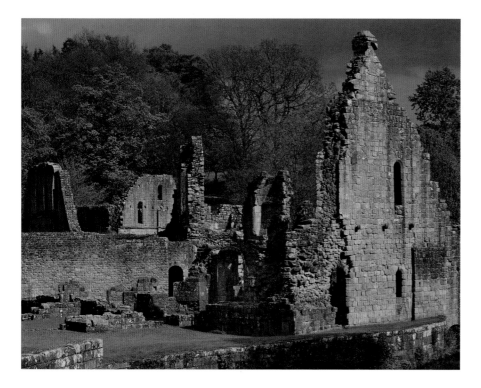

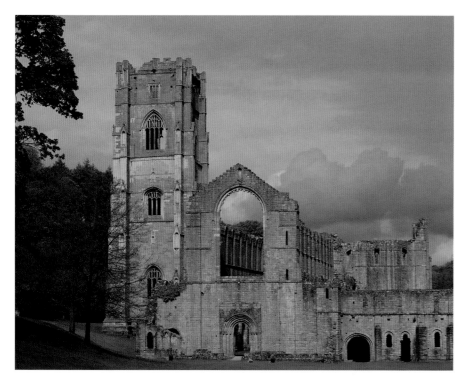

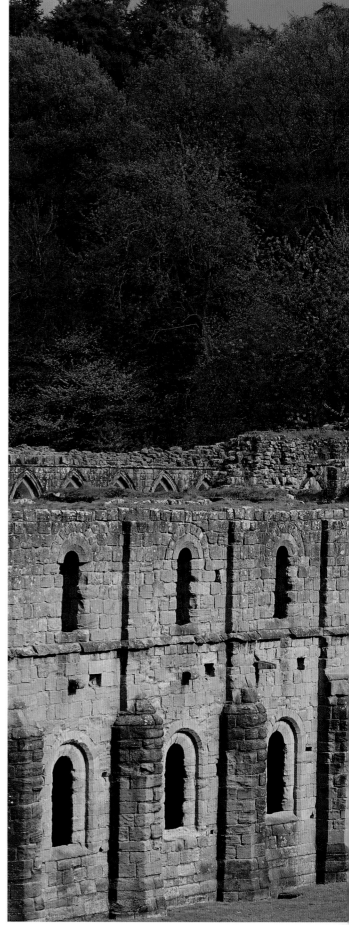

Top
The remains of one of the guest houses. Monasteries were important centres of hospitality for travellers and pilgrims.

Above
The west end of the abbey church. The tower was added in the early sixteenth century, when the abbey was still possessed of great wealth derived from wool produced on its agricultural estates.

Right
Looking like a fragment of a lost city, the main west range contained the refectory for the lay brothers, who worked on the fields. The cloister lies behind this range.

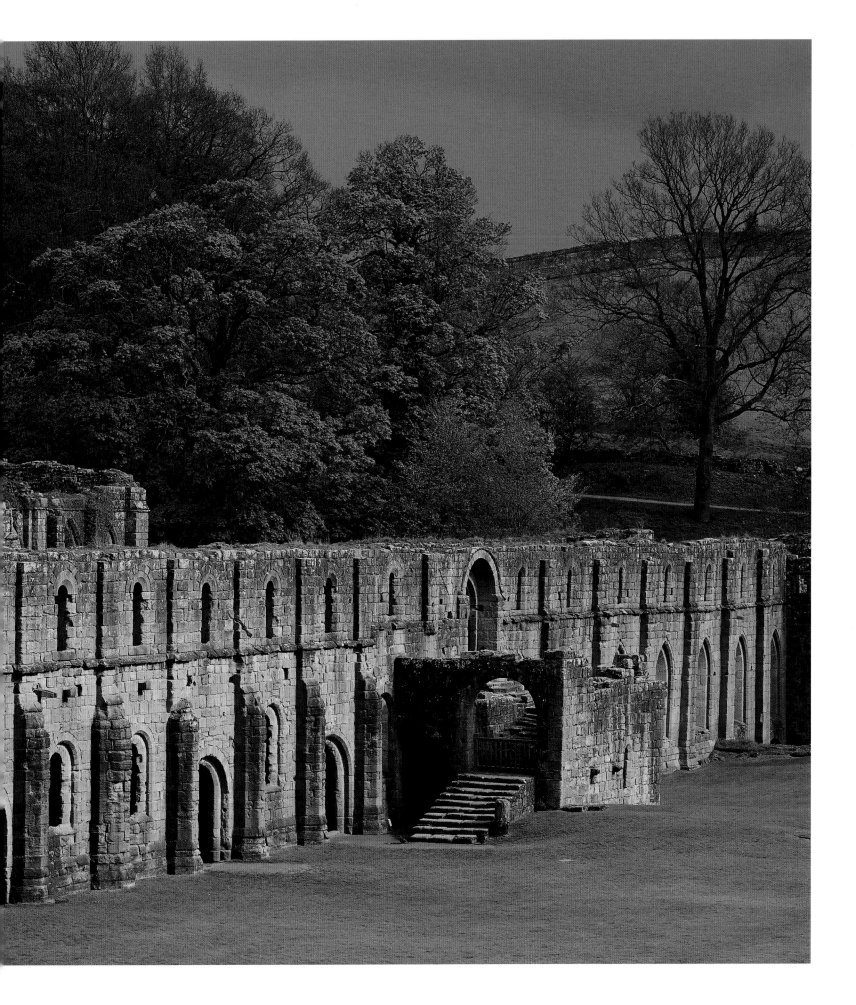

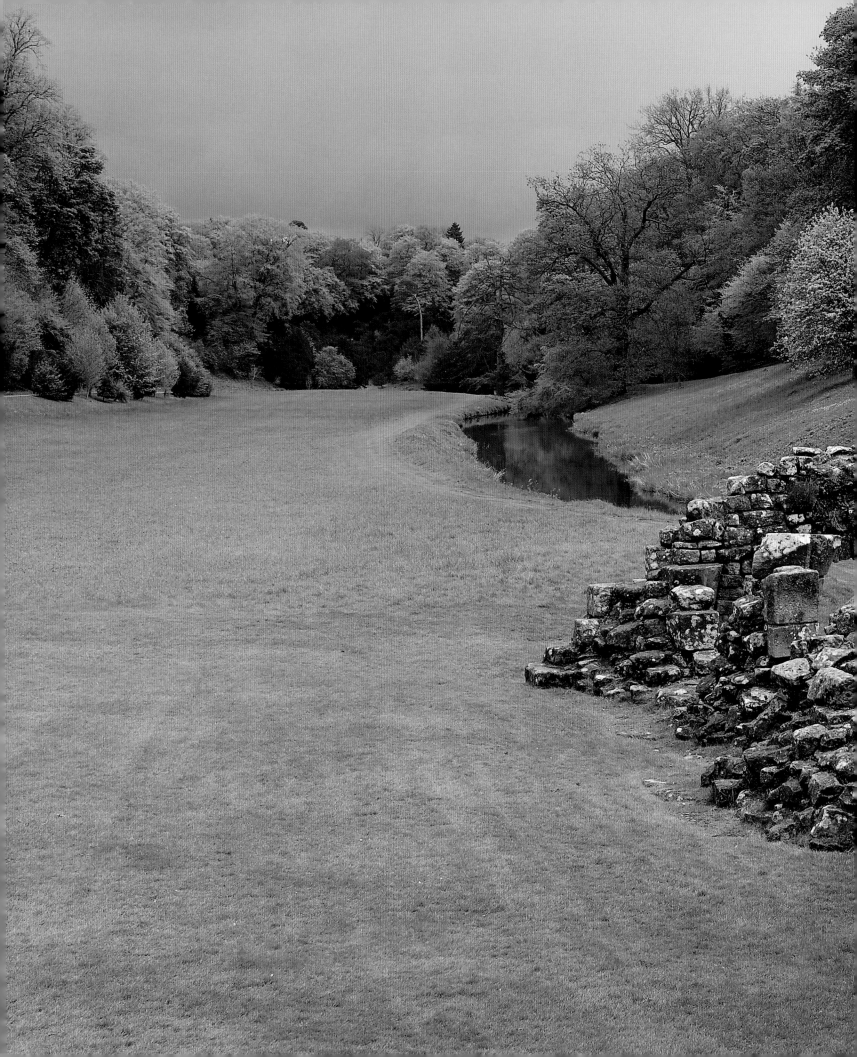

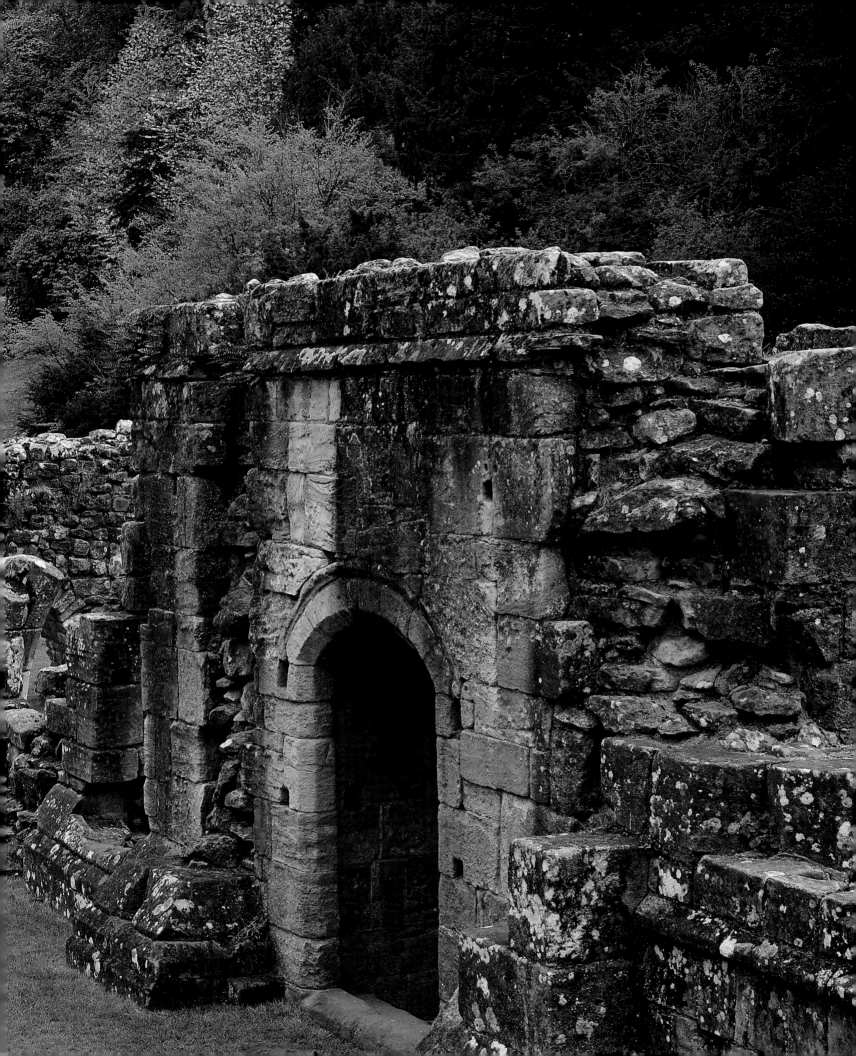

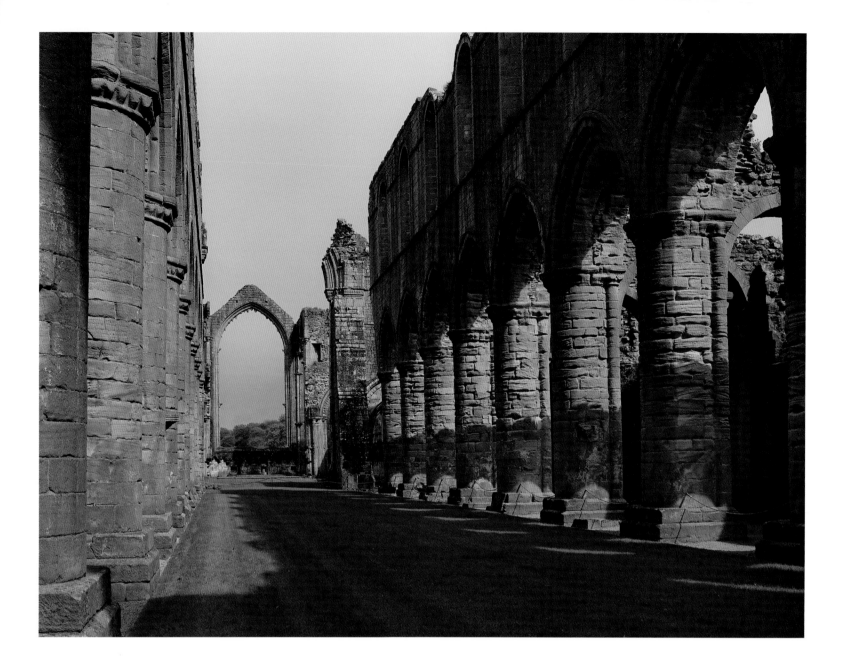

Pages 34–35
The remains of the
conduit house and
the passage that
led to the monks'
infirmary.

Above and opposite
Awe-inspiring
grandeur even in
ruins: inside the nave
of the abbey church,
looking towards the
east window and the
once richly decorated
Chapel of the Nine
Altars; the vaulted
cellarium of the west
range of the cloister.

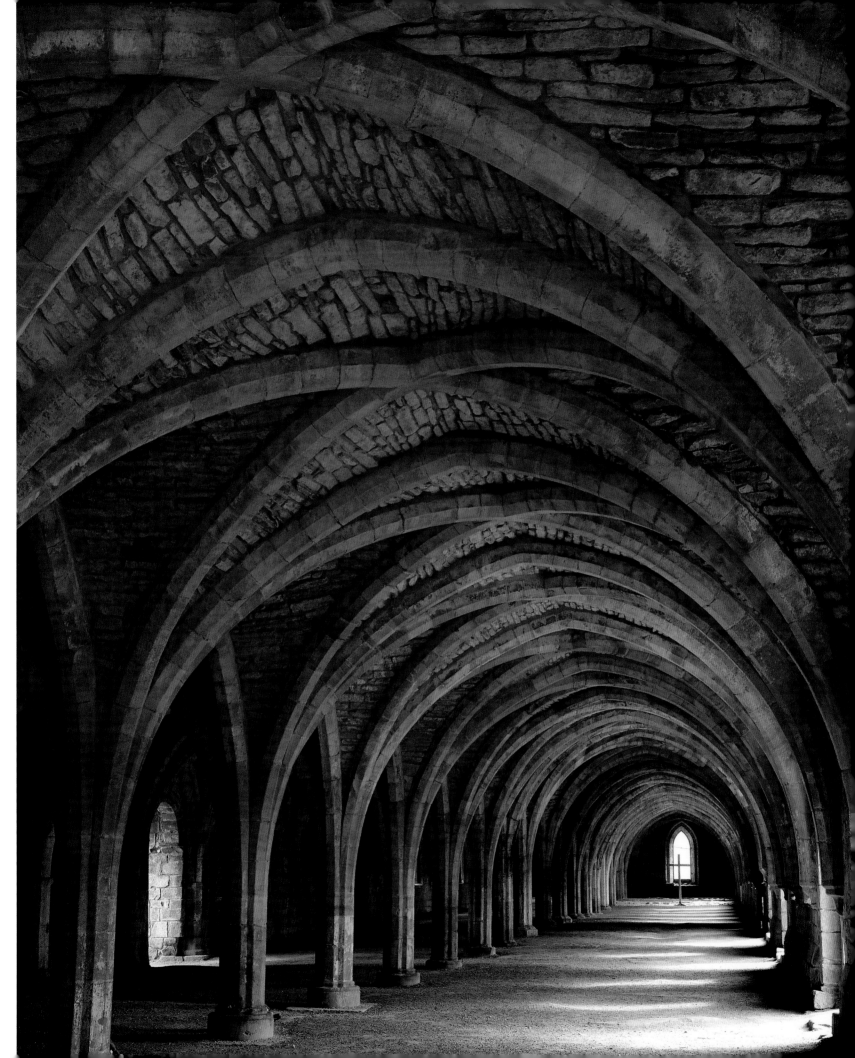

WHITBY ABBEY
North Yorkshire

The ruined thirteenth-century abbey church in Whitby, North Yorkshire, sits above the town's harbour, although all traces of the extensive monastic buildings that would have once stood alongside it have completely gone. Whitby Abbey occupies an extraordinarily dramatic cliff-top site, and can be seen for miles around, including from out at sea. In fact, it is thought that the status of the church as a landmark for sailors may explain why it was left relatively intact after the dissolution of the monasteries. The abbey's proximity to the sea also explains the effects of weathering on the stone, especially of the end facing the town, which has taken on the character of a piece of naturally formed rock.

The site is one of considerable importance in the history of Christianity in the north of England. There has been an abbey here since the seventh century, when King Oswy of Northumbria fulfilled a vow to establish twelve monasteries if he should conquer the pagan King Penda of Mercia. St Hilda, then the abbess of Hartlepool, was invited to be abbess at Whitby, which was a double monastery for men and women.

The abbey was the setting for the Synod of Whitby in 664 and the vision of Caedmon, which transformed the cowherd into a poet. It was partly destroyed by

Viking invaders in 867, but refounded towards the end of the eleventh century by Prior Reinfred – a former soldier in Willam the Conqueror's army – with gifts from William de Percy. Reinfred had apparently been determined to restore the abbey after seeing its ruins.

Reinfred's Benedictine abbey church was rebuilt in the early thirteenth century, beginning with the choir, where the three horizontal bands of arcading and surviving carved detail suggest the richness of the work, which would have been highly painted and decorated with coloured stained glass in the windows. The transept was rebuilt probably in the 1250s; the north still stands; and the south, which collapsed in 1736, would have projected into the monastic complex. A central crossing tower was completed by the 1280s, and survived until 1830.

At the dissolution the abbot's lodgings became Abbey House, a private residence for the Cholmley family. In the late seventeenth century the house was given a new façade and north range, built partly with stones taken from the old abbey. This range was ruined and left unroofed in the late eighteenth century, but was re-roofed and converted into a visitors' centre in 2002.

Samuel Buck's engraving of the abbey church published in 1711 shows the main church roofless but still largely intact, and it is strange to discover that the nave collapsed only in 1762, and the crossing later still. Extraordinarily, the west end of the church was shelled by the German navy in 1914, shortly after the outbreak of the First World War; however, what was damaged was restored to its pre-war condition.

Bram Stoker's *Dracula* (1897) is partly set in Whitby, and the dramatic presence of the abbey features in the journal of one of the characters, Mina Murray: 'It is a most noble ruin, of immense size, and full of beautiful and romantic bits; there is a legend that a white lady is seen in one of the windows.' The story of the White Lady may be a legend encouraged by Sir Walter Scott's epic poem *Marmion* (1808), in which a nun is walled up in Whitby Abbey for breaking her vows. Whatever the myths that have gathered around this place, it remains one of the most stirring sights in Yorkshire.

Opposite
The surviving mid-thirteenth-century north transept of the abbey church. The corresponding south transept collapsed in 1736.

Below
Whitby Abbey silhouetted above the harbour at Whitby. It seems that the abbey church was preserved as a familiar coastal landmark for sailors.

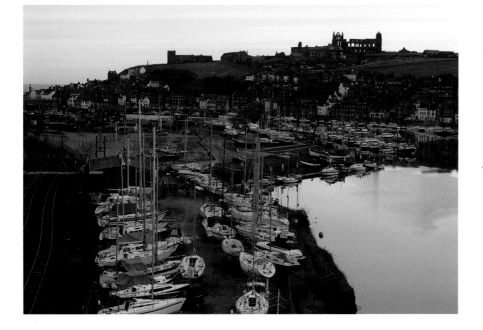

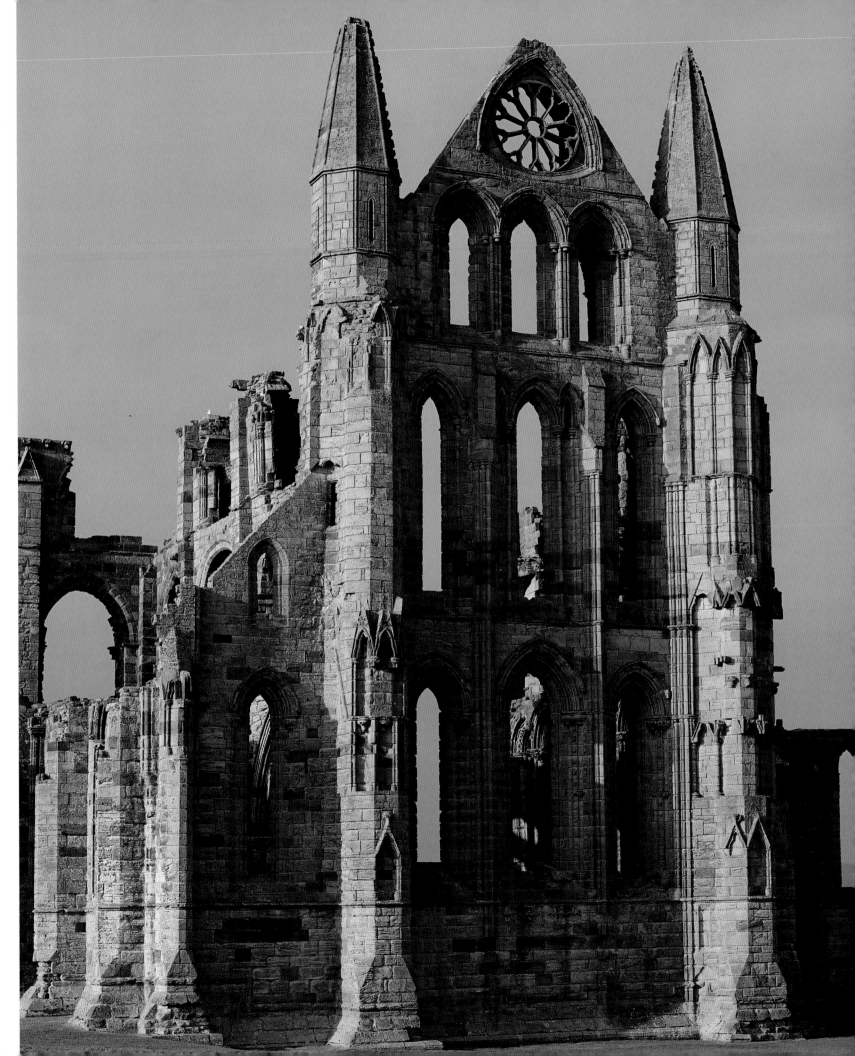

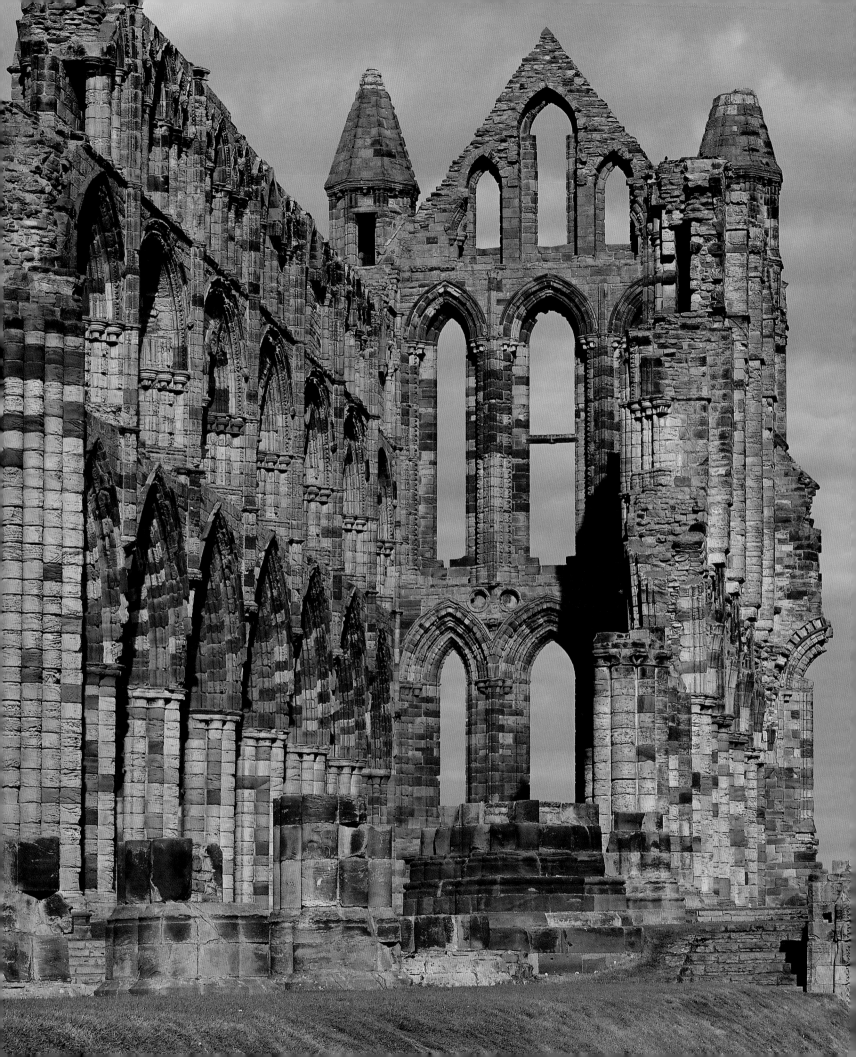

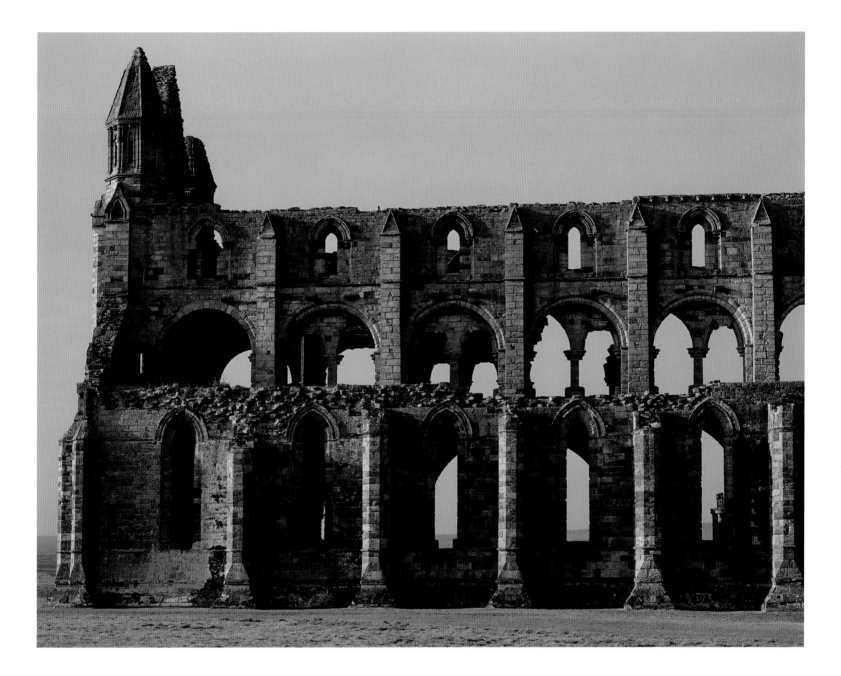

Above
The ruined choir
of the abbey church
seen from the north.

Opposite
The east end of
the abbey church,
showing the choir
and the position
of the high altar.

Pages 42–43
Made picturesque
by time: the remains
of the nave and
the north aisle of
the abbey church
resemble a sandcastle
washed away by the
waves of history.

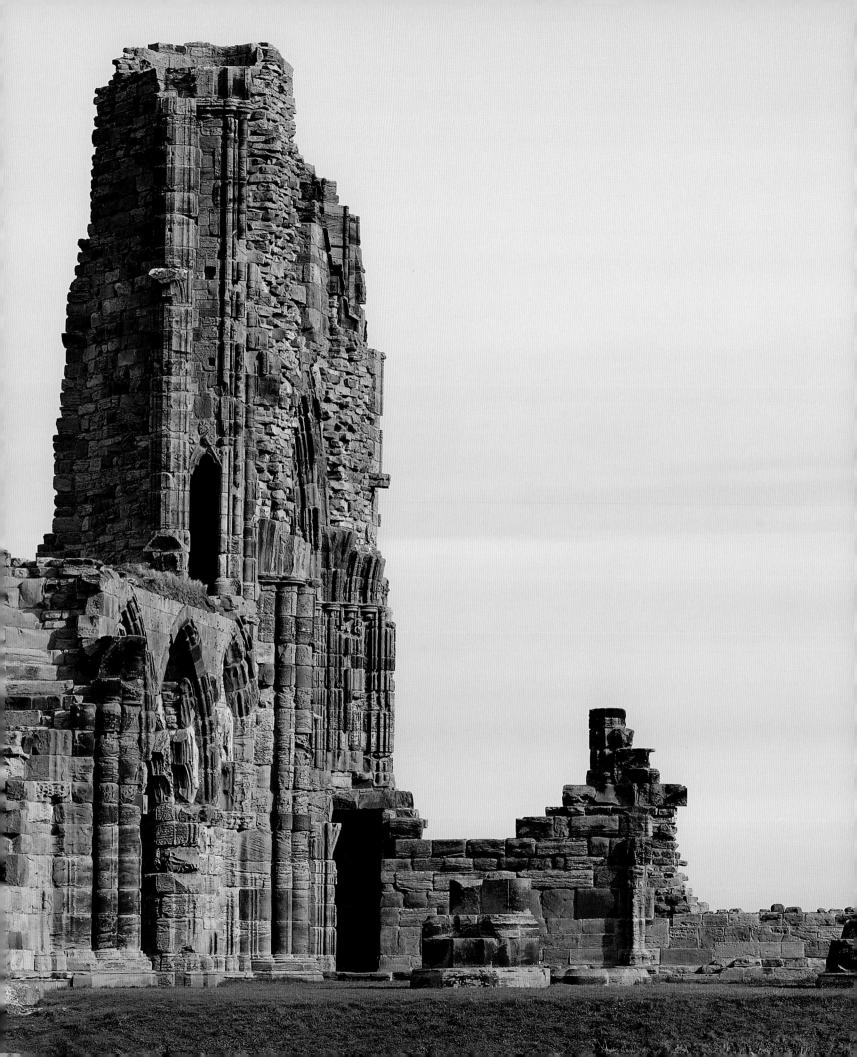

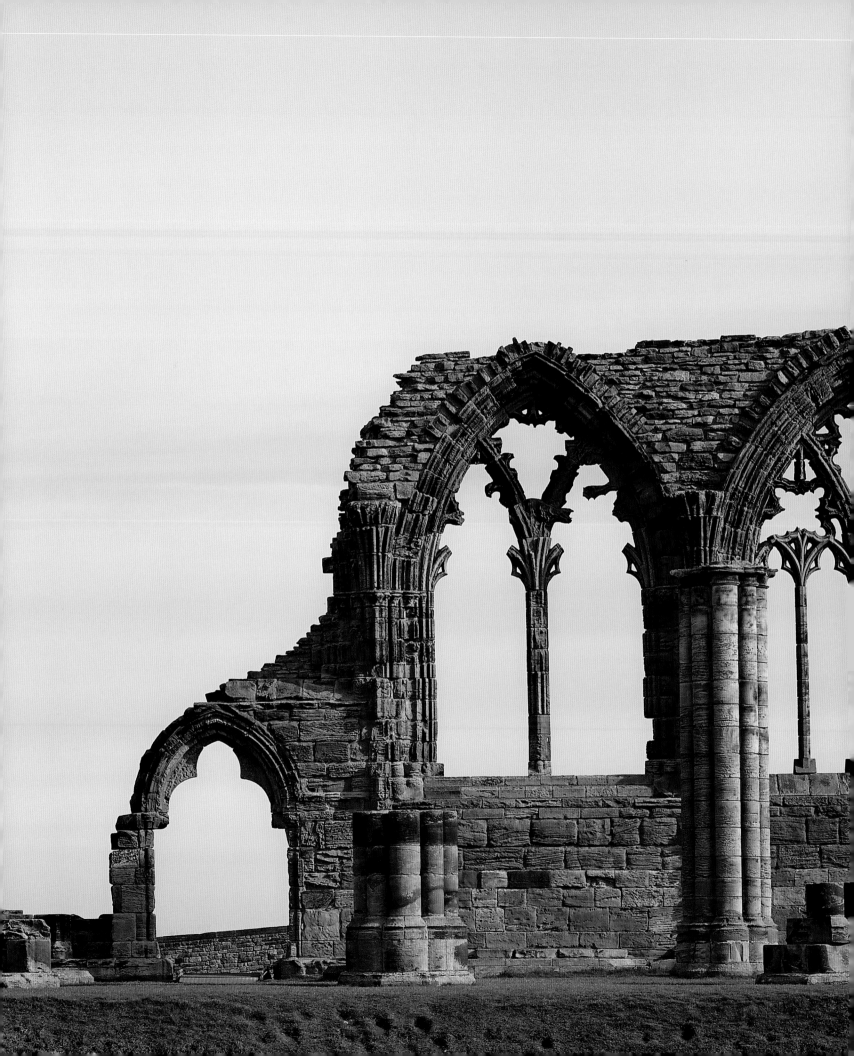

ST ANDREW'S
Covehithe, Suffolk

On the Suffolk coast stand the ruins of an extraordinary, remote church that tells a particular story of the rise and fall of the fortunes of the English parish church. St Andrew's, Covehithe, was once a great Perpendicular church typical of the sixteenth-century rebuildings, with a series of huge Perpendicular windows and delicate flintwork alternating with stone.

By the late seventeenth century the upkeep of the church appears to have been too much for the small community it served. It had also been somewhat knocked about by agents of Parliament during the Civil War. William Dowsing, an iconoclast and 'commissioner for the destruction of idolatry and superstition' from 1643 to 1644, recorded that he had visited the church and destroyed some 200 stained-glass images of cardinals and the Virgin Mary.

In 1672, almost thirty years after this act of despoliation, the parishioners received permission to remove the roof and create a smaller, thatched church in the west end of the nave against the tower. This new structure, built using stone and brick from the abandoned church, has an interior of great simplicity, incorporating some fifteenth-century poppy-head benches and a fifteenth-century font.

Thus the rest of the earlier church – the nave, the chancel, and the north and south aisles – were left to stand in stout ruin. The tower, which dates from the fourteenth century, was for many years considered an important landmark for sailors. For a time, the site fell under the remit of Trinity House, the body responsible for the maintenance of lighthouses.

The ruins of St Andrew's suggest past grandeur: judging by the scale and detailing of the nave, it must have been one of the grandest churches in the county. (The original nave was certainly on a par with those of the great parish churches of nearby Blythborough and Southwold.) The rood loft stair is still visible in the north wall of the old church, while the buttresses of the east wall have fine canopied niches for statues.

The ruins and tower are now in the care of the Churches Conservation Trust, but the small church is still a place of worship and tangible spirituality. It is sobering to think that, in fifty years' time, this handsome ruin may well have been swept into the ever-encroaching sea, which has already swallowed up much of the parish. Before long, its surviving church could follow the fate of the lost village of Dunwich; the church of St Peter there began to fall into the sea in December 1688.

Right
A fragile survivor from another age: the fourteenth-century tower and ruined fifteenth-century nave of St Andrew's.

Opposite
The openings of the tall, glass-less Perpendicular windows of the nave.

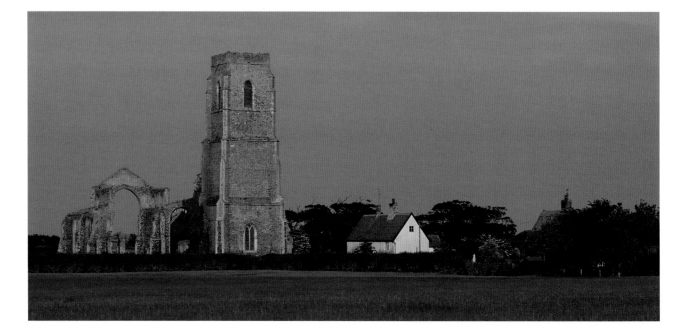

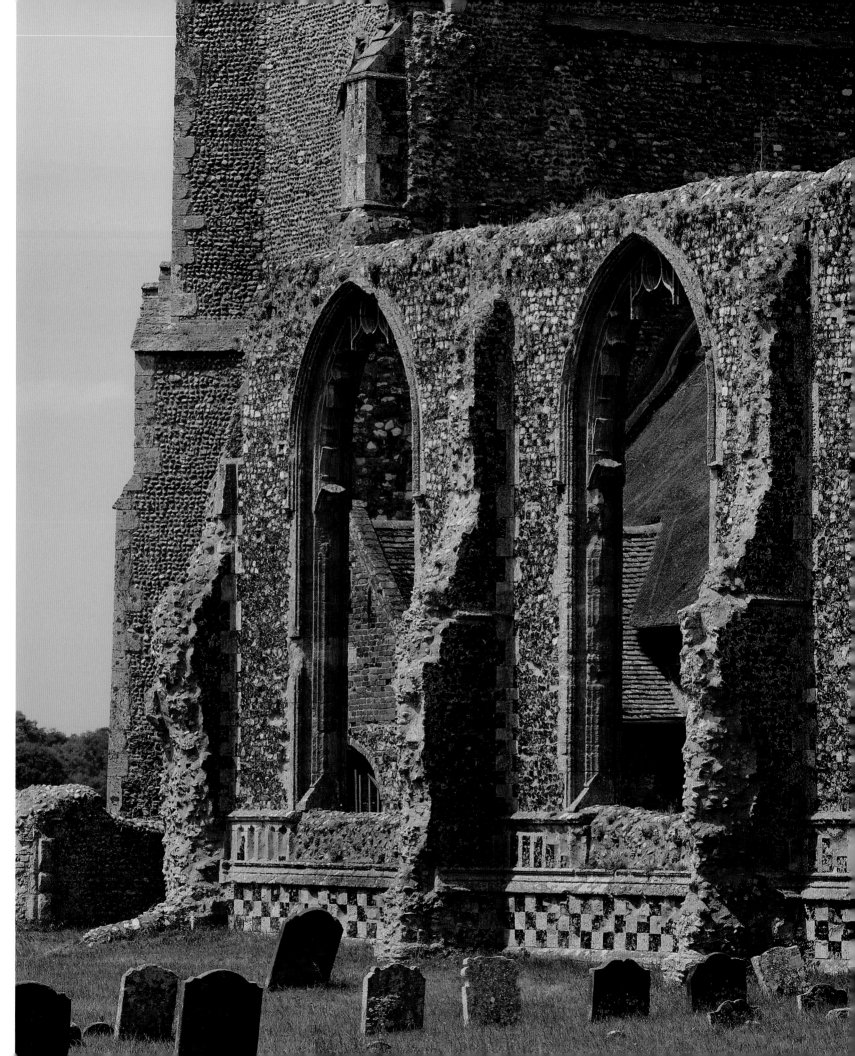

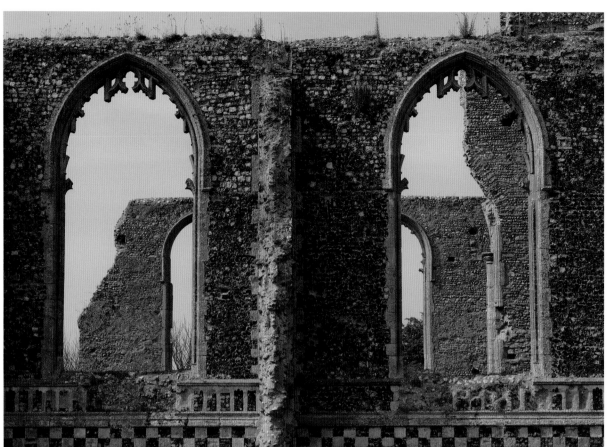

St Andrew's is a shrine to shrinking faith. In the seventeenth century the parishioners part-dismantled the huge church that they could no longer afford to repair, removing the roof and creating a smaller church within the setting of these flint walls and empty arches. The windows of the abandoned church were once filled with stained glass, while the interior walls would have been plastered and painted. The glass was smashed by William Dowsing and his men at the time of the Civil War. However, Covehithe was one of the places where they met resistance from the local population.

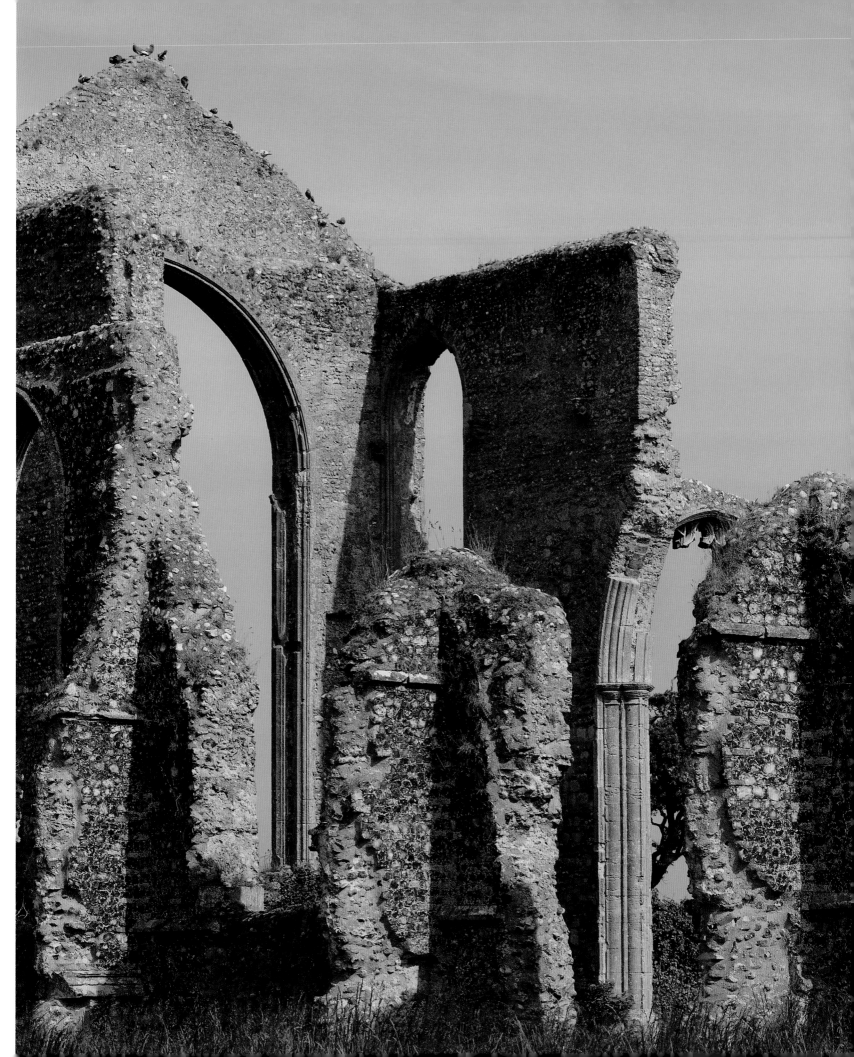

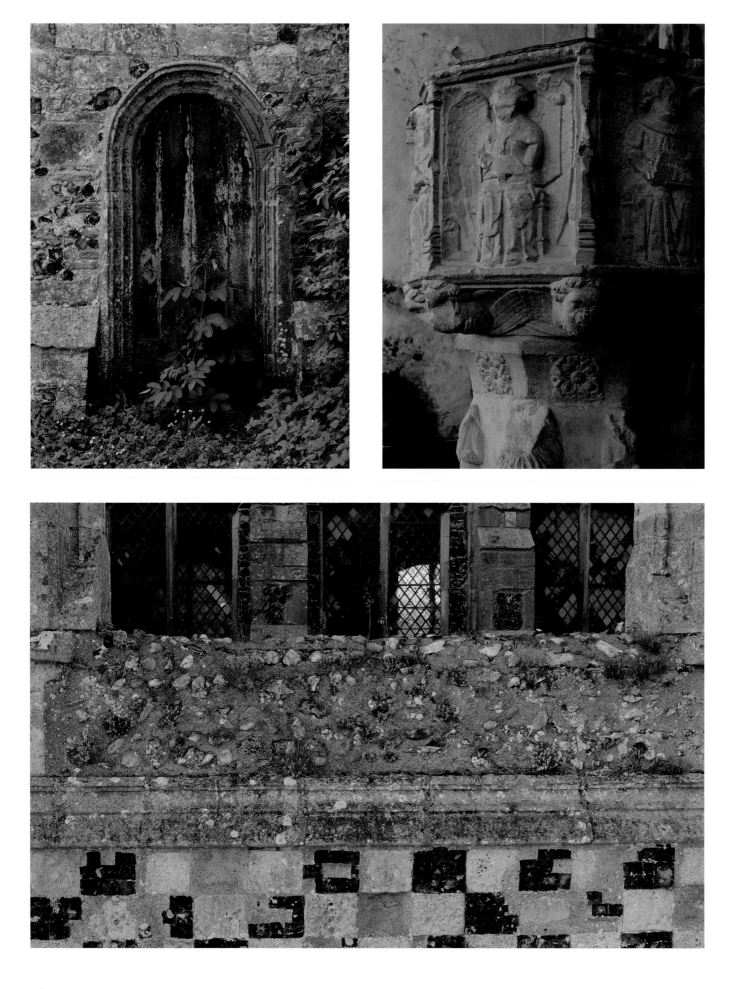

Opposite
God is in the details: (top left) the door to the tower; (top right) the original medieval font retained in the late seventeenth-century church; (bottom) the knapped and rough flint of the late fifteenth-century work.

Right
The modest, part red-brick porch to the simple, late seventeenth-century nave.

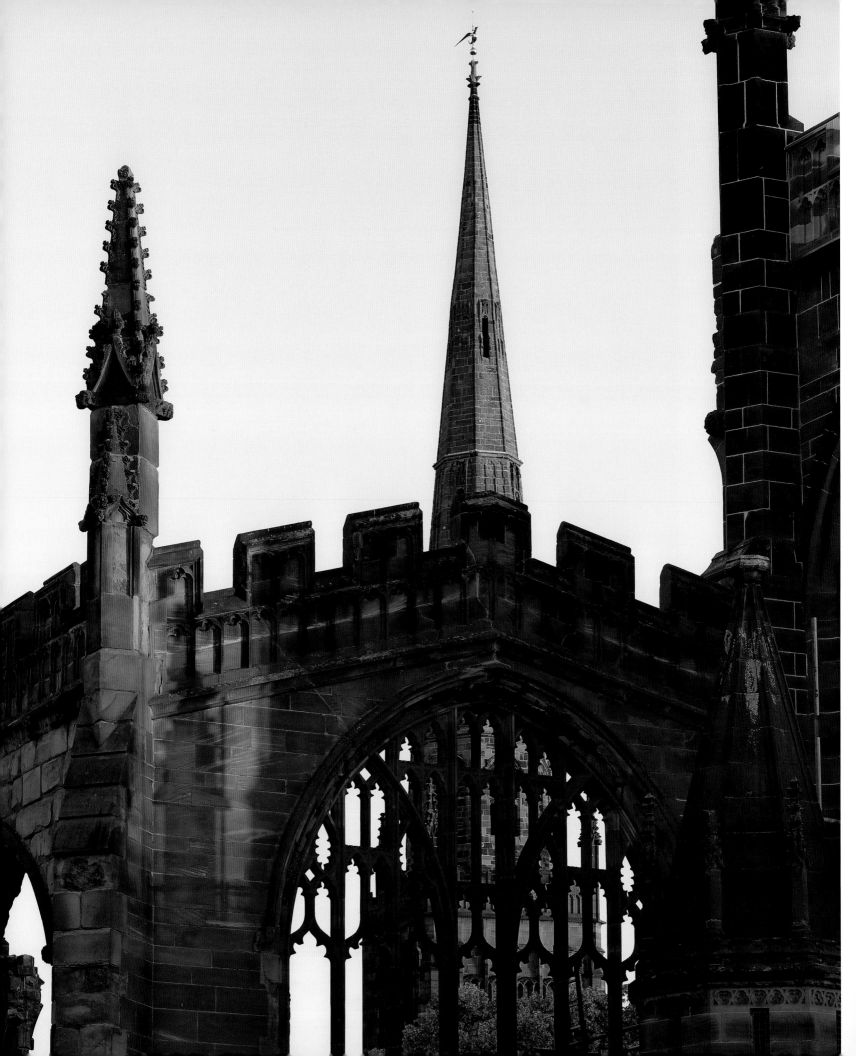

COVENTRY CATHEDRAL
Warwickshire

One of the most extraordinary survivors of the aerial bombardment of England during the Second World War is the shell of the medieval nave and chancel of Coventry Cathedral. The cathedral was originally a fifteenth-century parish church, one of the largest in England, which had been mostly funded by a family of Coventry merchants, the Botoners. The huge church was designated a cathedral in 1918. There had in fact been an earlier cathedral in the city, but at the dissolution of the monasteries in the 1530s, the see of Coventry and Lichfield was transferred to Lichfield.

On the night of 14 November 1940 Coventry, one of the largest cities in the Midlands, was devastated by eleven hours of heavy bombing. The Luftwaffe destroyed most of the city and the cathedral church at its heart. The city was targeted because of its concentration of munitions factories. Some 60,000 buildings were destroyed by 500 tons of high explosive and 30,000 incendiary bombs dropped by 500 planes. As Brian Bailey observed in *The Ordnance Survey Guide to Great British Ruins* (1991), 'The church had taken medieval masons 60 years to complete, but it needed a single night to destroy it.'

Sir Basil Spence's dramatic new cathedral, Modernist in style, preserved the remains of the old cathedral as a kind of garden of remembrance, a permanent memorial to the devastation caused by the aerial attack. The decision to build a new cathedral was made the morning after the bombing. Not long after the destruction, the cathedral mason, Jock Forbes, saw two wooden beams lying in the shape of a cross. He tied them together and stood them on an altar of fallen masonry, inscribing the words 'Father Forgive' on a nearby wall. Another cross was made from three nails taken from the roof truss.

Spence was chosen as architect by means of a competition held in 1951. In *Phoenix at Coventry: The Building of a Cathedral* (1962), Spence wrote: 'I saw the old cathedral as standing clearly for the sacrifice, one side of the Christian Faith and I knew my task was to design a new one which should stand for the Triumph of Resurrection.' He also argued that the two buildings could symbolize the Old and New testaments as one.

Work on Spence's cathedral was begun in 1954, and lasted for eight years. The chancel of the old cathedral effectively became an open-air narthex (or lobby) to the new building, and a double-height porch was added in the space between the two. The interior of the modern cathedral was immediately adorned with new art by John Piper, Jacob Epstein and Elisabeth Frink, among others.

The consecration was carried out on 25 May 1962, and five days later the completed cathedral was the venue for the premiere of Benjamin Britten's specially commissioned *War Requiem*. Coventry Cathedral is still one of the best-known Modernist buildings in England; theologically, it is widely associated with reconciliation and forgiveness. Even if 1950s Modernist architecture is not your thing, the sight of the new cathedral, standing in striking contrast to the ruins of the old (still used for acts of worship from time to time), is truly unforgettable.

Opposite
Early-morning light catches the spire of Coventry Cathedral. The Perpendicular window in the foreground lost its glass on the night of 14 November 1940, when the city was heavily bombed by the Luftwaffe.

Right
The cobbled street that runs past the shell of the old cathedral is indicative of the age of the city, much of which had to be rebuilt after the Second World War.

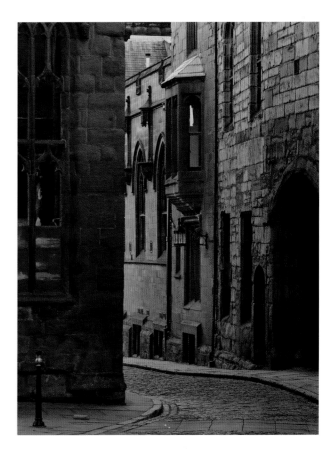

Below, left and right
The window spaces
of the screen-like
fifteenth-century
chancel create
unexpected viewpoints.

Bottom
Sir Basil Spence,
architect of the post-war
cathedral, contrived to
create tall, vertical planes
of glass to echo the
splendour of the original
Perpendicular windows.

Opposite
The tower of the old
cathedral was one
of the few parts of
the building to
survive the bombing
of 1940 intact.

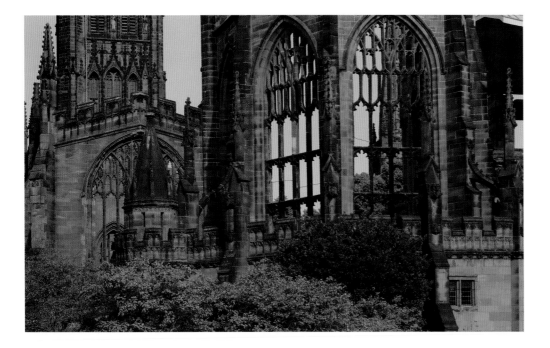

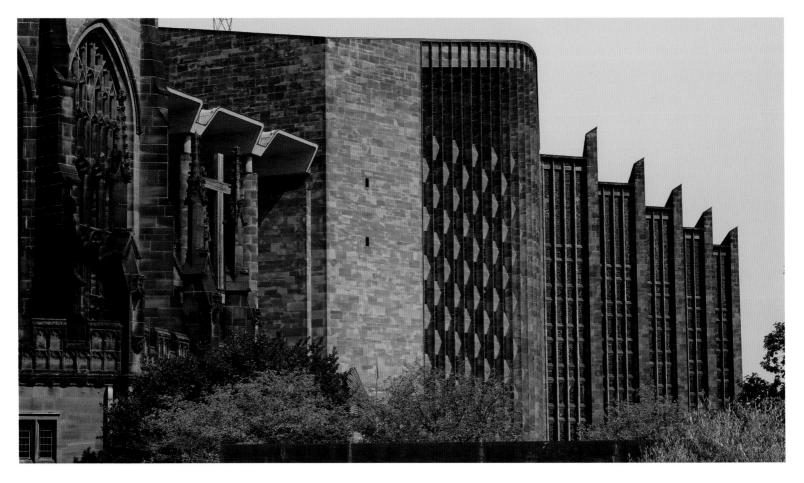

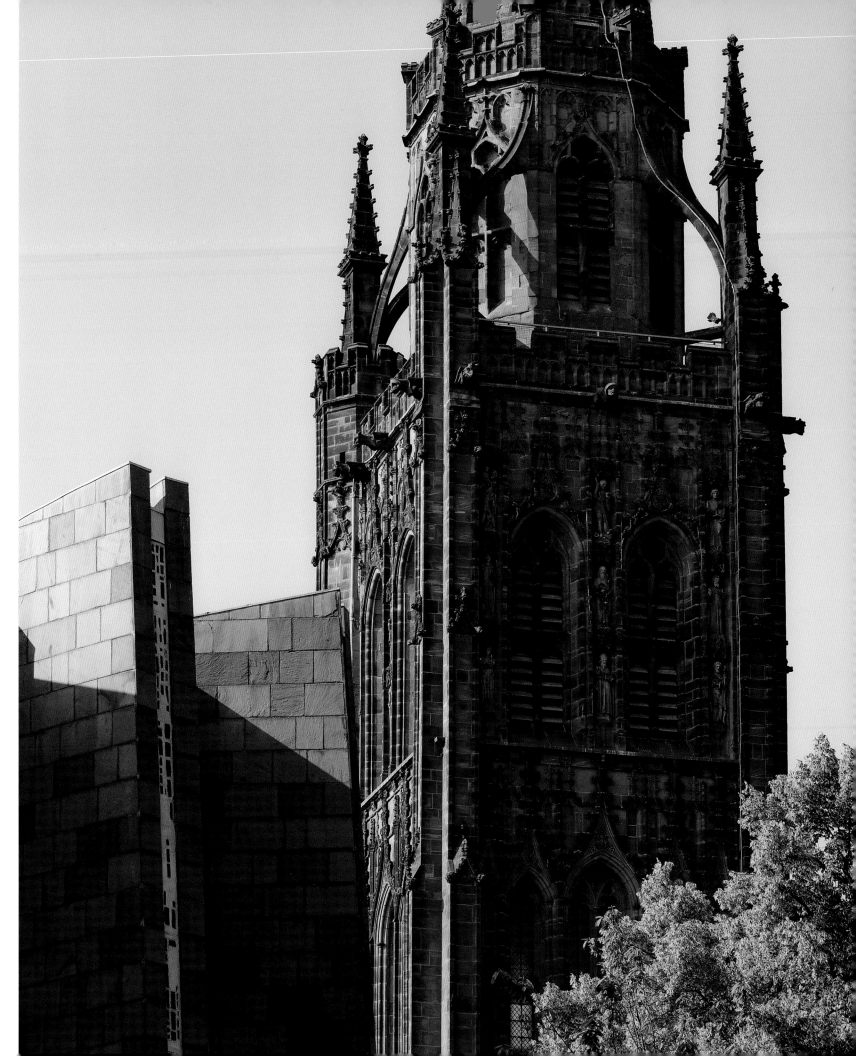

Right
Twentieth-century
sculptures, such
as *Reconciliation* by
Josefina de Vasconcellos
(bottom), imbue both
the ruins and the
mid-twentieth-century
post-war cathedral with
a sense of humanity.
The most moving is
perhaps Jacob Epstein's
magnificent floating
bronze of the Archangel
Michael subduing the
devil (top), a symbol
of reconciliation and
triumph out of disaster.

Far right
The modern cathedral
glimpsed through the
soaring windows of
the old chancel.

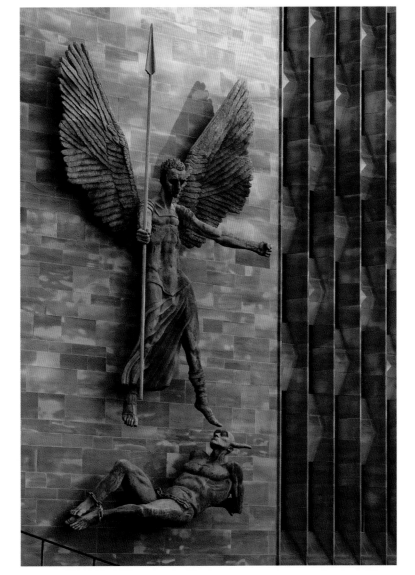

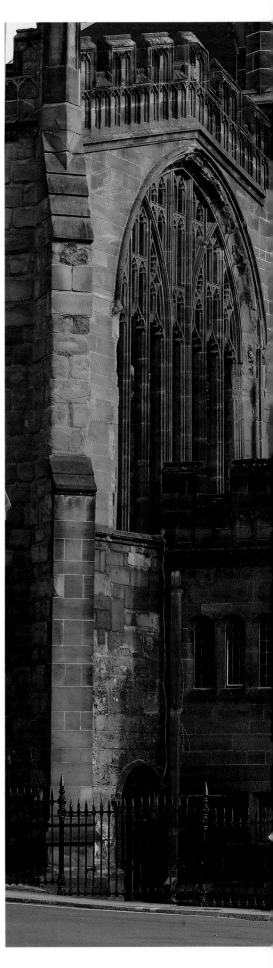

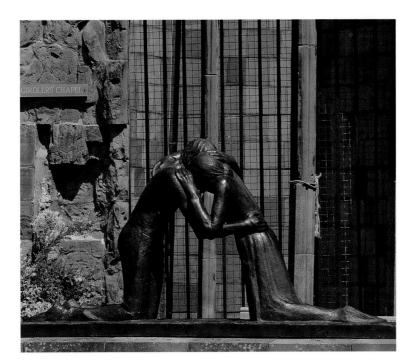

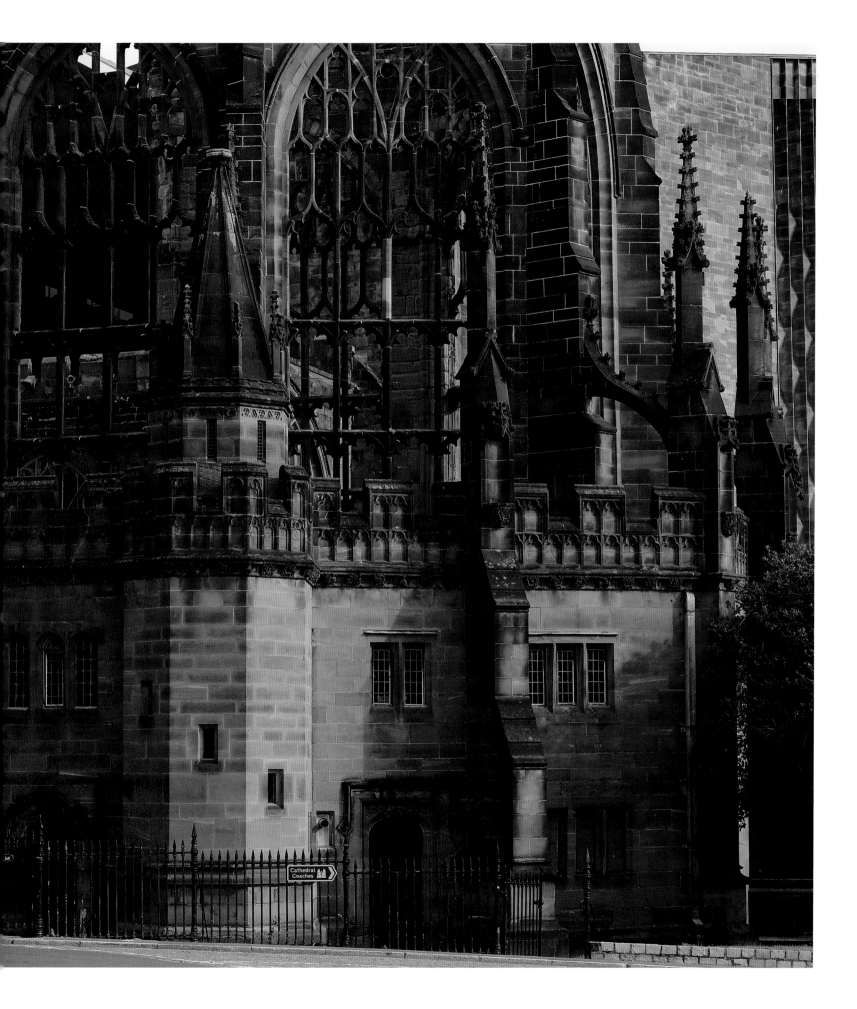

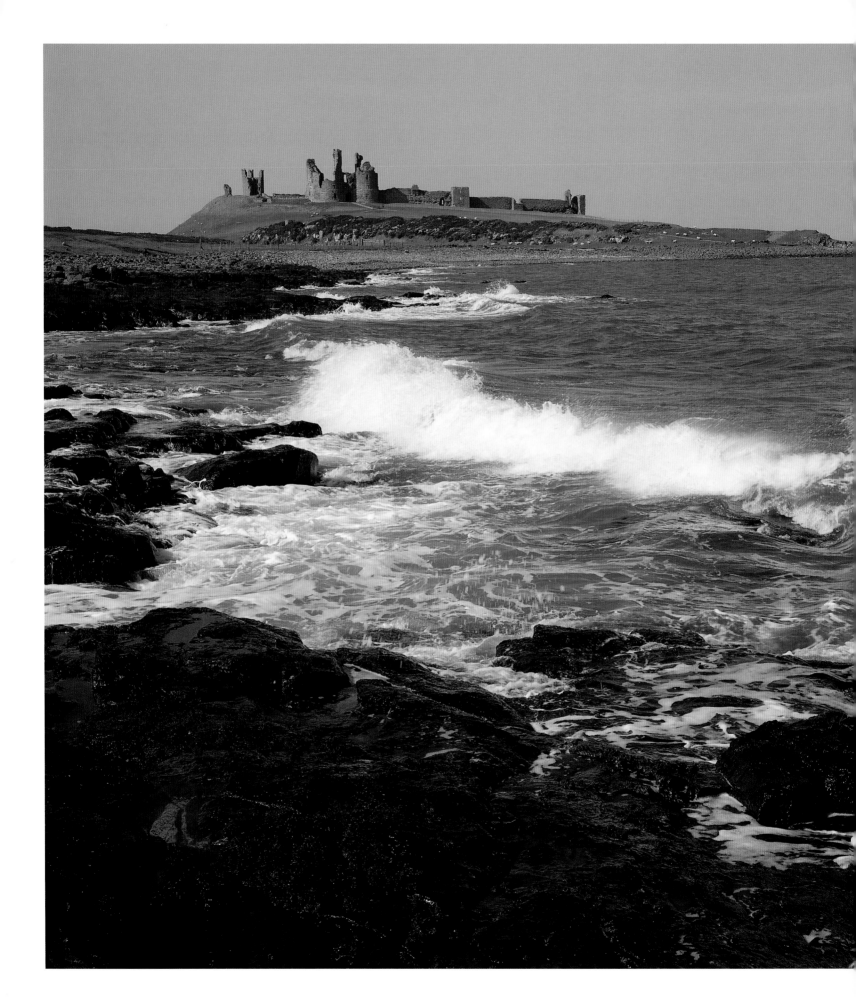

CASTLES AND FORTS

When the word 'ruin' is used in conversation, many people will automatically conjure up an image of a ruined castle. Indeed, there are few English towns that do not have their own ruined castle, from Berwick-upon-Tweed to Guildford, and from Corfe Castle to Rochester. Quite often, these castles are strangely stranded within the centre of the town's historic quarter, and are usually fairly battered, looking like an abstract version of the thing they once were. However, they previously dominated the towns in which they stand, and provided both protection and authority.

In feudal England the castle offered a key element of security and command, a central point in the very structure of society. The Normans' motte and bailey castle (literally, mound and banked enclosure) was a significant tool in their conquest of the Anglo-Saxon people. The architecture of the castle, usually built or rebuilt in stone, remained practical, dramatic and defiant. One of the finest surviving examples of a Norman castle structure is the White Tower, the central keep in the Tower of London complex.

From the twelfth century, the fortification of a castle was bound up with a formal licence to crenellate being issued by the monarch. Castles were built with towers and central gatehouses, which played an important role in their solidity and outline. By the late fourteenth century, castle architecture was discernibly being inspired as much by chivalric traditions as by the need to provide a fortified dwelling for a landowner.

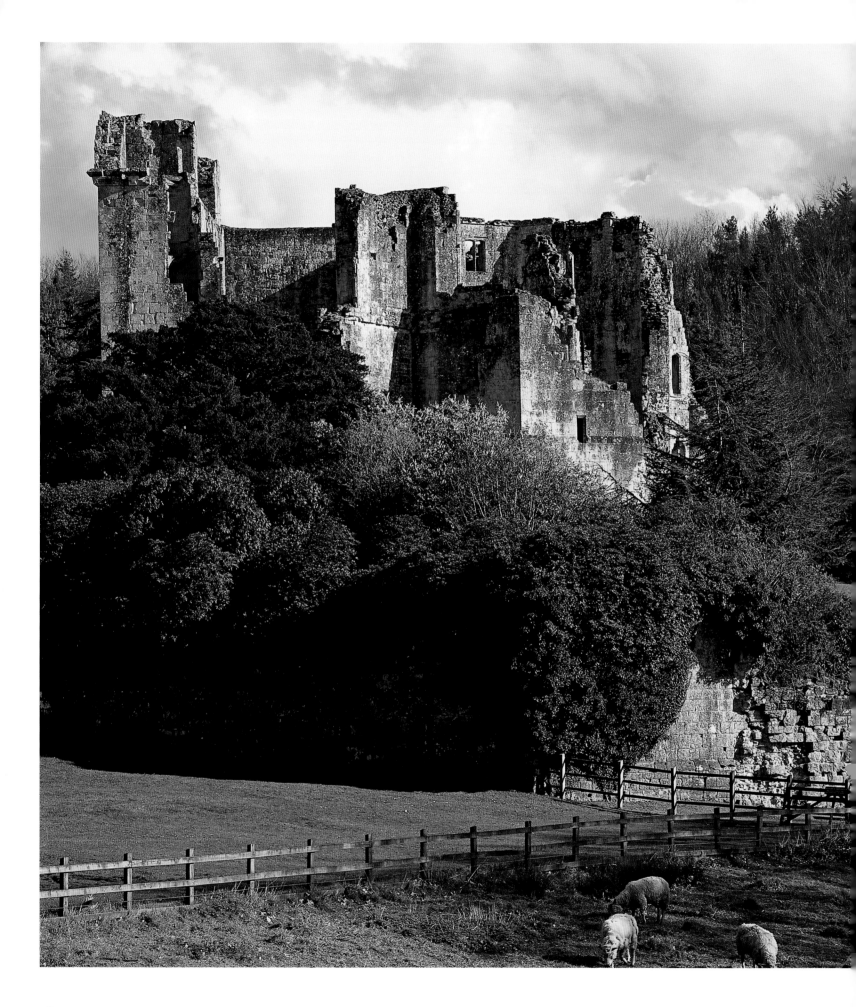

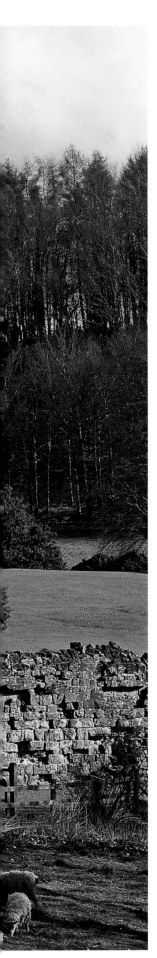

Pages 56–57
All around the coast of England there are ruins of castles that have played their role in defending the borders of our part-island nation. Dunstanburgh Castle in Northumberland lies close to the border with Scotland.

Left
Ruins of earlier castles sometimes became features of the landscaped parks of the eighteenth century, as in the case of Old Wardour Castle in Wiltshire.

By the sixteenth century, the shape, outline and martial quality of the traditional castle had morphed into the somewhat distinct forms of the specialist military fort on the one hand, and the stately residence of an aristocrat on the other. The specialist forts at Camber, Walmer and Deal, built to defend the Channel coast, were designed to withstand cannon fire, rather than to be the grand residences and centres of government administration represented by the great medieval castles. Henry VIII poured the stolen revenue of the church into his fortifications.

Many of the castles of England saw their last (and frequently only) action during the Civil War, but strategically they were often no more significant than major houses. Basing Castle in Hampshire, largely rebuilt in the 1530s, was subjected to a major siege in 1645, when its walls were surrounded by 800 Roundheads. Other battles were fought in front of older castles, many of which were actually little more than garrison buildings. Nonetheless, after the end of hostilities, Parliament under Cromwell ordered the 'sleighting' of many of the country's castles, the breaking of the walls to prevent the castle's military use against the state.

Some older castles remain as residences. Others have been continuously occupied by the military as formal garrison buildings, or pressed into service as courthouses and prisons. Hundreds more were de-roofed and de-gated, their stone carried away for use elsewhere. Military buildings continued to be built, however, increasingly on the coast: in the early nineteenth century, the threat posed by Napoleon Bonaparte prompted the construction of the Martello towers, the small, round, garrisoned coastal forts inspired by the Genoese tower on Mortella Point in Corsica. In the Second World War, the same fear of invasion saw the large-scale erection of pillboxes, or concrete machine-gun posts, at a variety of strategic locations, especially in coastal areas.

The English military building of every period – whether castle, fort or other – represents a defining theme in English, and British, history: defence against invader or enemy, real or imagined (indeed, from the sixteenth century more money was spent on military fortifications than on any other architectural endeavour). The ruined medieval castle stands for an earlier era of threats from both home and abroad, while the castles deliberately ruined after the end of the Civil War represent a period of conflict within a nation divided. The latter are also perhaps symbolic of the social breakdown that led eventually to England's early development of the constitutional monarchy, the powers of which are regulated by an elected House of Commons. This pattern of balance between state and people remains in place today.

Surprisingly emotive, too, are the tended or untended survivors of the Second World War defences against invasion, which litter the south coast in particular. In most cases these ruins are neither listed nor subject to any process of protection. More than anything, however, they symbolize the real threat of invasion and possible loss of national power to a foreign state that occurred within living memory throughout most of Europe.

PORTCHESTER CASTLE
Hampshire

England is a land of surprising contrasts. There are parts of old England that lie just a stone's throw from the world of motorways and office blocks. One such is the village of Portchester, 10 kilometres (6 miles) north-west of Portsmouth in Hampshire. The main street, which is lined with handsome Georgian houses, forks at an oak tree growing on a patch of green. Take the left-hand fork and you come to Portchester Castle.

Despite the dramatic presence of the Norman keep in one corner of the site, what excites real wonder and awe is the realization that the thick, battlemented grey walls are largely of Roman construction. This is in fact the most extensive surviving Roman fortification north of the Alps. The whole complex presents an extraordinary slice of the history of England.

The Roman fort was first called Portus Adurni, and was built mostly in the third century – probably between 285 and 290, during the reign of the emperor Diocletian – by Marcus Aurelius Carausius as part of the protection of the coast against Saxon invasion. Carausius successfully cleared the seas of pirates, and, on hearing of a plot to have him executed, declared himself emperor; for a while, he controlled Britain and parts of Gaul, but lost the latter in 293. He was killed in the same year, and was succeeded by Allectus, who proclaimed himself ruler of Britain alone (our first national monarch?). In 296 a full-scale invasion brought Britain back under Rome's military control.

Portchester Castle may well have been a military site before that time, a defence of the natural harbour below, and it certainly remained an active and significant part of the defence of the south coast until the sixteenth century. Inevitably, the castle was added to over the centuries. In its final built form – the remains of which we see today – it consisted of an outer bailey with gates and bastions, an inner bailey moated with a gatehouse, a royal palace, and the great keep (the only building still roofed); these buildings are mostly grouped in the northern corner of the fort site.

Only the outer walls and watergate are Roman; the church, landgate and keep are from the 1130s. The church is part of an Augustinian priory founded

before 1128, while the royal palace was built for Richard II in the late fourteenth century. During the Anglo-Saxon period, a village had grown up inside the walls, and the castle was one of the strongholds used to defend the Kingdom of Wessex from Viking attacks. It seems very likely that the Roman fort was, in fact, never entirely abandoned after the collapse of the Roman Empire.

The perennial conflicts with France that define the succeeding centuries of English history are reflected in the changing use and status of Portchester Castle. After the Norman Conquest, William I granted Portchester to William Mauduit, who then began work on the castle (a 'halla', or hall, is mentioned in the Domesday Book of 1086). In 1216 the castle fell to Prince Louis, son of Philip Augustus, King of France, during a French invasion prompted by the First Barons' War (1215–17) against King John (who had used the castle as a base for hunting). It was retaken in 1217 by Henry III, who made it a stronghold. In 1346 the army of Edward III assembled here before embarking for France and the famous Battle of Crécy, while the fine palace built for Richard II extended the accommodation and served as the venue for the celebration of his marriage to Isabella of Valois. Henry V stayed here en route to Agincourt in 1415.

The castle clearly declined in importance after the founding of the Royal Dockyards in Portsmouth in

1495, although Parliamentarian troops were garrisoned here in 1644 during the Civil War. From 1665 it was used to house 500 prisoners captured in the Second Anglo-Dutch War (1665–67), and was pressed into similarly grim service during all the wars of the eighteenth century. In 1760 Edward Gibbon, later famous as the author of *The History of the Decline and Fall of the Roman Empire*, was briefly the governor here, and wrote that the conditions for the 3200 prisoners were 'very loathsome and the men's barracks not much better'.

After serving as a prison, the castle was returned to the ownership of the Thistlethwaite family, of the neighbouring Southwick estate, from whom it had been seized. In 1984 it passed into the care of English Heritage, although the church remains a working parish church; teas can be bought in the adjoining church hall. The castle grounds are open to everyone. The buildings and walls are worn, with roofs open to the sky, and valerian grows in the brickwork.

The main complex of buildings is entered by ticket. This includes the still-roofed Norman keep, the rooms of which are cool and quiet, although the adjoining ruins often ring with the laughter of children in period costume. In the museum, an explanation of the history of the castle ends on a generous note: 'We can never know everything.' The wider enclosure formed by the outer walls cuts out the writhing modernity of the nearby roadways and dockyards.

The surviving Norman keep was built in the north-west corner of the Roman fort.

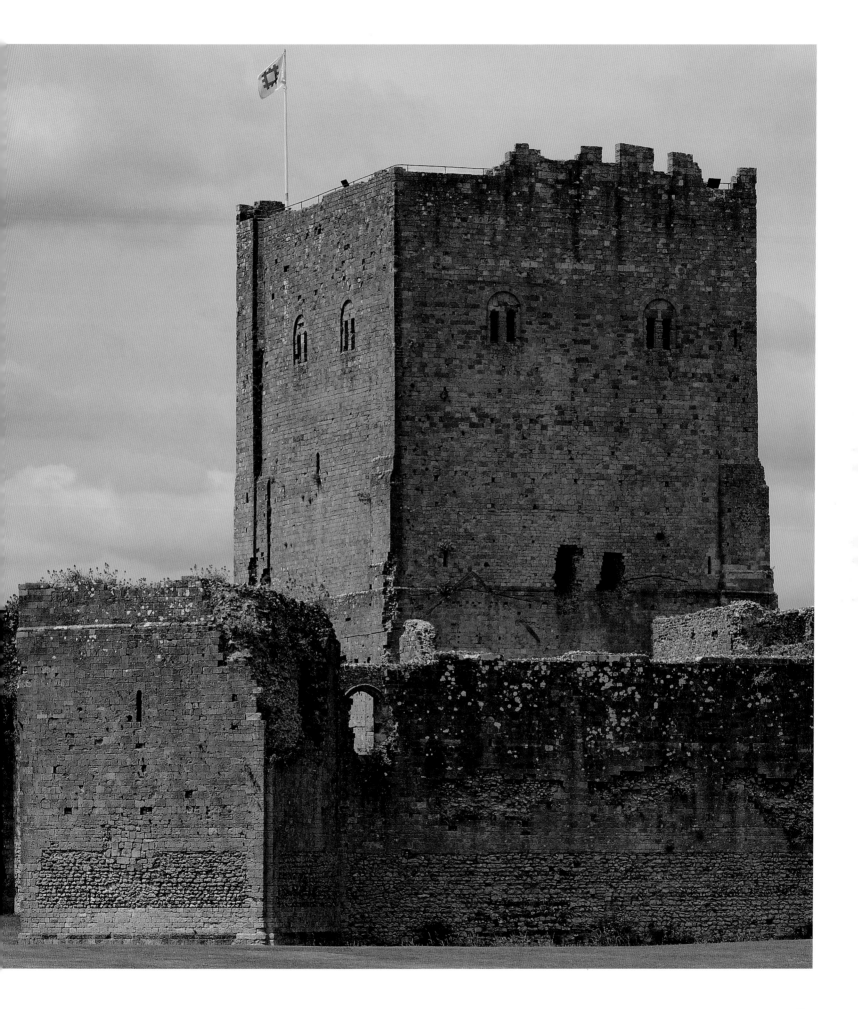

Opposite
The dramatic solidity
of one of the walls
of the Norman keep,
built in the 1130s.
The keep was raised
in height twenty
years later, and again
in the fourteenth
century.

Right
Shaped by history:
a fragment of the
Roman fort reworked
as part of the
Norman castle.

Right, bottom
A view towards
the landgate to
Portchester Castle,
a medieval reworking
of the Roman
entrance.

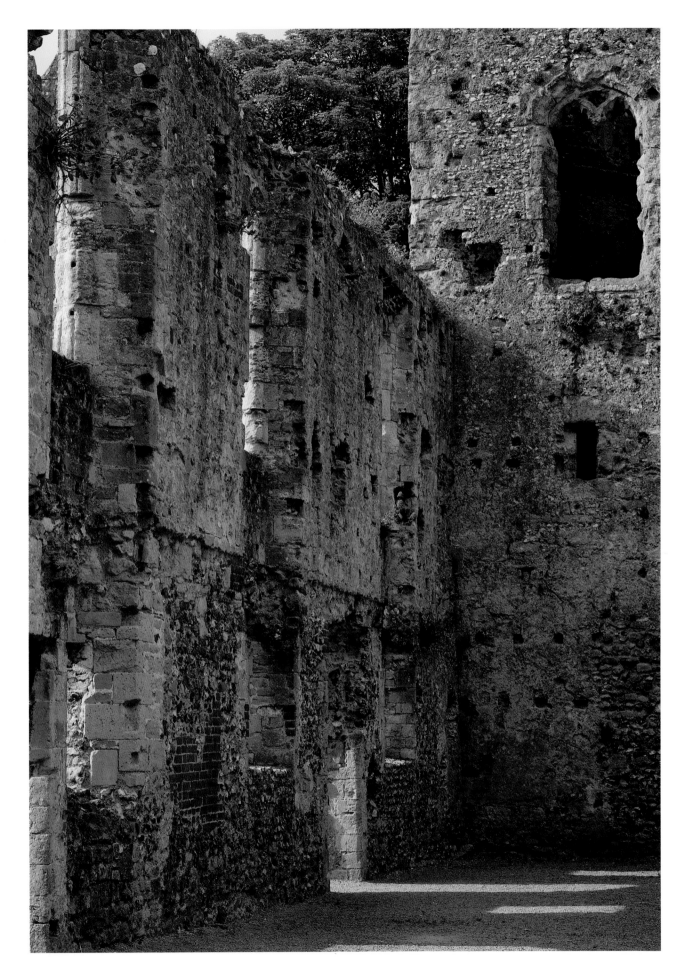

Left
The east range of
the castle, looking
towards Ashton's
Tower. Completed
in 1385, the tower
is named after
Sir Robert of Ashton,
constable of the castle
from 1376 to 1381.

Opposite
The view from the
Norman keep down
into the inner bailey.
The great hall built
as part of Richard II's
palace of the 1390s
stands in shadow
in the bottom right-
hand corner of the
photograph.

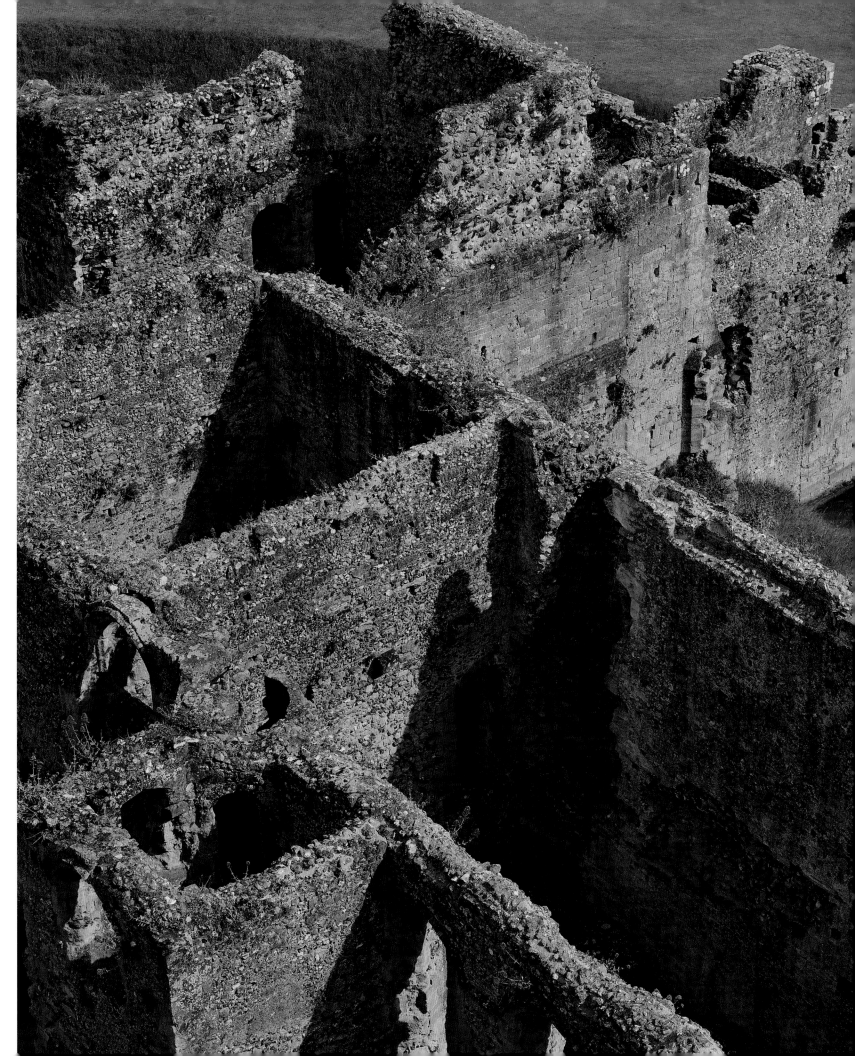

DUNSTANBURGH CASTLE
Northumberland

Huge, uncompromising and set on a dramatic coastal promontory, Dunstanburgh Castle seems at first sight more like the walls of an ancient city than an abandoned castle. Originally enclosing some 4.5 hectares (11 acres), the castle lies between the coastal villages of Craster and Embleton, and was begun in 1313 for Thomas, Earl of Lancaster, a cousin to Edward II. In that year an order was issued to Master Elias, the master mason, to build 'a gatehouse 80 feet high with a tower on either side of the gate'; this can still be seen today.

Thomas was a figure of ability and ambition. He had been one of the three earls who had ordered the execution of the royal favourite, Piers Gaveston, in 1312, and was a major landowner in the Scottish border region. It is not surprising that he should have built a significant new castle here, given the long tradition of invasion by the Scots. However, scholars now argue that Thomas's castle was equally intended to suggest a quasi-royal status, perhaps deliberately evoking the famous palaces of Arthurian legend (such as Arthur's own Camelot and Joyous Garde, the castle of Sir Lancelot).

The gatehouse that rises so dramatically on the approach would originally have been further glamorized by its mirrored reflection in the complex of meres that gave additional defence. The gatehouse's similarity to the design of the Welsh castles of Edward I is seen by some historians as evidence of Thomas's overt challenge to Edward II, whose local stronghold was at Bamburgh, only a short distance to the north.

The theatrical impact of the castle was thus inspired as much by brilliant fantasy as by bitter necessity. Thomas's joy in his new castle was short-lived, however. In 1321 he led a revolt against Edward II, and was captured and taken prisoner. Convicted of treason, he was executed in Pontefract the following year. The castle was maintained as part of the defences against the Scottish.

In 1362 the castle came into the hands of John of Gaunt, Duke of Lancaster (third son of Edward III). After becoming a lieutenant in the Scottish Marches,

John extended the castle's fortifications considerably, adding a new entrance in the process; the original gatehouse became known as the donjon, or lord's tower. At his death, the castle passed to his son, who claimed the throne in 1399 as Henry IV.

In 1461 the Yorkist Edward IV tried to wrest the castles of the east coast from the hands of the Lancastrians. Dunstanburgh's constable, Sir Ralph Percy, held it for the Lancastrians, but eventually submitted to the Yorkists. In 1462 the castle was besieged again, this time after the arrival of Margaret of Anjou, wife of the deposed Henry VI, and a small French army caused Percy to declare for the Lancastrians. A Yorkist force, led by Sir Ralph Grey and the earls of Warwick and Worcester, eventually forced a surrender. Following a brief period of further Lancastrian occupation, the castle fell to the Yorkists for a third time in 1464.

By the mid-sixteenth century the castle had fallen into disrepair; a report describes it as a 'very reuynus howsse'. However, its potential usefulness was still being discussed in a document of 1550: 'surely it would be a great refuge to the inhabitants of those parts, if enemies came to annoy them, either arriving by sea or coming by land out of Scotland'. The donjon was used as a dower house for the Craster family at the end of the century. The castle as a whole became an admired landmark, a reminder of another time. From the late eighteenth century it was also a much-admired subject for painters, including J.M.W. Turner.

In 1929 the castle was given to the Ministry of Works. Despite a minor resurgence in defensive use during the Second World War – a series of pillboxes and minefields was created along the nearby beach in case of invasion – the castle saw no further action; the only recorded explosion here was a mine detonated by an unfortunate fox. Now owned by the National Trust and managed by English Heritage, the castle shares one of the finest stretches of coast with several notable castles and abbeys, both ruined and restored, such as the monastery on Holy Island. For sheer drama, however, Dunstanburgh ranks as one of the most memorable ruins in northern England.

Opposite
The dramatic fourteenth-century gatehouse of Dunstanburgh Castle was adapted as a residence and later abandoned altogether.

Pages 70–71
Dunstanburgh's dramatic position on the Northumberland coast was enhanced by the addition of a series of defensive meres, creating the illusion of a castle on an island.

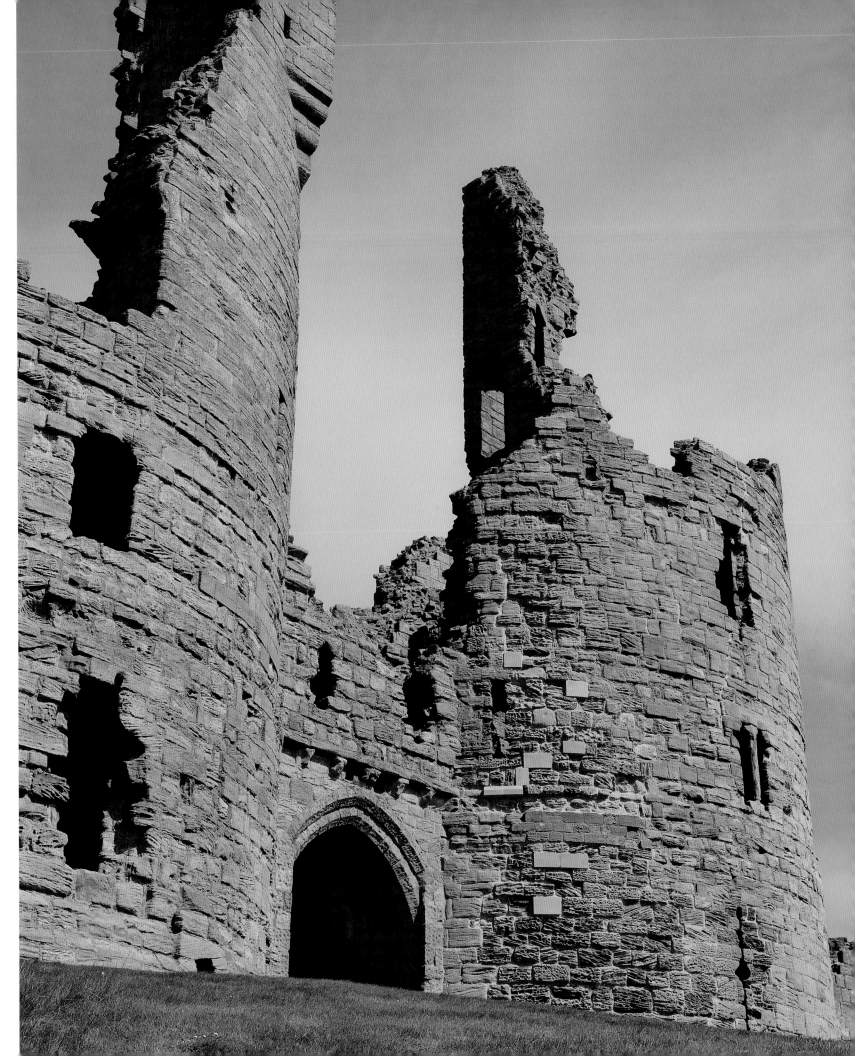

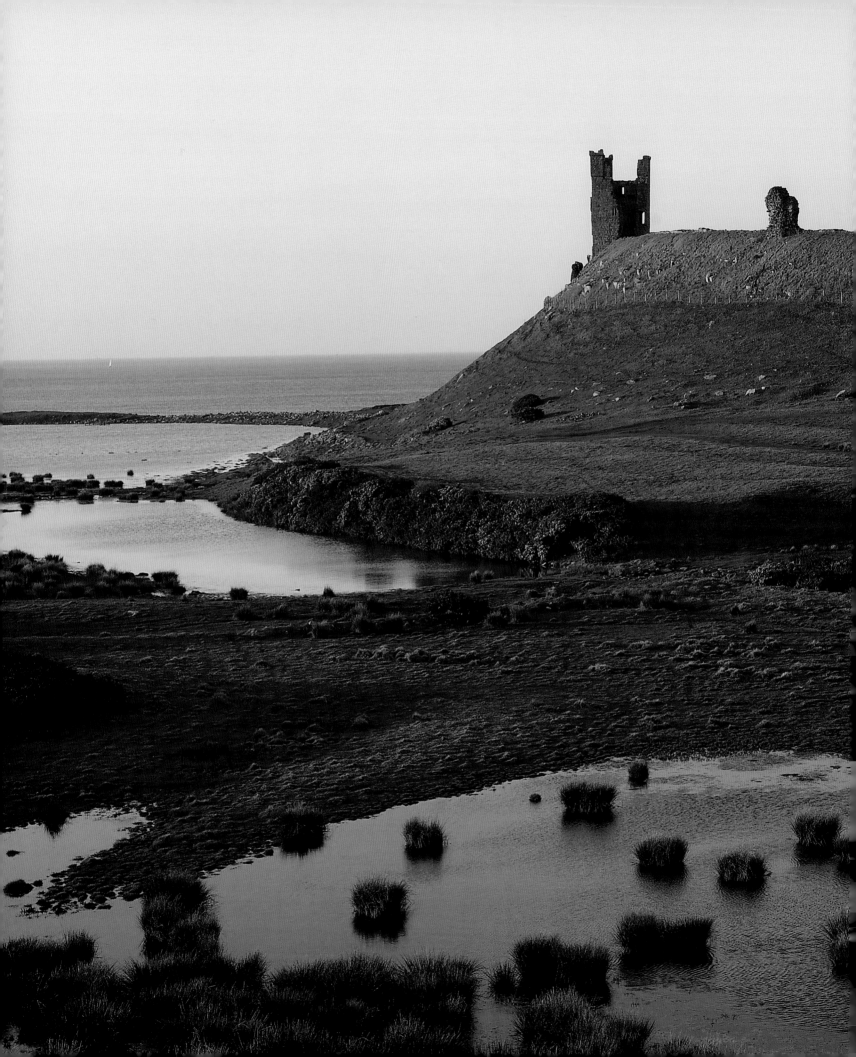

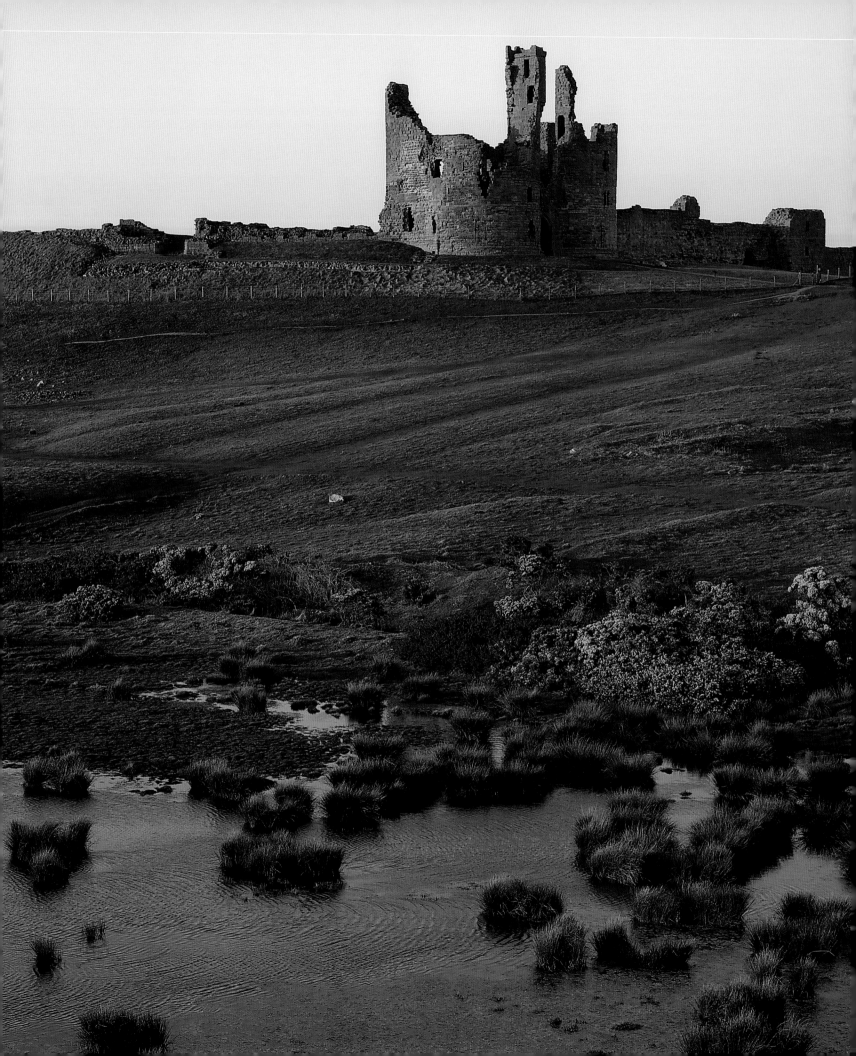

Below
The gatehouse built in 1313, for Thomas, Earl of Lancaster, seen from within the castle itself.

Below, right
A staircase on the corner of the gatehouse. Now exposed, it once led to the roof.

Bottom
The Lilburn Tower seen from the south-east. The tower is named after John de Lilburn, who became constable of the castle in 1322.

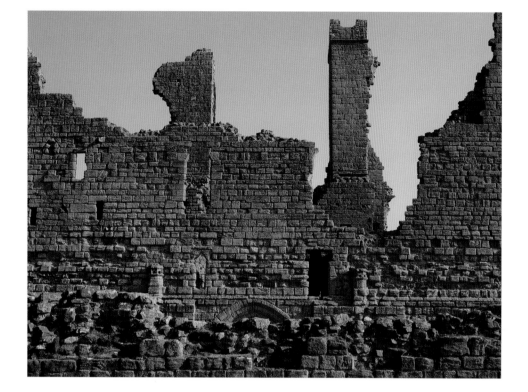

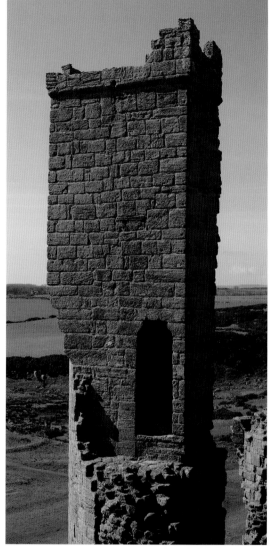

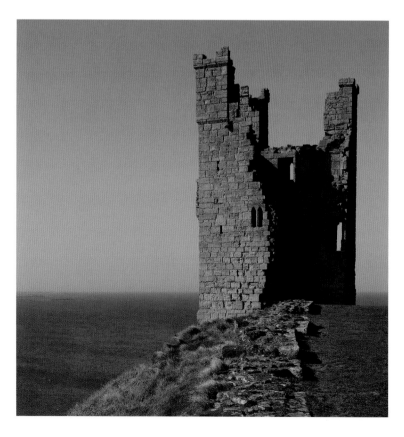

Opposite
These remains are believed to be those of the constable's hall and chamber, mentioned in an account of 1351.

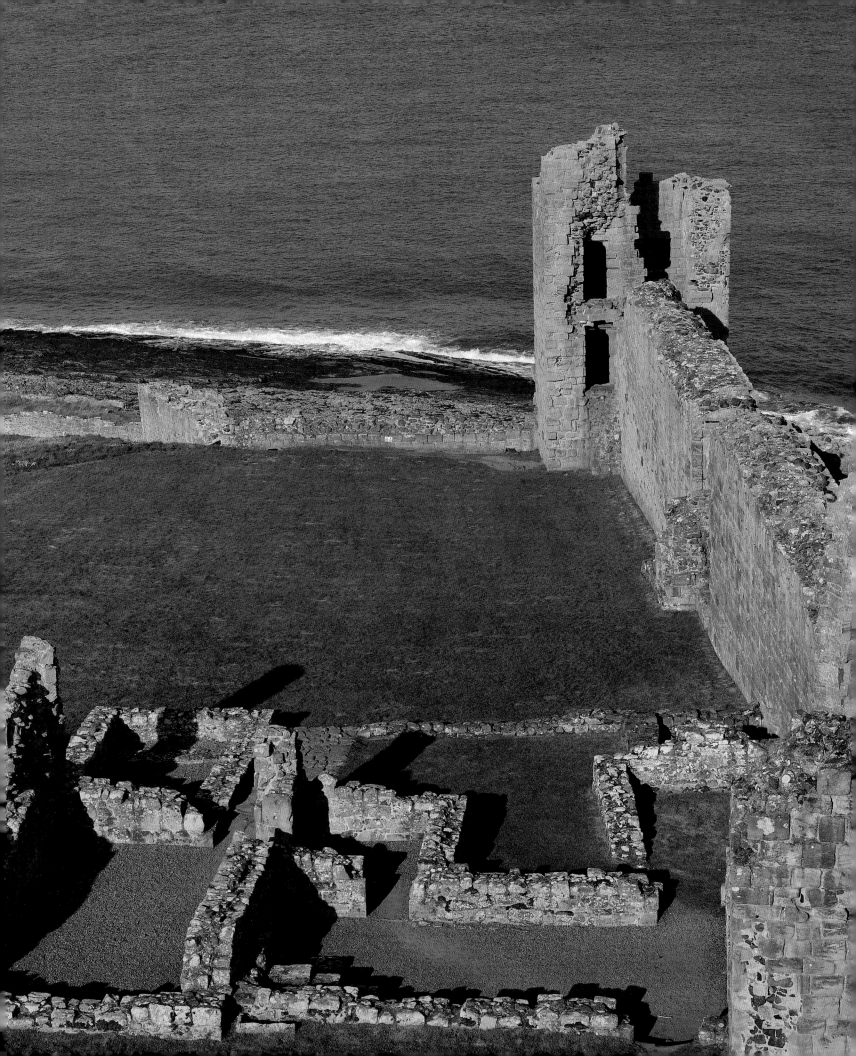

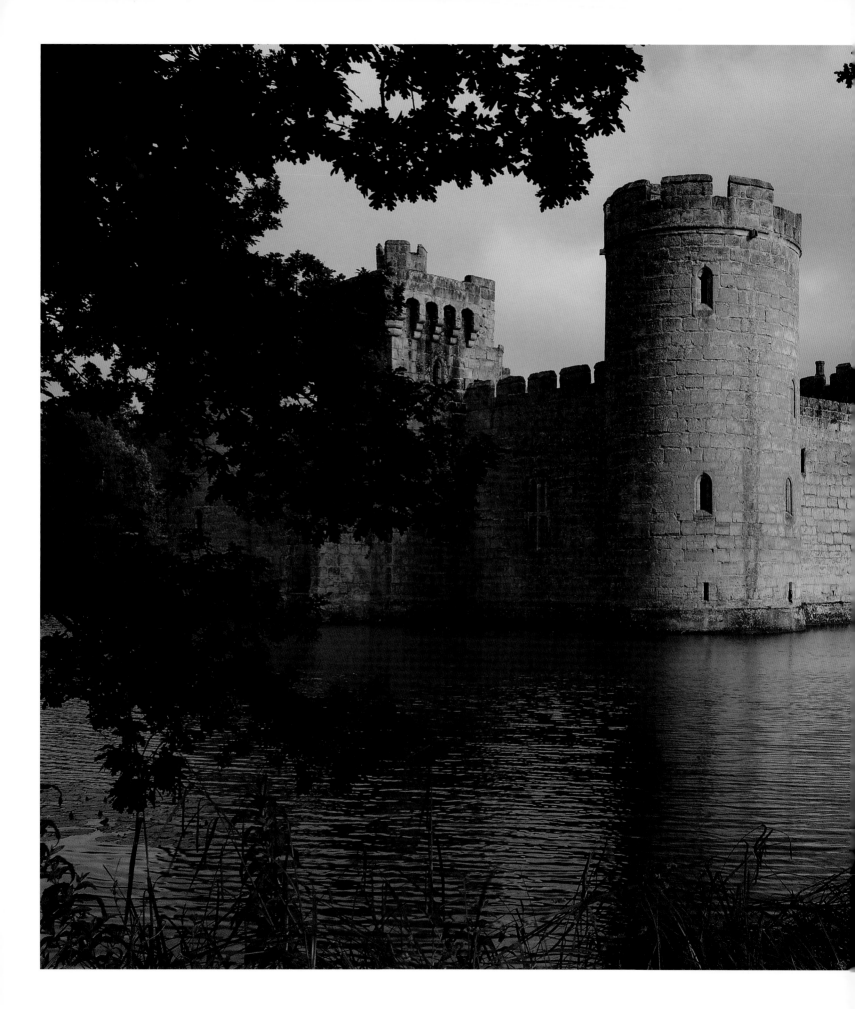

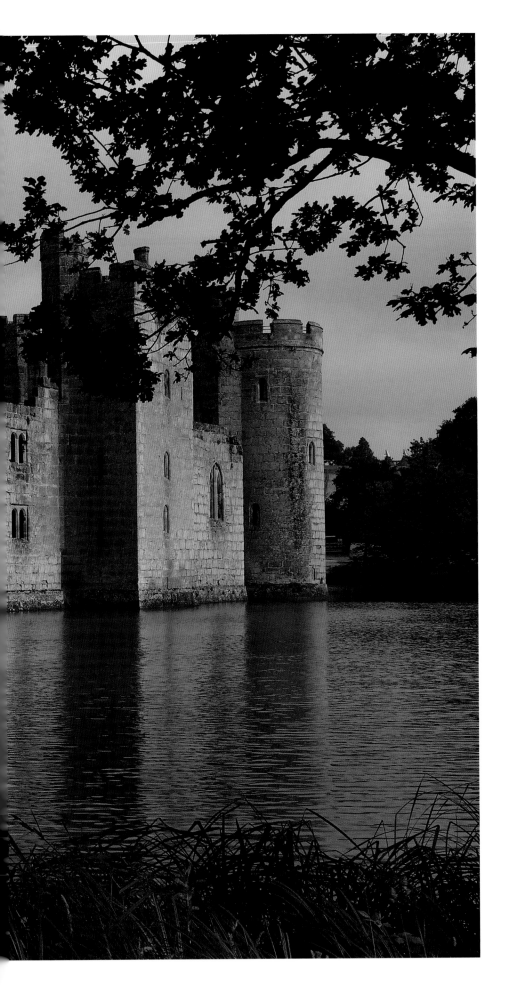

BODIAM CASTLE
East Sussex

In contrast to Dunstanburgh (page 68), the castle
at Bodiam is the dream castle of the English south,
built with huge rounded towers and high walls, and
protected and framed by a wide, dramatic moat. It
was constructed between 1385 and 1388 by Sir Edward
Dalyngrigge, and appears to have been regarded as
part of the defence of the southern coast against the
French during the Hundred Years War (1337–1453).
The licence to crenellate was issued 'to our beloved
and faithful subject Edward Dalyngrigge Knight, that
he may strengthen with a wall of stone and lime, and
crenellate and may construct and make into a Castle
his manor house of Bodhyam, near the sea, in the
county of Sussex, for the defence of the adjacent
country, and resistance to our enemies'.

Given its sheer presence, deliberately chivalric
outline and dramatic setting, Bodiam has come to be
seen as an effort at display rather than defence alone.
A castle was the most significant sign of rank, and the
royal mason, Henry Yevele, may have been involved in
Bodiam's construction. The current moat is apparently
only a part of the original elaborate waterworks
designed to stress the status and glamour of the castle.

Bodiam passed from the Dalyngrigge to the
Lewknor family in 1470, and in 1483, during the Wars of
the Roses, it was surrendered to the army of Richard III;
it was later returned to the Lewknor family under
Henry VII, and remained with them until 1588. In the
early seventeenth century it was acquired by the Tufton
family, the earls of Thanet. The 2nd earl sold the castle
to Nathaniel Powell in 1644, and it was possibly after
this that some of the castle was dismantled.

By the mid-eighteenth century the castle was
very much the overgrown, Romantic tourist attraction,
and the subject of countless paintings and visits by
well-heeled sketching parties. Nonetheless, in 1829 the
castle was acquired by a local landowner, John 'Mad
Jack' Fuller, who intended to protect it from
demolition and undertook certain repairs.

In 1916 Lord Curzon, former Viceroy of India,
drove his prospective bride, Grace Duggan, down to
Sussex, told the chauffeur to stop at Bodiam, and
made her shut her eyes until he told her to look. Later

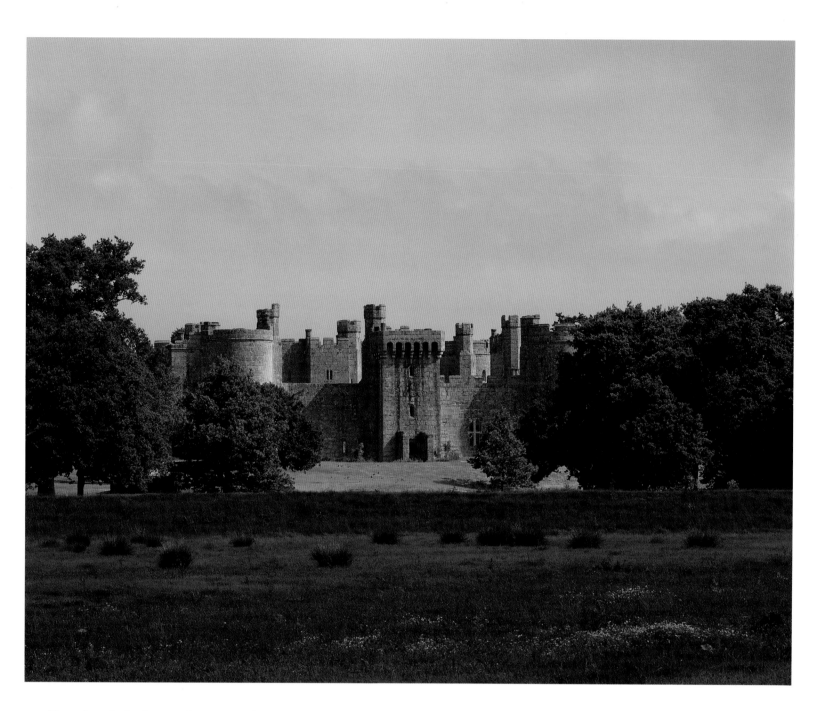

recalling what she had seen, she wrote in her diary:
'I have that picture in my heart for all time ... I dared
not take my eyes off it, for fear that when I looked
again it would have disappeared in a mist or cloud –
it could only be a fairy castle.' Duggan accepted Lord
Curzon's offer of marriage, and her husband-to-be
bought the castle. After briefly considering Bodiam
as a possible residence, he set about restoring it with
the assistance of his architect, William Weir, repairing
the walls and crenellations with care and sensitivity,
clearing the moat and rebuilding the causeway. On his
death in 1925 Lord Curzon bequeathed the castle to
the National Trust, and here visitors can come to
indulge their happy fantasies about our chivalric past.

Pages 74–75
Fourteenth-century
Bodiam Castle – the
English chivalric
ideal – seen from the
south-east, across its
glorious moat. The
corners are marked
by stout drum towers,
while square towers
and gate towers
divide the flank walls.

Above
Exits and entrances:
the postern gate, or
secondary entrance,
in the south wall of
the castle. From this
perspective, the wide
moat is surprisingly
invisible.

Opposite
The main gatehouse,
consisting of paired
towers punctuated
by machicolations,
openings through
which boiling oil
could be poured.
Some historians now
think that these
openings were just
for show. The central
shield above the door
shows the coat of
arms of the castle's
builder, Sir Edward
Dalyngrigge.

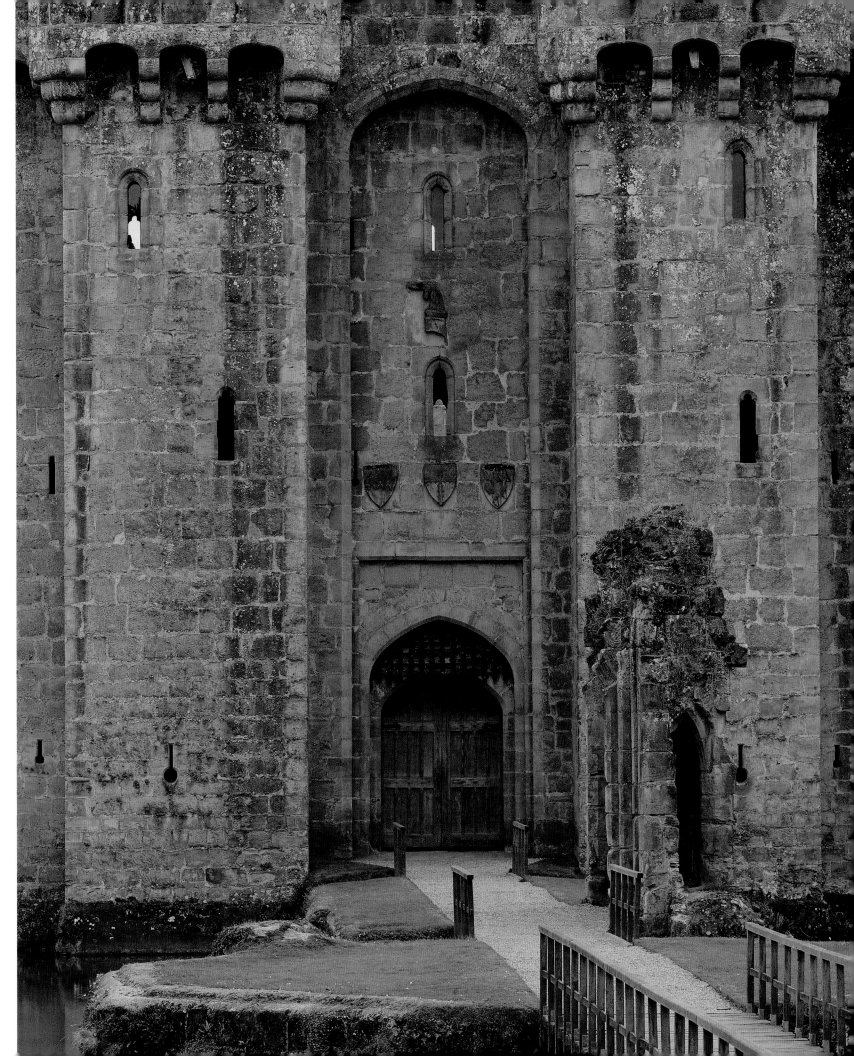

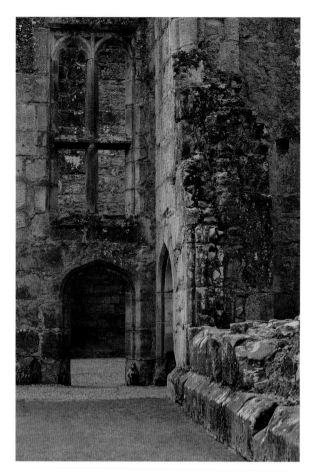

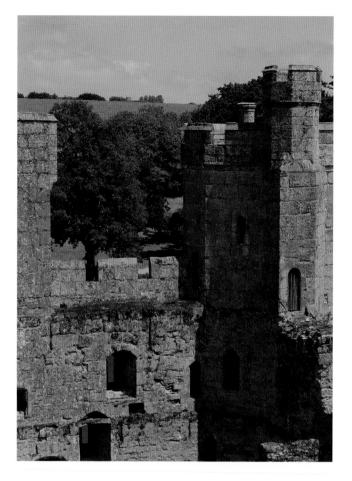

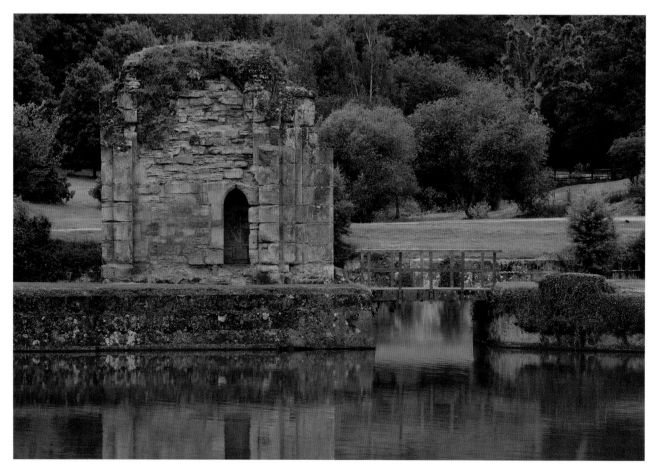

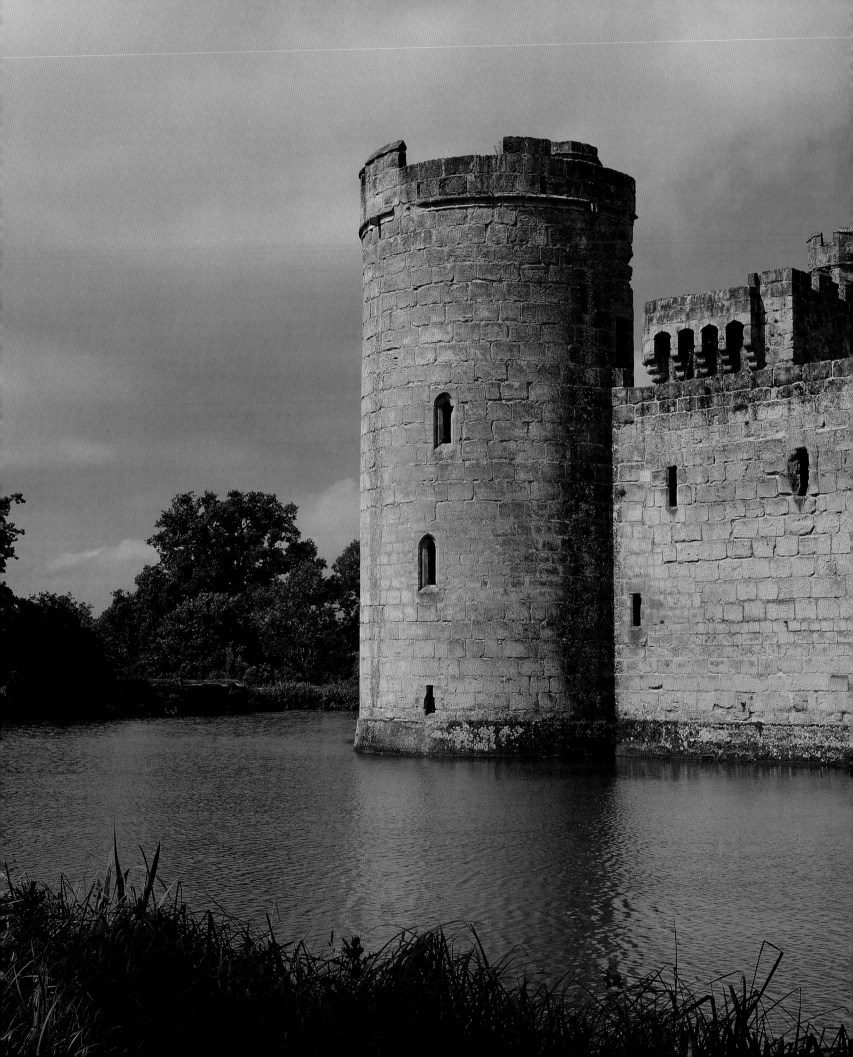

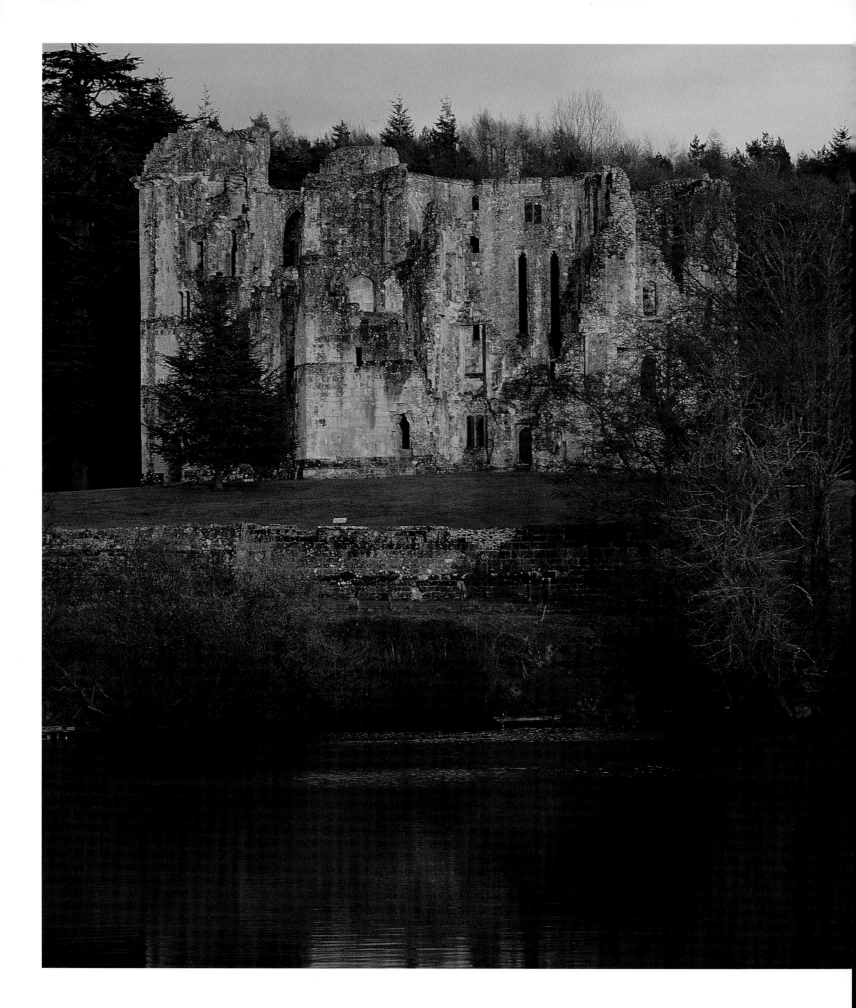

OLD WARDOUR CASTLE
Wiltshire

Some of the most elegant of all English castle ruins are those of Old Wardour Castle in Wiltshire, built towards the end of the fourteenth century by John, 5th Baron Lovel. It could be argued, however, that this is more of a fortified house than a castle proper. Permission to build was given in 1392 by Richard II, and the mason was one William Wynford. The Great Tower at the core of the castle was built on an attractive hexagonal plan, apparently inspired by the Burgundian castles of Jean, duc de Berry, and featured a central great hall on the first floor and symmetrical wings set at angles; there is no evidence of the bailey or gatehouse that would have enclosed the tower. This is a unique example of such a design in England.

The name 'Old Wardour Castle' reflects the fact that the castle passed out of use after the Civil War. The title of 'New Wardour Castle' was bestowed on a large new house built in the eighteenth century to designs by James Paine. At this time the semi-ruinous but still elegant old castle effectively became a feature of the surrounding parkland.

In 1547 the castle was acquired by the Arundell family, and thirty years later Sir Matthew Arundell remodelled the interior as an up-to-date residence, with help from architect Robert Smythson. Rooms were enlarged and windows altered in line with contemporary expectations of comfort and display. Examples of Smythson's work include the Renaissance doorcase to the stairway in the inner court. The windows he added, however, were deliberately archaic in form, to harmonize with the Gothic castle into which they were being introduced. They were also inserted with a regard for symmetry, meaning that a number were false.

Old Wardour Castle, like so many castles in England, saw its only military action during the Civil War. In May 1643 the doughty sixty-one-year-old Lady Blanche Arundell (daughter of the Earl of Worcester) and her household attempted to hold out against a Parliamentarian force of more than 1500 men, led by Sir Edward Hungerford. They succeeded in doing so for five nights. Her husband, Thomas Arundell, 2nd Lord Arundell of Wardour, was in Oxford with the

king at the time, and later died at the Battle of Lansdown. When Lady Blanche surrendered, the castle was placed under the command of Colonel Edmund Ludlow.

Lady Blanche's son returned to Wardour to lay siege to his family's castle, seriously damaging it with mines in the process; Ludlow surrendered after three months, in March 1644. It is recorded that, as a Royalist musketeer by the name of Hilsdean lay dying during this conflict, he realized that he had been shot by his own brother, a member of the Parliamentarian garrison. The Arundell family did not return to live in the castle after the Civil War, but occupied another property nearby.

In 1769 the 8th Lord Arundell began work on the great Palladian country house known as New Wardour Castle. Together with a lake, a grotto and a banqueting house, the old castle became an ornament in the landscaped park of the new mansion. It was, however, an ornament that genuinely celebrated the family's attachment to the land, their courage and their long association with the Roman Catholic faith (reflected in the new building by an elegant chapel, still in use today). The old castle is now in the care of English Heritage, while the house, for many years a girls' boarding school, has been converted into a number of private residences.

Right, top and bottom
The east front has a recessed entrance between two towers and the high windows of the great hall on the first floor. The notable symmetry of the window openings is the result of sixteenth-century alterations.

Pages 80–81
Old Wardour Castle, built in the late fourteenth century and partly destroyed during the Civil War, seen across the lake created in the eighteenth century. The remains of the castle are formed from the hexagonal Great Tower; there is no trace of the original outer bailey or gatehouse.

Opposite
The south side of the Great Tower, brought down in the Civil War by the explosion of a mine during a siege in 1644. The castle was being held for Parliament by Colonel Edmund Ludlow, having been captured from Lady Blanche Arundell.

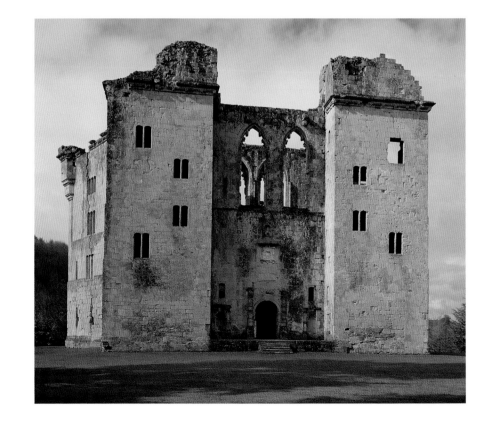

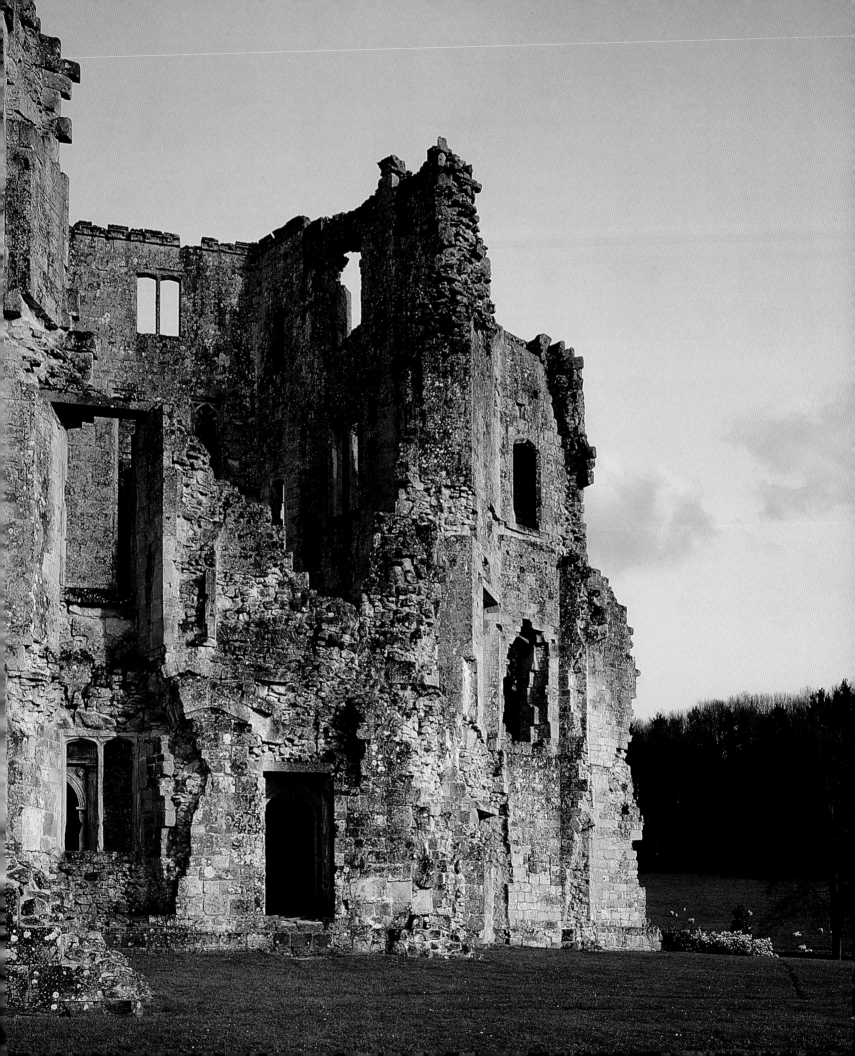

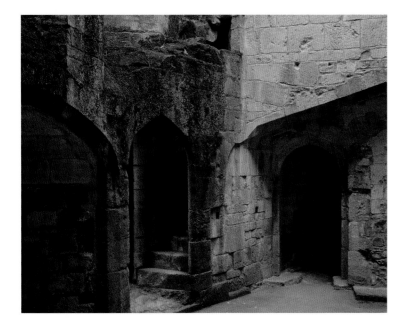

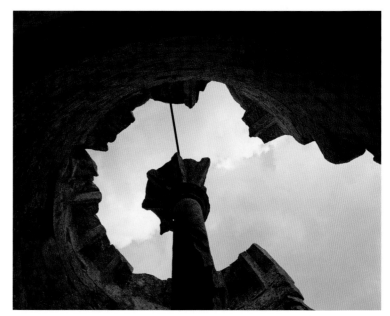

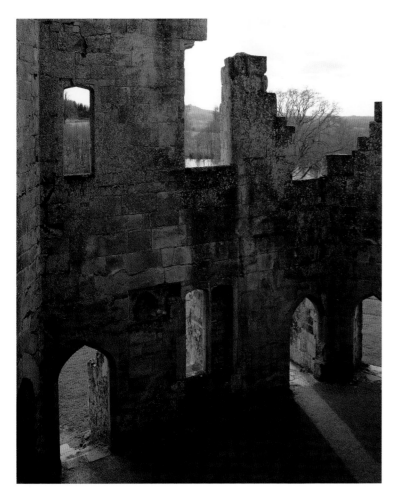

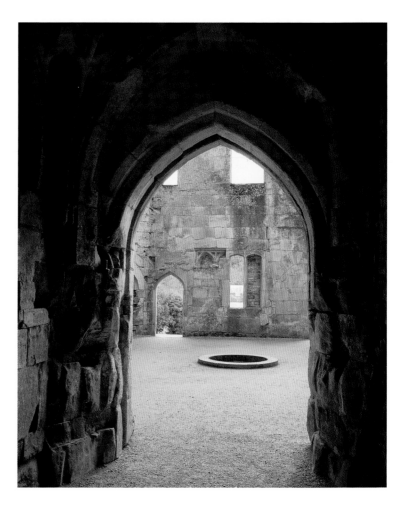

Above
The dark shell of a once-glorious interior, including an entrance to a spiral staircase (top left), a surviving pillar from another spiral staircase (top right) and an archway leading to the courtyard that lay at the centre of the Great Tower (bottom right).

Opposite
The Doric portal for the staircase that climbs to the great hall. Such Classical detailing was added in the 1570s by Sir Matthew Arundell.

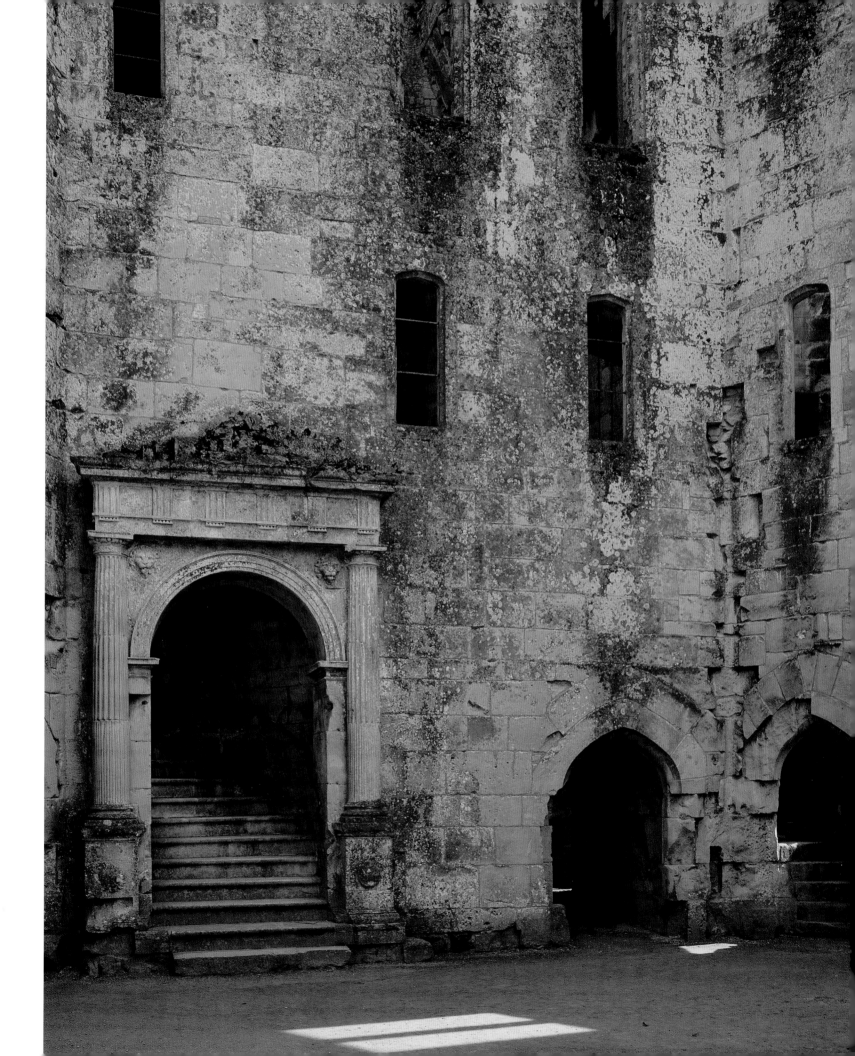

DROP REDOUBT FORT
Kent

There can be few places that illustrate the long and complex tradition of defending and defining the English shore as clearly as Dover. Some two thousand years of history are concentrated into the environs of this town. To the east is the well-preserved glory of Dover Castle, with its Roman lighthouse, Anglo-Saxon church, Norman castle, various barracks and quarters, and the wartime tunnels that provided a base for the military during the Second World War.

To the west, meanwhile – unheralded by signposts, and little supported by the usual paraphernalia of interpretation and consumer-tourism – lie the Western Heights, an extraordinary collection of military ruins. At the heart of this vast complex stands the Drop Redoubt Fort, a brooding but little-known brick fort built in the early 1800s as part of the defences against a feared Napoleonic invasion. In fact, the building was barely finished before the war with France was over.

The construction of the complex was actually begun as part of the re-fortification of Dover during the American War of Independence (1775–83). New buildings were added over the course of the nineteenth century, and the west of Dover, just under the Western Heights, was covered with barrack buildings used up until the Second World War.

Arrival at the site is a low-key affair; at the time of my visit, a few people were sitting in their cars, eating their lunch and looking out to sea. Nearby is a decayed nineteenth-century armoury store, on to which was added a series of Second World War gun mounts, in brick and concrete, unrepaired but safe, and labelled for the interested passer-by. Follow the footpath down to the east and some boards indicate the former location of a series of huge barrack buildings, now entirely lost and replaced by scrubland. Climbing up again, you find the Drop Redoubt Fort itself, built using a controversial quantity of bricks: the political reformer William Cobbett calculated that the same number of bricks could have been used to build new houses for the working families of two counties; in Parliament, the fort was described as the biggest waste of money in British history.

Drop Redoubt Fort was designed according to the principles espoused by the seventeenth-century French

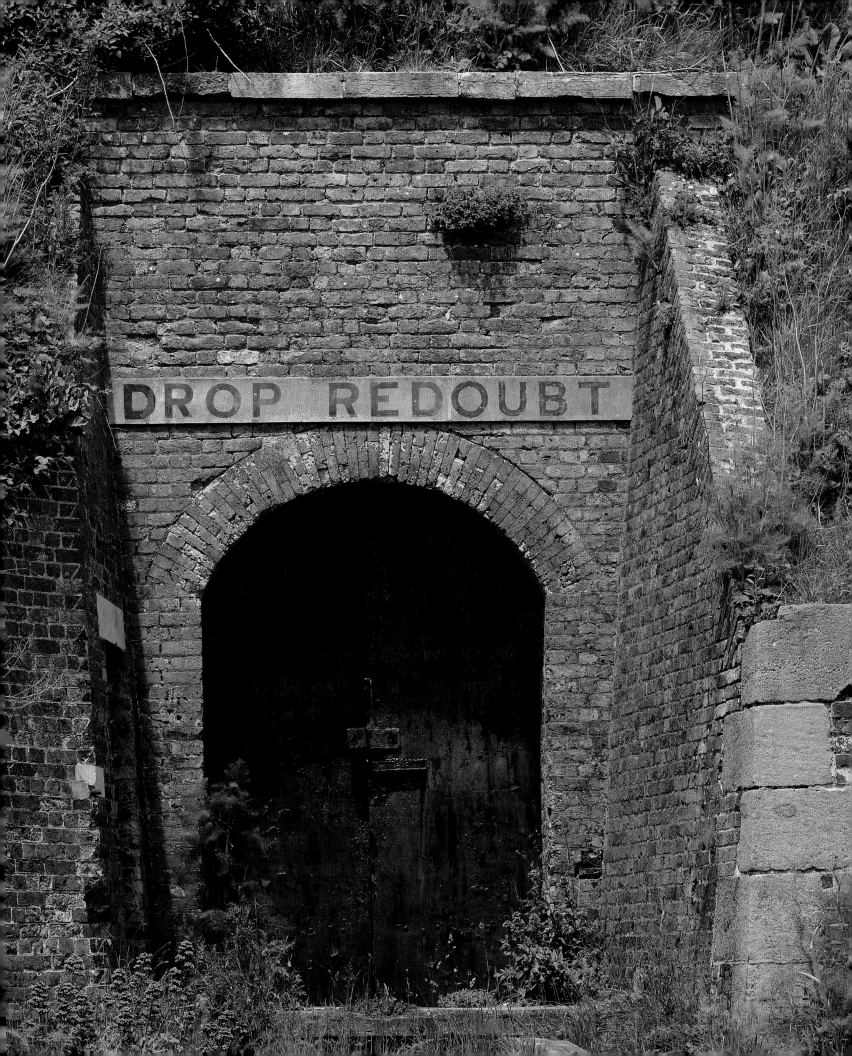

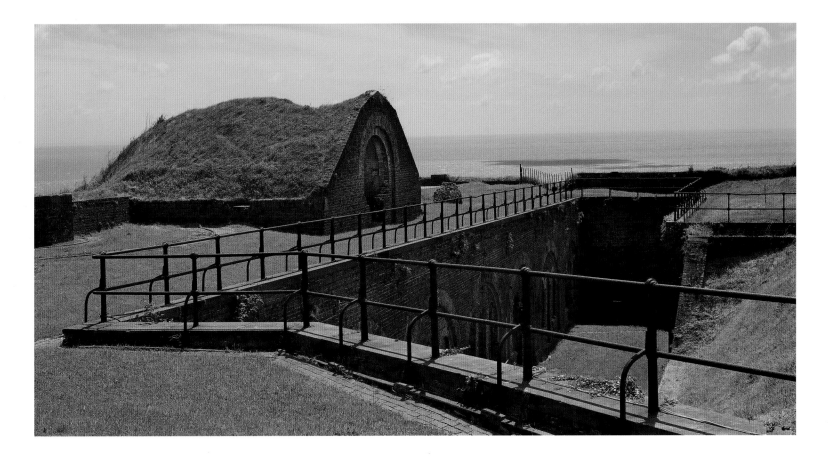

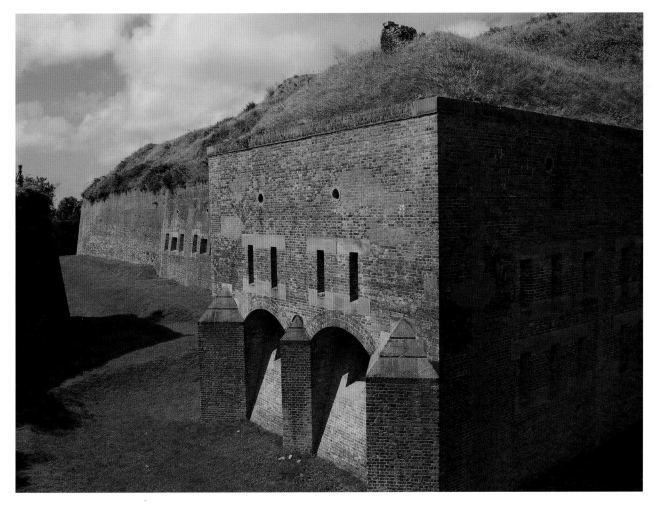

Pages 86–87
Drop Redoubt Fort overlooks the harbour of Dover, one of the points at which England is closest to France – and a likely landing site for an invasion.

Opposite
One of the entrances to Drop Redoubt Fort, named after the remains of a nearby Roman lighthouse known locally as the 'Devil's Drop of Mortar'.

Above
The early nineteenth-century brick-built fort is a warren of enclosed spaces protected by a deep, moat-like ditch.

Left
Killing machine: there is an unavoidable eeriness to the half-blind rifle openings that look out over the defensive ditch.

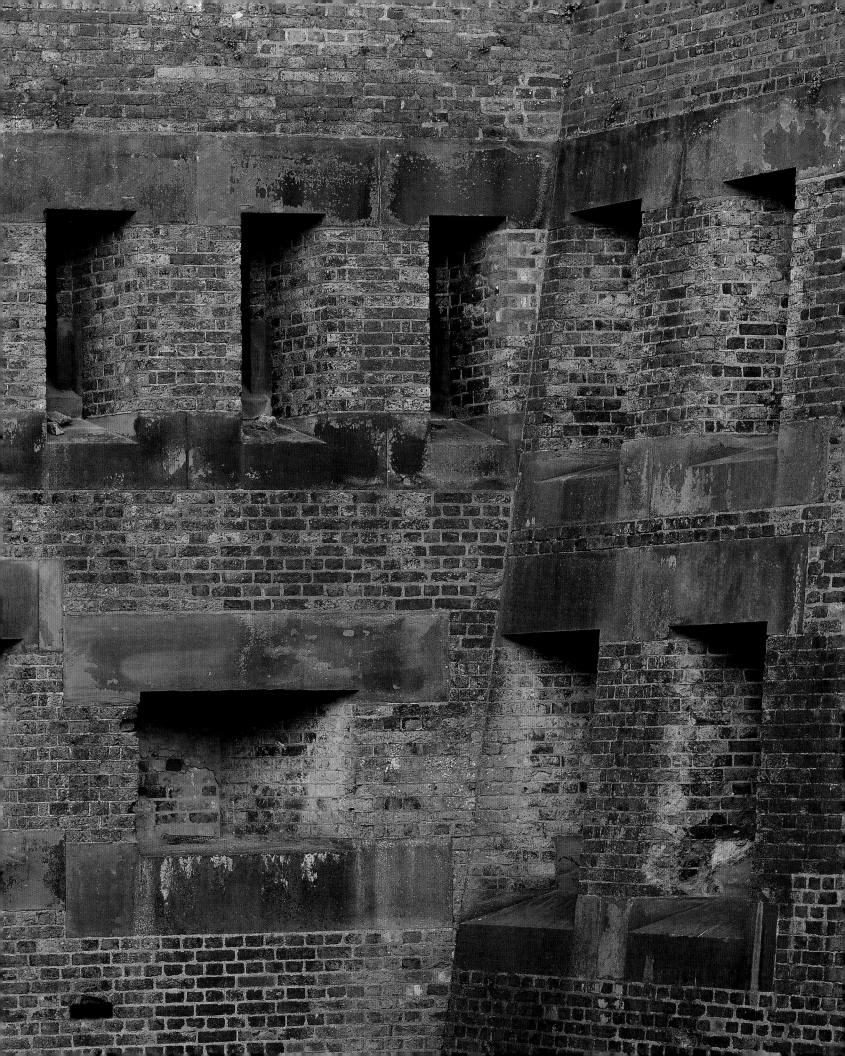

Opposite
The elegant plan of
the fort is based on
the published designs
of seventeenth-
century French
military engineer
Marshal Vauban.

Below, left and right
Running throughout
the fort is a warren of
tunnels and stairways
reminiscent of the
imaginary prisons
drawn by the Italian
artist Piranesi.

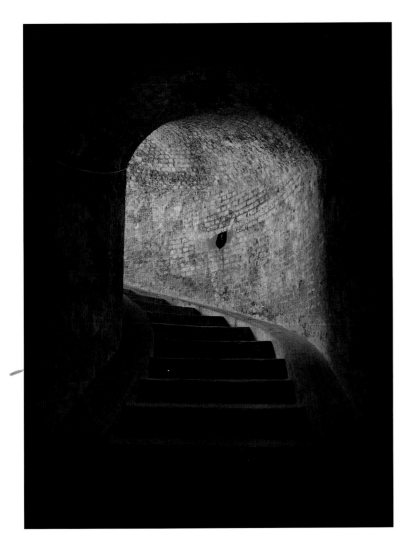

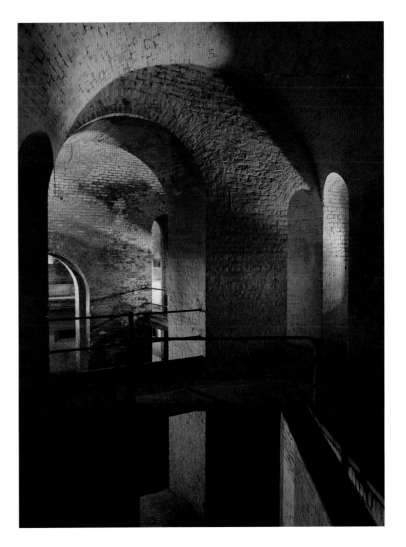

military engineer Marshal Vauban. Its huge geometric
form is sunk within the redoubt, so that the fine
brickwork and stone openings for guns are all in fact
concealed within a vast ditch. On my visit I entered
through a narrow passage, and stepped out into the
ditch, overwhelmed by the overlooked grandeur of the
structure. I had the strongest sensation of being
watched, and yet could plainly see that I was alone.

The stone-framed gun-slits have the appearance
of eyes, and even the chalked graffiti of teenagers
in love (or not) cannot shake the tremendous sense

of unease experienced by a lone traveller here.
For those who prefer the company of others and
entertainment, there are weekend openings of the
core of the fort itself, complete with Napoleonic-era
military re-enactments.

As a comment on where this magnificent if
unsettling ruin sits in the story of England's self-
determination, part of the complex is currently a
detention centre for the fast-track repatriation of failed
asylum-seekers – a reminder of the way in which the
nation defines (or defends) its borders today.

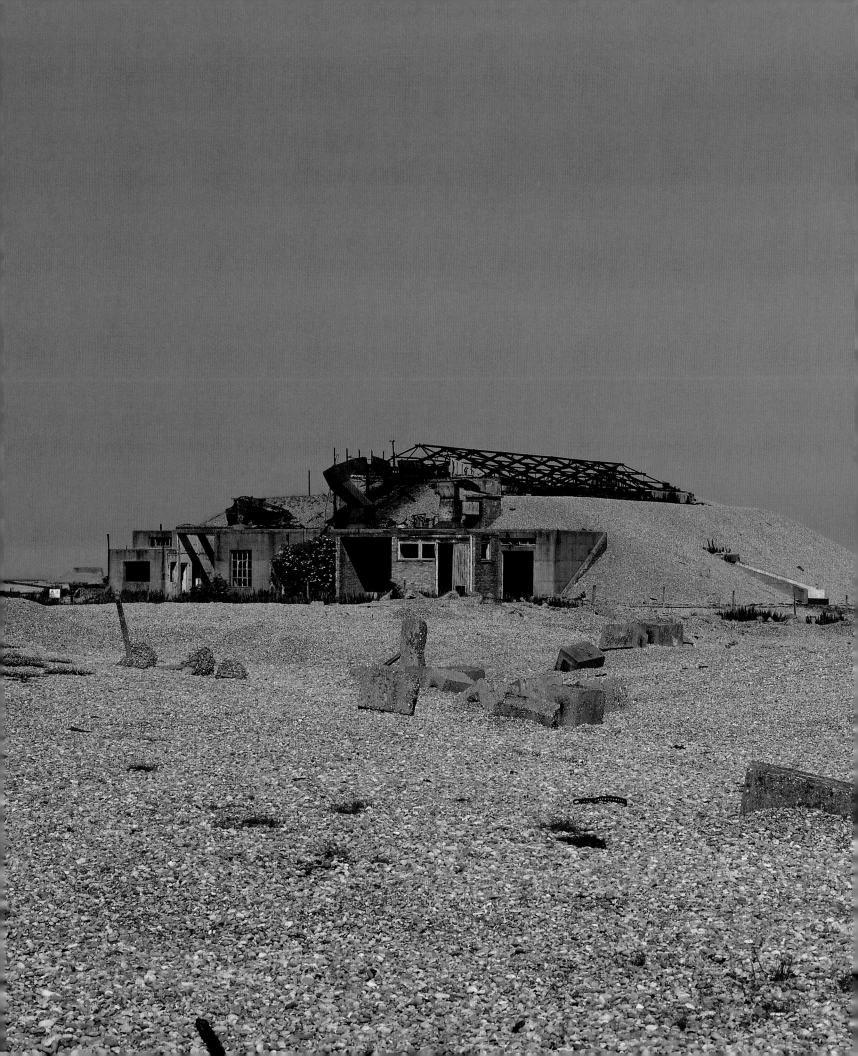

ORFORD NESS
Suffolk

Nothing quite prepares you for the oddness of Orford Ness. The village of Orford, with its castle, church and red-brick cottages, is the picture of smiling Englishness. Thus, when you arrive at Orford Quay, dotted with parked cars and served by a tea shop, the distant hulks that stand on a shingle spit seem to belong to another planet. Today, visitors cross to 'the island', as it is known, via a ferry, and alight on the peaceful marshes enclosed by flood walls.

The marshland was first drained for grazing in the twelfth century, and is now managed as a nature reserve by the National Trust, which acquired the site from the Ministry of Defence in 1993. The first ruined buildings encountered on the island belong to a First World War Royal Flying Corps experimental testing range, and form a recognizable street-like formation. In the mid-1930s the same buildings were occupied by brilliant young scientists working on the development of radar with Robert Watson-Watt.

The National Trust took on this derelict military site not only because of the exceptional landscape and its importance to wildlife, but also in recognition of the enormous interest in its military history. For some of the buildings on this stretch of shingle – itself a natural formation that has come together over tens of thousands of years – belonged to the Atomic Weapons Research Establishment (AWRE). Formed in 1950, the AWRE commandeered this site at the height of the Cold War to test all parts of the atomic bomb, right down to the trigger mechanism.

To ensure the absolute effectiveness of the bomb, its case and trigger had to be subjected to all manner of environmental testing, including extremes of shock, temperature, vibration and gravitational force. To this end, huge concrete laboratories, or 'test cells', were constructed, into which bombs could be driven on lorries and then unloaded. The earliest laboratories were enclosed by lightweight aluminium roofs designed to blow off in the event of an accident. Later laboratories featured heavy, reinforced-concrete roofs supported on pillars, which were intended to absorb any accidental blasts. These later, highly distinctive buildings were quickly nicknamed the 'pagodas'.

Fifty years ago this was a site of intense scientific and military activity, driven by the concerns of the Cold War. A huge building in one part of the site was used for the surveillance of the Soviet military; today, it is used as a broadcasting station for the BBC World Service. After the closure of the AWRE buildings in the early 1970s the site deteriorated rapidly, and by the time it came into the hands of the National Trust, it was in a state of advanced decay.

I was part of the Trust's historic buildings team that looked into the site's potential – a team that also included Angus Wainwright, an archaeologist who had previously been working at Stowe in Buckinghamshire. Given the extreme weather conditions in the Orford area, the Trust had to accept that what it had in Orford Ness was a sequence of important ruins that could be preserved only in general terms; that major restoration would have been unmanageably expensive; and that further decay is part of the very story of the site.

The symbolic significance of Orford Ness is palpable, especially its role in the Cold War, the events of which defined the second half of the last century. It is a landscape of extraordinary character and value; as you walk along the shingle beach, it feels as though you are trespassing on a weird, lunar landscape. Birdwatchers flock here, as do artists and sound-recordists, while such writers as W.G. Sebald and Christopher Woodward have captured its bizarre romance.

Grant Lohoar, the warden here for fifteen years, revels in the human stories collected from former military and scientific personnel, and in the reactions of visitors, 'who either love or hate it – they are never indifferent'. One member of one of his guided parties claimed to have encountered a ghost, a uniformed figure asking what business they had in one of the laboratories, and insisting that they leave. This story reminds us that, within living memory, this managed wilderness and ruin-scape was one of the most secret and secretive sites in England, its boundaries patrolled by armed guards visible to the fishermen at Orford, or the youngsters sailing their dinghies past the quay, but appearing to belong to quite another world.

Opposite
The huge hulks at Orford Ness were built at the height of the Cold War by the Atomic Weapons Research Establishment to test the components of the atomic bomb.

Pages 94–95
Built in the 1960s, this concrete ring once supported a rotating aerial – the function of which is now a mystery.

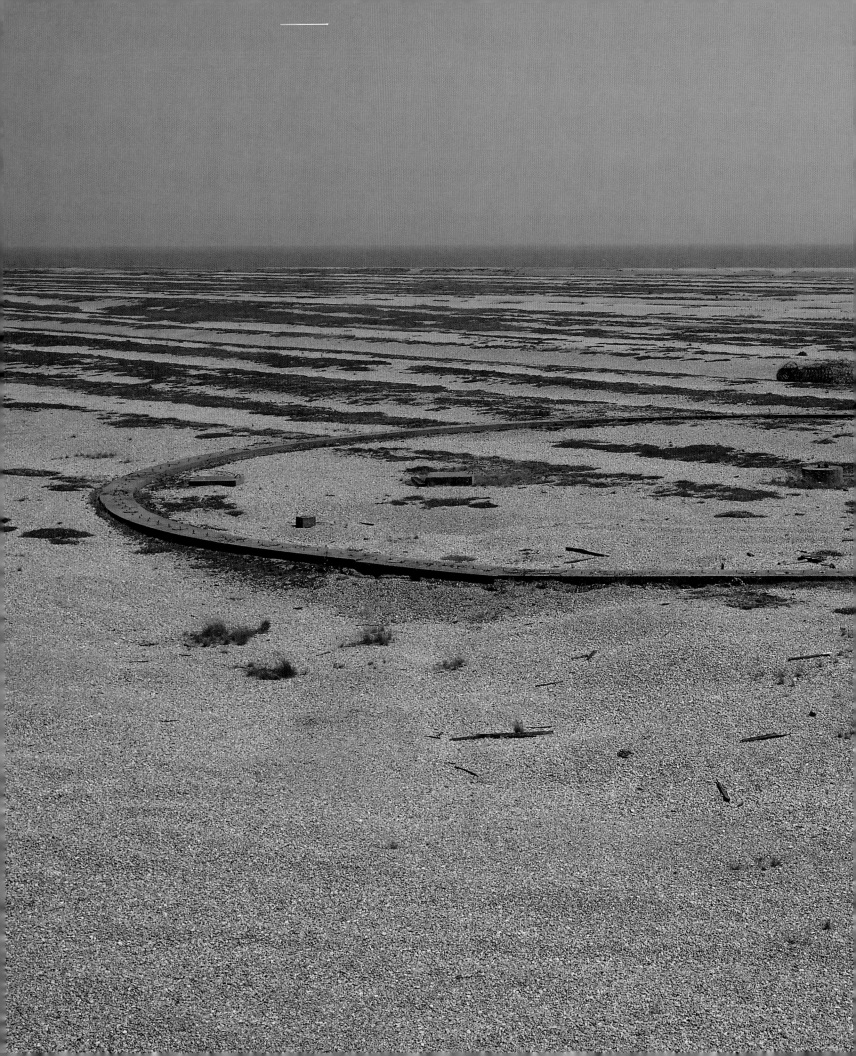

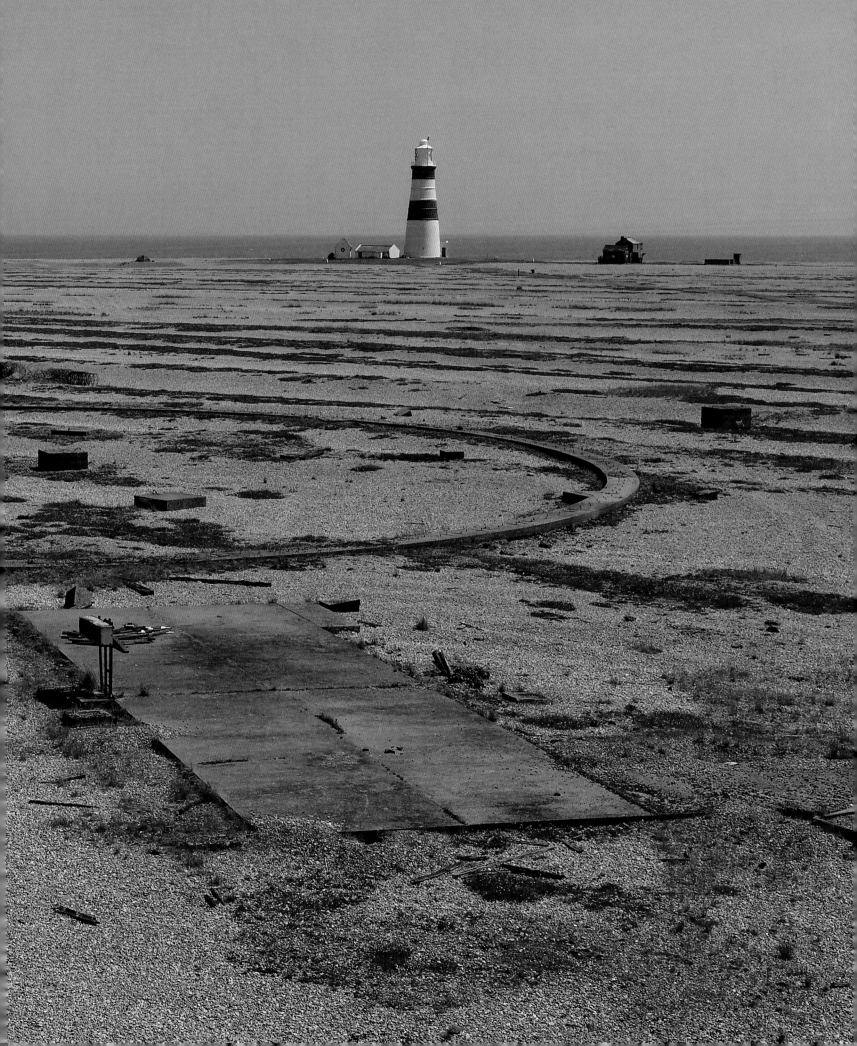

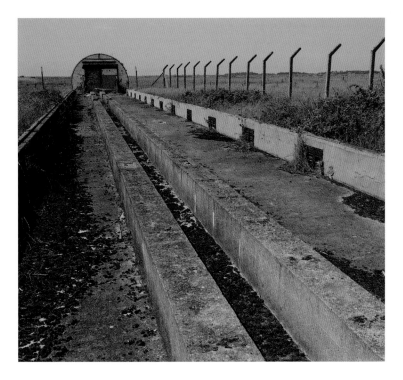

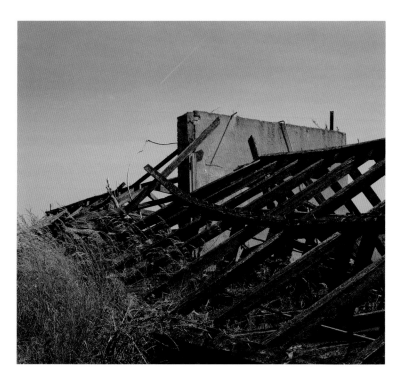

The remains of the Model Bombing Range from the 1950s, used for testing scale models of bombs and rockets.

The 'Black Beacon' (top, right), an experimental radio navigation beacon built in 1928.

The 'pagodas', the environmental testing laboratories designed for the Atomic Weapons Research Establishment.

The collapsed roof trusses of a stores building from the 1950s on the site of the old airfield.

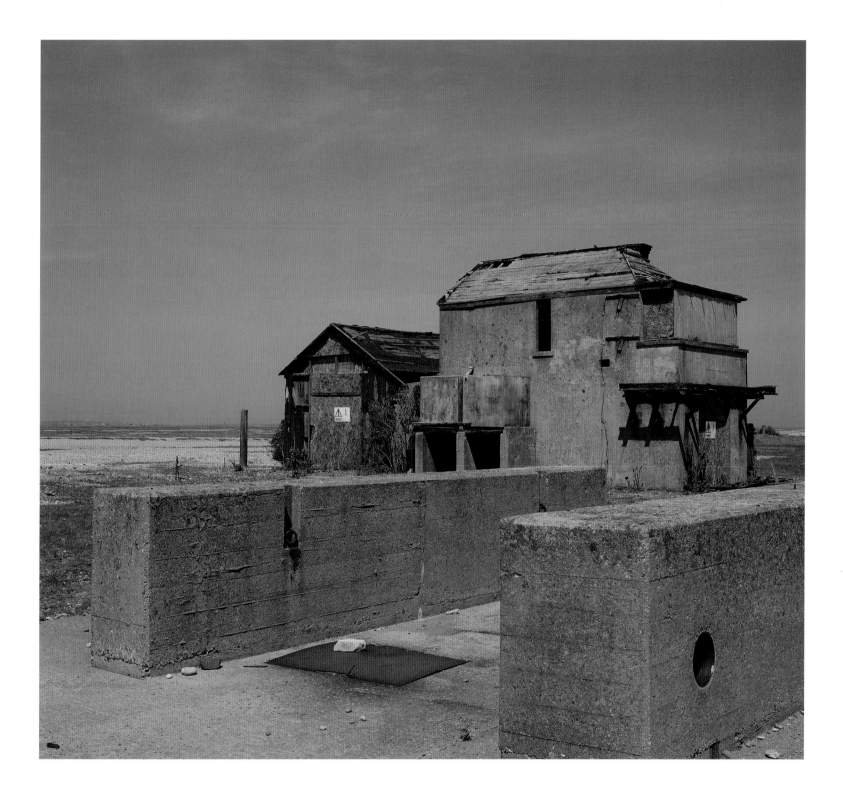

The battered remains of the nineteenth-century Orford Ness coastguard hut, built to watch out for boats in trouble. It is possible that these remains will soon be swept into the sea.

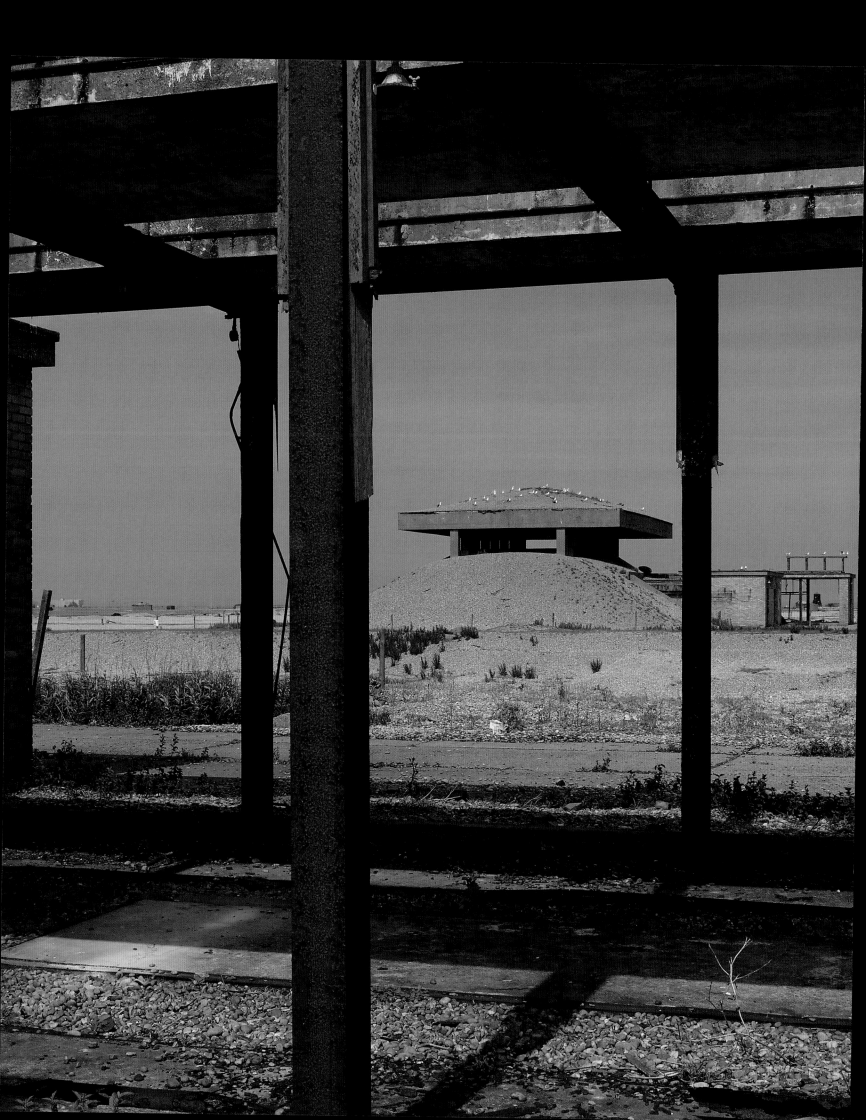

Opposite and right
The atomic testing laboratories were constructed using reinforced concrete. Shingle was then pushed up against the walls by bulldozers.

Right, bottom
The once-pristine control building for the testing laboratories, occupied by AWRE scientists until the early 1970s.

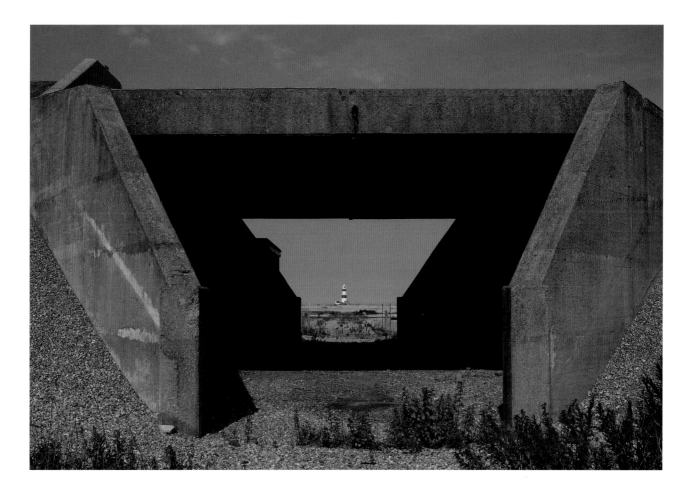

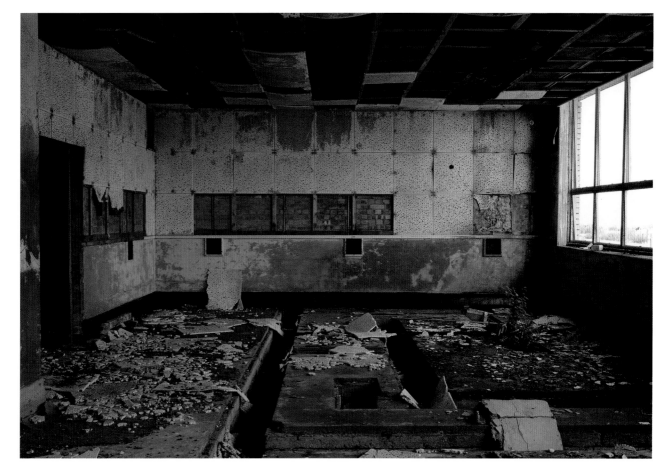

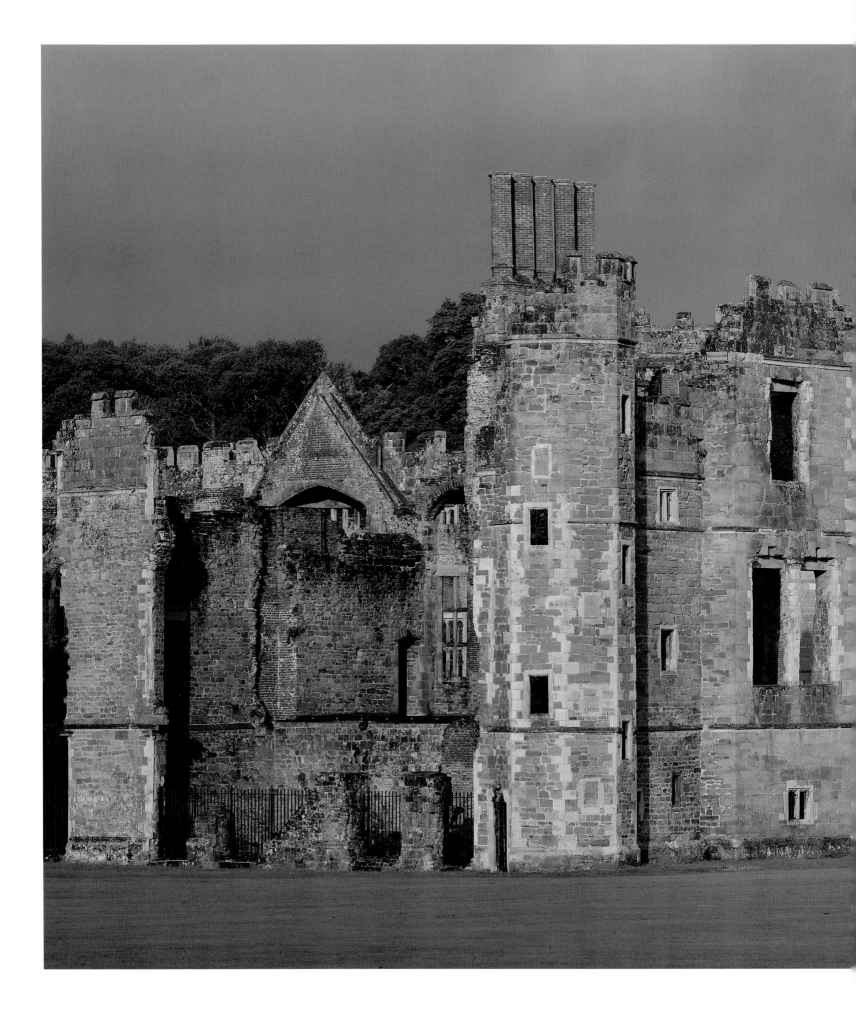

COUNTRY HOUSES

The story of the English country house is a rich and complex one. The very phrase encompasses everything from the old manor houses of the feudal system to the 'prodigy houses' of the Elizabethan era, the fantastic palaces of the English Baroque, the smooth porticoed mansions of the eighteenth-century Palladian movement and the shapely Gothic Revival piles built in the nineteenth century. Such houses normally stood at the centre of great agricultural estates to show that, to paraphrase Noël Coward, the upper classes still had the upper hand.

It is important to realize, however, that there have always been casualties. This includes the houses that became of secondary importance to those landed families whose possessions had been made complicated by centuries of dynastic marriage within the landowning class; houses that were destroyed by an accident, usually a fire, and left to decay; and houses that were caught up in the Civil War, either burned down during retreats, or, after the conflict, deliberately dismantled to prevent their potential military use by others.

Country houses are some of the great landmarks of English culture, not least because of their position in the English landscape. They were the centres of their communities, the focal point of the county, the estate and the household. In their very fabric they represent the best of English craftsmanship and art. Indeed, there is much in their fine crafted-ness and furnishings, in their splendid gardens and landscapes, for everyone to enjoy.

This is clearly evidenced by the popularity of the houses in the custodianship of the National Trust and English Heritage, and of the hundreds that remain in private and charitable hands, such as Chatsworth and Blenheim Palace.

The reputation of country houses, and our engagement with them, is often qualified by a degree of awe and ambiguity regarding the power and wealth held by their owners. Such power and wealth were frequently lavished on perfecting a certain way of life, which, until the mid-twentieth century, was generally supported by a well-drilled army of resident servants. The houses themselves were always built to impress, to dazzle visitors and local populations – even visiting royalty.

Given this history of dominance, it is perhaps not surprising that in the early twentieth century, Liberal, and then Labour, politicians took satisfaction in breaking down the long-established influence of the landed classes in whose hands so much of the wealth of England was concentrated (as much through mineral rights as through agricultural ground rent). However, the sale of art collections and, indeed, entire buildings for their commercial value, without regard to their place in the nation's history, caused some alarm. When the major collapse of the world of the country house occurred, just after the Second World War, there was a general acceptance that such houses had played a key role in shaping England's cultural identity. The dispersal of their collections, and often the ultimate demolition of the houses themselves, was regarded as something to be fought against in the public interest.

After thousands of country houses had been requisitioned for institutional or military use during the conflict with Germany, hundreds were simply not re-occupied. The families who had owned and often built them were either unable to afford their maintenance and staffing, or simply convinced that there was no return to the ways of the past, that society had changed for ever. The National Trust, thanks to the country houses scheme introduced by Liberal peer Lord Lothian, intervened to rescue some of the finest from sale (and sometimes potential demolition), as well as the consequent dividing up of collections and historic estates.

Nevertheless, for two decades, in remoter parts of the country, closed-up country houses in ruins were almost as much of a commonplace as the ruined abbeys that adorn the English countryside. In *No Voice from the Hall* (1998), architectural historian John Harris recalls his adventures in the 1950s visiting abandoned country houses, many of which were eventually demolished. It was an experience that sharpened his passion to understand and record such buildings.

In 1974 the Victoria and Albert Museum's exhibition *The Destruction of the Country House* did much to alter perceptions about the depth of the issue. Annual reports by Save Britain's Heritage, the Society for the Protection of Ancient Buildings and English Heritage continue to flag up historic country houses that are in desperate need of repair, that are in ruins but

Pages 100–101
The ruins of Cowdray House lie on the edge of the town of Midhurst, West Sussex. The house has been uninhabited since it was gutted by fire at the end of the eighteenth century.

Lowther Castle in Cumbria, de-roofed in the 1950s, stands as a symbol of the changing attitude towards the English country house.

could be saved. Thankfully, many will be restored, and hardly any are likely to be consolidated as 'preserved ruins'. As in the case of castles and abbeys, the ruins of a country house can be the scene of a pleasant picnic or walk with the family. For the curious traveller, such ruins can somehow be especially haunting, for they are the remnants of the stories of people and communities.

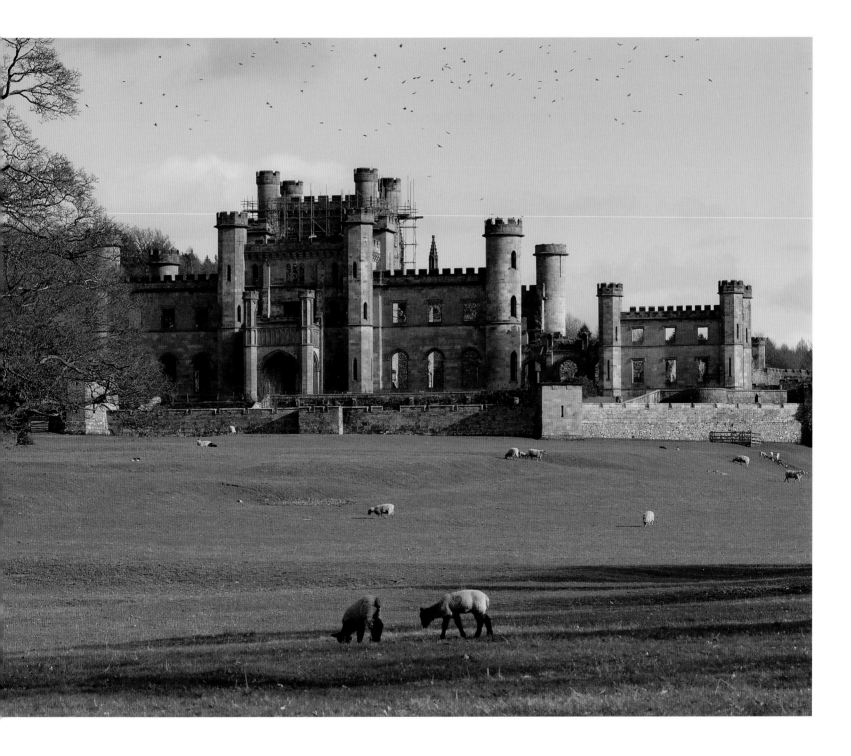

COWDRAY HOUSE
West Sussex

Opposite
The dramatic scar in one of the walls of Cowdray House is often thought by visitors to have been inflicted during a Civil War battle. However, the house was in fact the victim of a major fire in the late eighteenth century.

The ruins of Cowdray House spread out before the onlooker like scene flats from a grand opera. As a child growing up not far from this set of ruins, I always imagined this great castellated house, just on the fringes of Midhurst, must have been a casualty of the Civil War. A roofless shell, with a magnificent scar down the middle of the principal elevation, it suggests some moment of conflict and crisis.

But the story of the collapse of this great country house is more prosaic, reflecting instead how buildings are subject to the fluctuations of ordinary human misfortune – and how their remains are saved for reasons of changing taste. For Cowdray House simply burned down in an accidental fire in 1793, and was then left to moulder.

Lord High Admiral. On his death in 1542, Cowdray passed to Sir Anthony Browne, his half-brother.

By the eighteenth century the great Tudor house had already become a curiosity, documented by such writers as Daniel Defoe, Horace Walpole and, in 1782, Samuel Johnson, who said, 'We see here how our ancestors lived.' But it was not to remain this way. On 24 September 1793, a great blaze lit up the sky over Midhurst, as Cowdray House – by now the much-esteemed residence of the Viscounts Montague – was consumed by a disastrous fire that destroyed the core of the building and much of its celebrated contents.

In a moment worthy of a novel by Sir Walter Scott, only a week before the fire the heir and hope of the line, the 8th Viscount, had died in a boating accident, just before his marriage to a great heiress that was to have restored the family's fortunes. This double calamity meant that the house was never restored, as none of his sisters had the resources to rebuild. Even a distant cousin, a monk who left his order at Fontainebleau in France so that he could marry and produce an heir to the title, died without children.

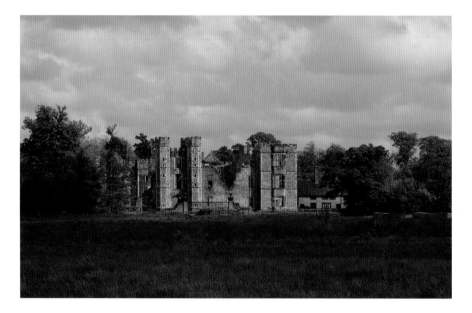

Above
Located in a picturesque setting in the South Downs, the ruins of Cowdray House have been admired by artists since the early nineteenth century.

The original house had been built in the mid-sixteenth century for Sir William Fitzwilliam, a powerful figure in the court of Henry VIII. In 1533 a royal licence was issued for a 240-hectare (600-acre) park, a warren (for breeding game) and fish ponds, and the fortification of the existing manor house with walls, battlements and towers. The new, crenellated house would resemble a castle, with corner towers, a great gatehouse and a huge hall range within. Sir William, an ally of the king, was made Earl of Southampton, and served as Lord Privy Seal and

A nearby hunting lodge was adapted as a family residence, and the house was left as a ruin. Within twenty years it had become a popular destination for tourists and artists alike, attracting the attention of day trippers from London and both John Constable and J.M.W. Turner. The towering remains of the house soon became a beloved English landmark, almost a feature in the park of the new residence that grew around the old lodge. In 1913 Sir Weetman Dickinson Pearson (later Lord Cowdray), who had acquired the estate in 1908, engaged the architect and antiquary Sir William St John Hope to oversee the cleaning, repair and stabilization of the ruins as a matter of historical pride.

Further repairs were carried out in the 1980s, and in 1996 the present Lord Cowdray helped to set up the Cowdray Heritage Trust – with support from local people, the estate and English Heritage – to care for the ruins. Cowdray House ruins are now both preserved and actively opened to the public by the trust, which stages events, open-air theatre and costumed demonstrations in the great kitchen.

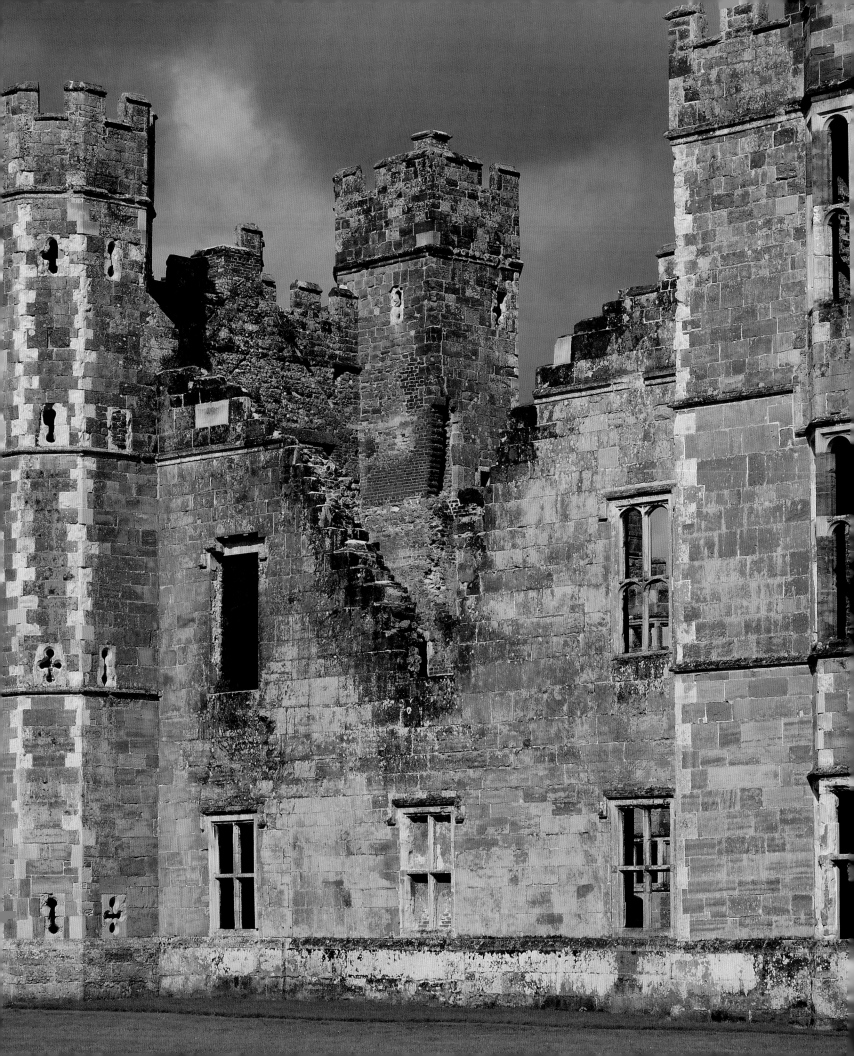

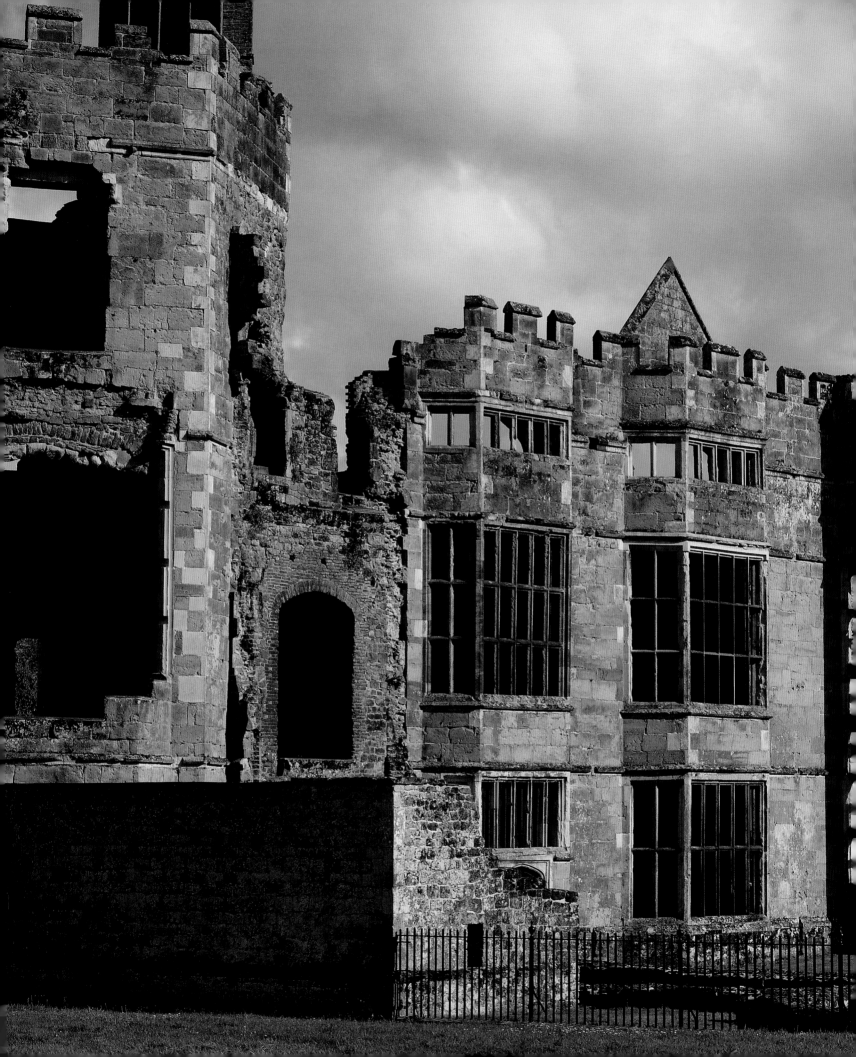

Opposite
A sense of theatre: the ruins of Cowdray House read like a series of theatrical scene drops. Behind the gatehouse lie the remains of the west range, which contained the great hall, and the parlour and great chamber of the private apartments.

Right
A view towards the great kitchen, located under the corner tower, with some intact rooms above.

Right, bottom
The finely detailed gatehouse shows this to have been a house of the first rank at the time of its completion.

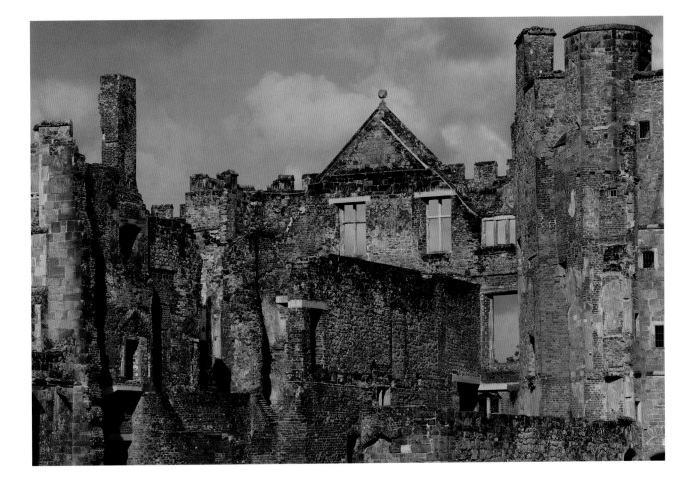

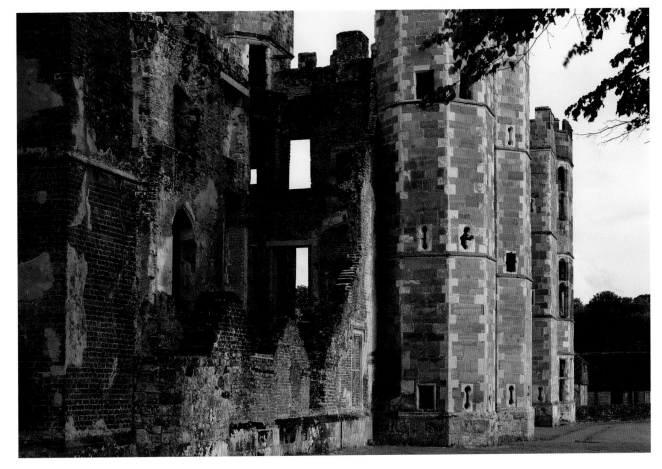

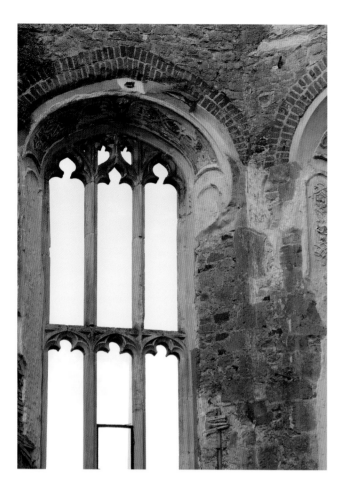

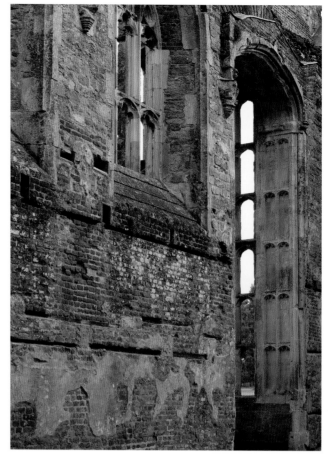

Far left
A window to the former chapel, which lay behind the great hall and beside the principal staircase.

Left
The oriel window of the great hall underlines the former grandeur of Cowdray House. The great hall was originally crowned with a vast timber hammerbeam roof, recorded in watercolours made in 1782 by S.H. Grimm.

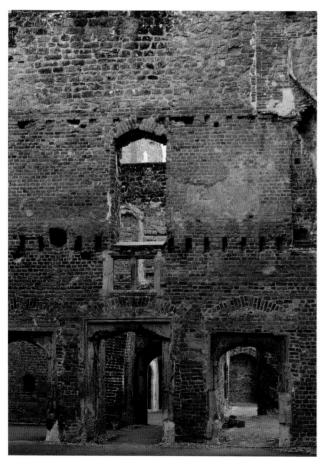

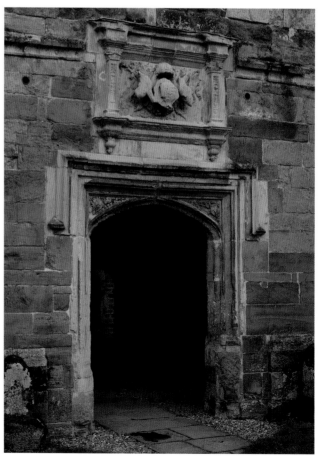

Far left
The 'low' end of the great hall, with (from left to right) the entrances to the pantry, kitchen and buttery. The head of the household would have sat at the 'high' end of the hall.

Left
The Royal Arms erected over the entrance to the great hall celebrate Henry VIII's visits to the house in 1538 and 1539.

A detail of the elegant carved stone vaulting in the entrance to the great hall. The anchor refers to Sir William Fitzwilliam, Earl of Southampton, who built Cowrday and later served as Henry VIII's Lord High Admiral.

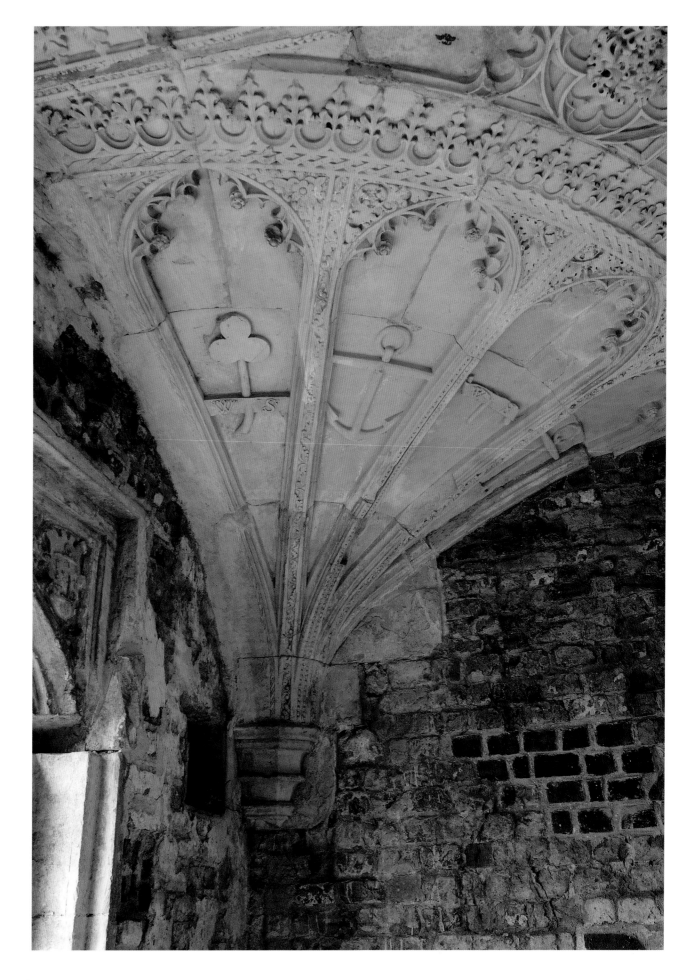

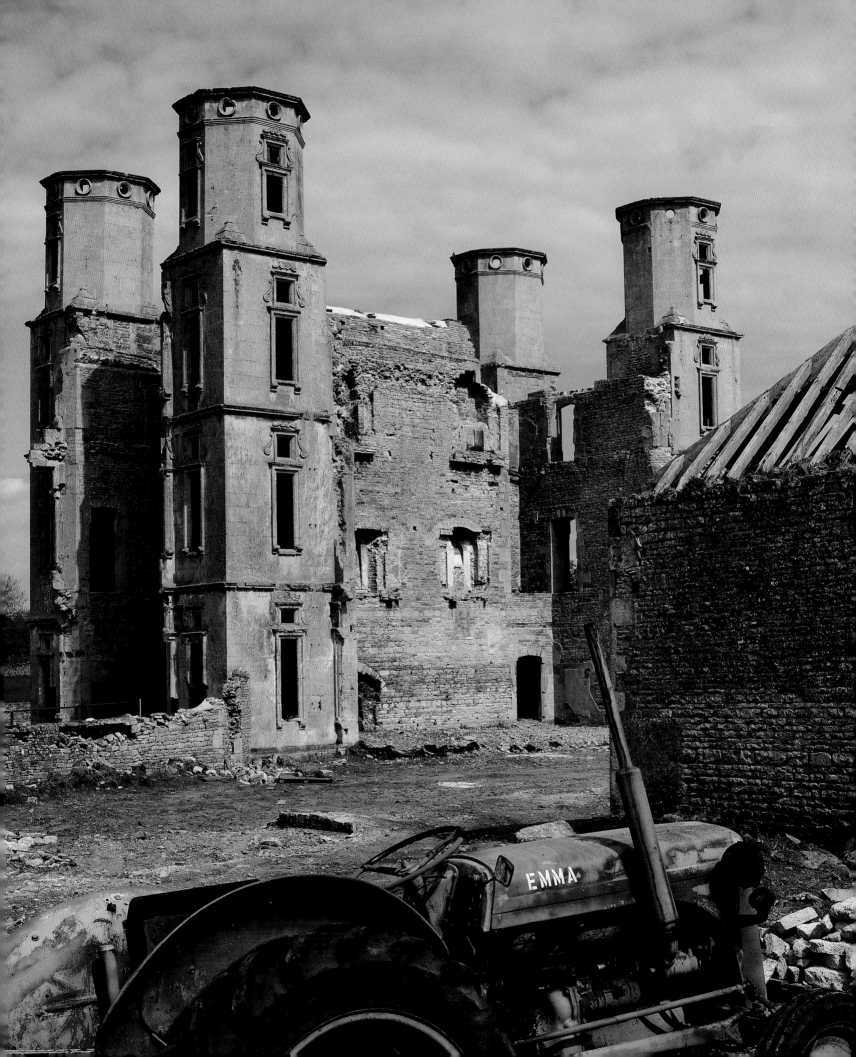

WOTHORPE TOWERS
Lincolnshire

Opposite
Although in ruins,
Wothorpe Towers,
a private house of
retreat built in the
early years of the
seventeenth century,
still possesses an
unmistakable
elegance. In his
Worthies of England
(1684), the English
cleric and historian
Thomas Fuller
described Wothorpe
as 'the least of Noble
Houses, and best
of Lodges'.

Hidden in a steep wood above the A1 near Stamford rise four craggy towers, glimpsed briefly by motorists as they speed past on the road below. They could belong to a castle, but they are in fact the remains of an elegant private lodge, Wothorpe Towers, an early seventeenth-century house built on the edge of the Burghley estate for Thomas Cecil, 1st Earl of Exeter, the eldest son of William Cecil, the 1st Lord Burghley, Elizabeth I's famous first minister and adviser.

Wothorpe was an exceptionally intimate and ornate structure, with Classical strapwork detailing drawn from the published designs of Sebastiano Serlio, the highly influential Italian Renaissance architect. The main entrance was on the west side, and was approached via a flight of steps that led to a hall; beyond the hall a dining-room and drawing-room looked out over the main garden to the east. The house was said to be a place of retreat and recreation, for Thomas 'to retire out of the dust while his great house at Burghley was a-sweeping'. After his death it became a secondary Cecil home and a dower house.

The central block – crowned by the four octagonal towers – lay between two service wings; together, the buildings formed three sides of a courtyard. The gable ends and dormers were stepped and topped with small obelisks. Quite simply, this was a house as elegant as a chateau in the Loire valley, with a garden of correspondingly immaculate order.

In 1759 the house was part-dismantled. Current thinking is that it was deliberately turned into a ruin, or 'eye-catcher', at a time when Lancelot 'Capability' Brown was involved in the re-landscaping of the Burghley estate. The alert, finely crafted towers, with their elegant Classical details and strong echoes of the architecture of the ancient world that inspired Renaissance designers, mark a curious specimen of an aristocratic dwelling in ruins. Until recently, a farm occupied the adjoining Elizabethan and Jacobean buildings that stand in the house's shadow.

As an example of how the future of ruins can change unexpectedly, in 2004 Wothorpe and its associated buildings were acquired by Paul and Janet Griffin, two architectural enthusiasts. Having created a trust for the ruins, the Griffins are now restoring the surrounding gardens, and turning the adjacent buildings into their home. Wothorpe, once an aristocratic jewel, had become a forgotten folly; today, it is well protected and about to be opened to the public for the first time in its history. It is also, once again, part of a beloved home.

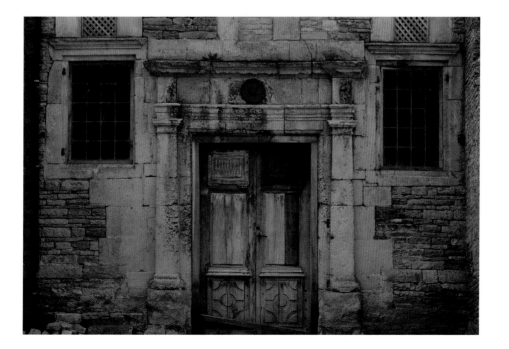

Left
The entrance to the stable range, inspired by Classical architecture.

Pages 112–13
Built on an eminence, Wothorpe Towers lay at the centre of an elaborate formal garden. In the mid-eighteenth century the house was partly dismantled to serve as a picturesque ruin in the wider landscape, reflecting the fashion of the age for architectural curiosities.

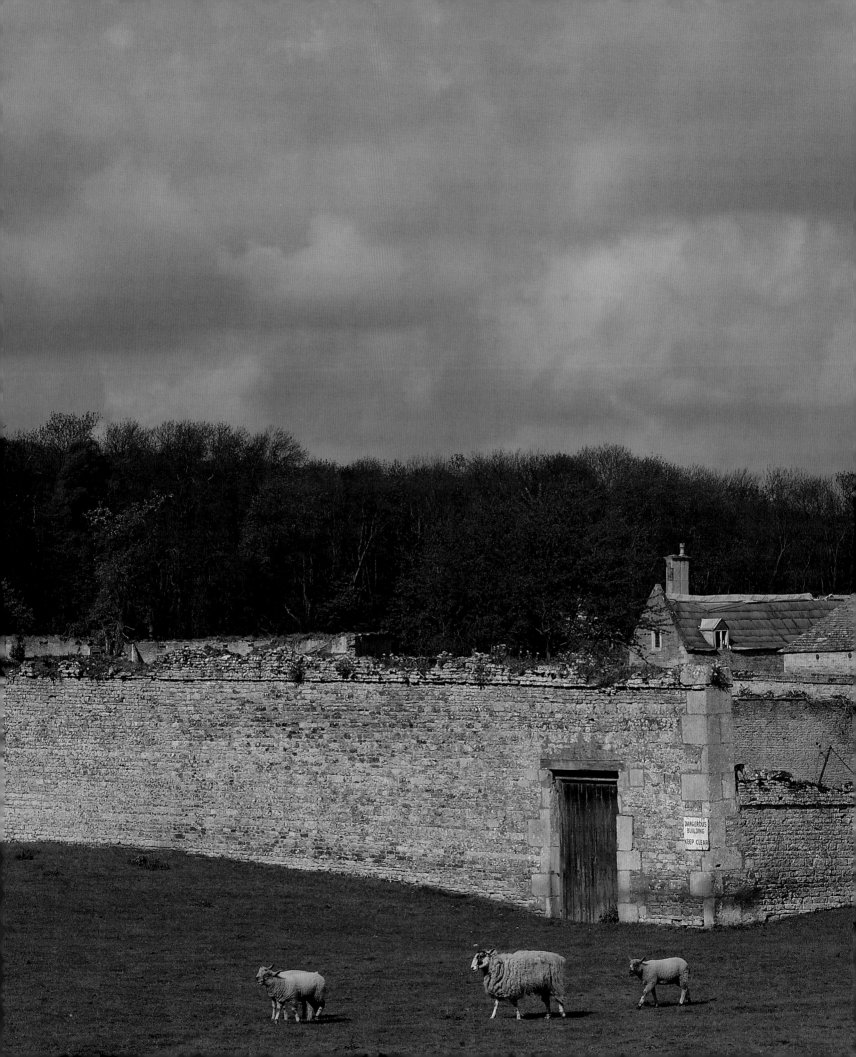

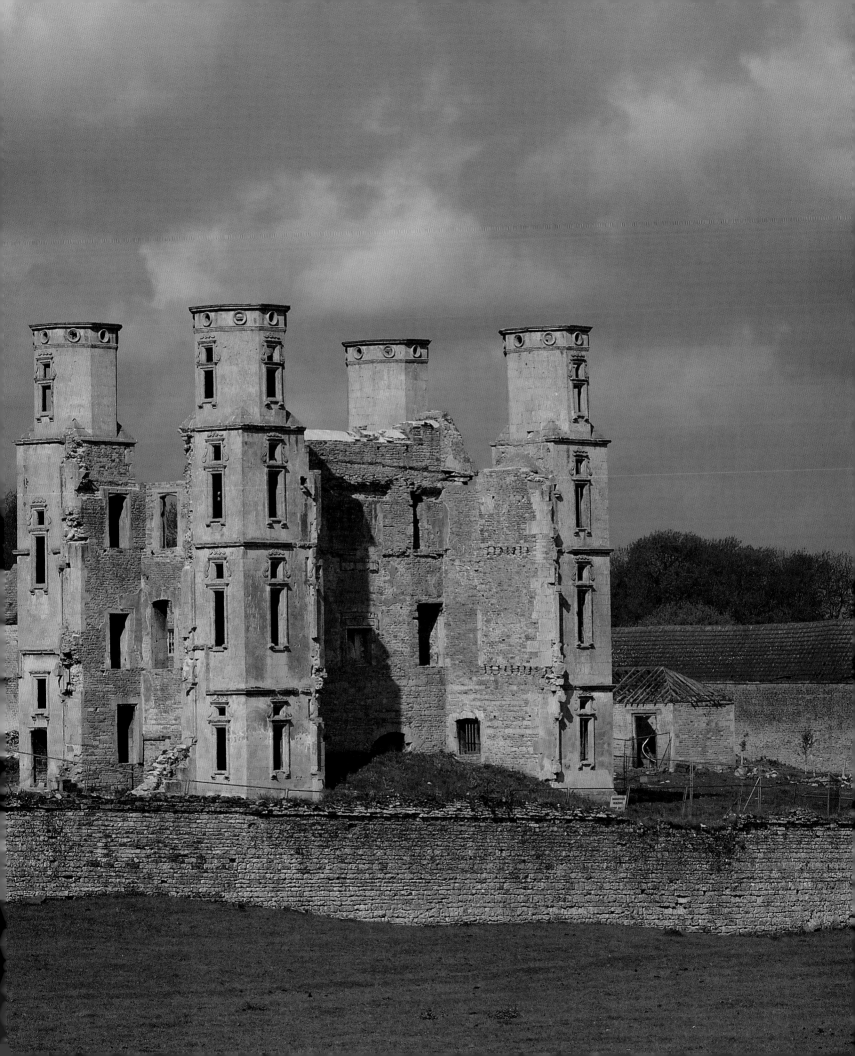

Finely detailed and originally provided with many hearths for comfort, Wothorpe Towers has been a shell for more than 200 years. It is currently being preserved by a newly founded charitable trust.

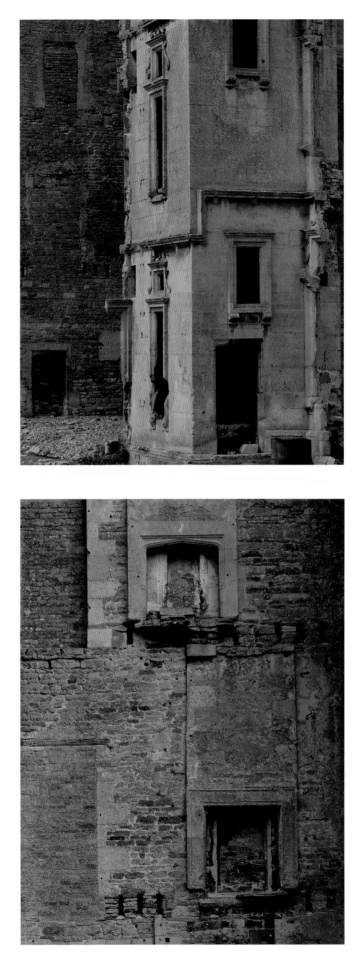

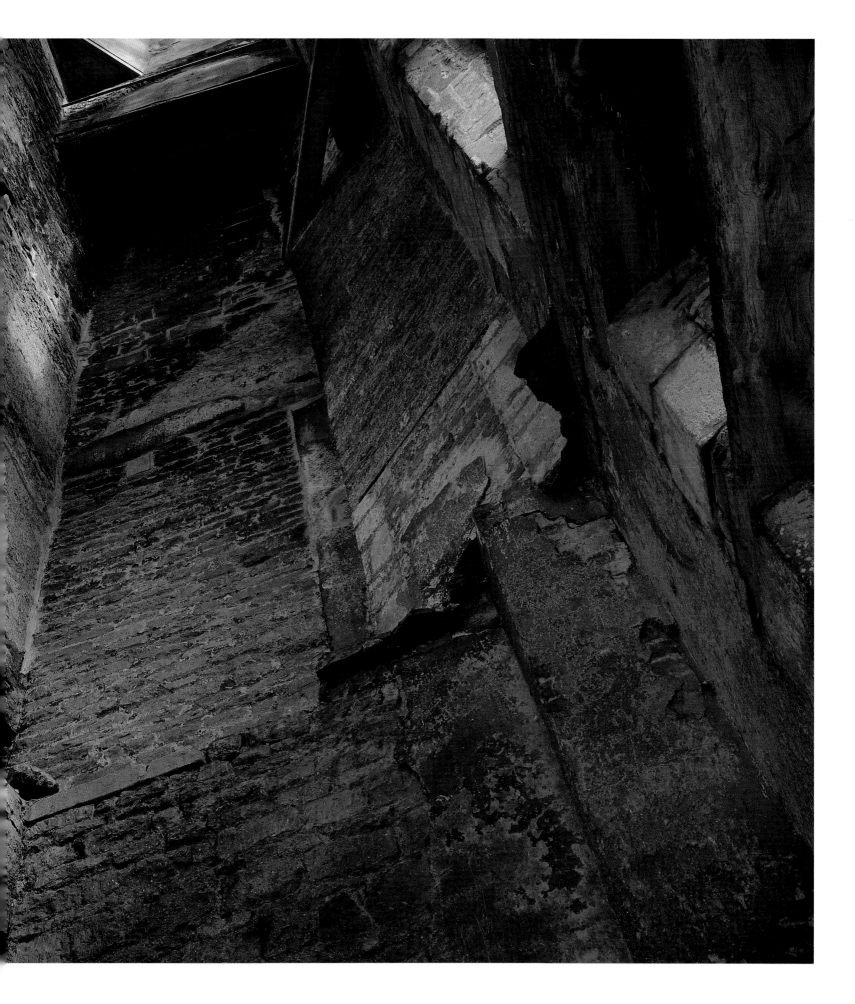

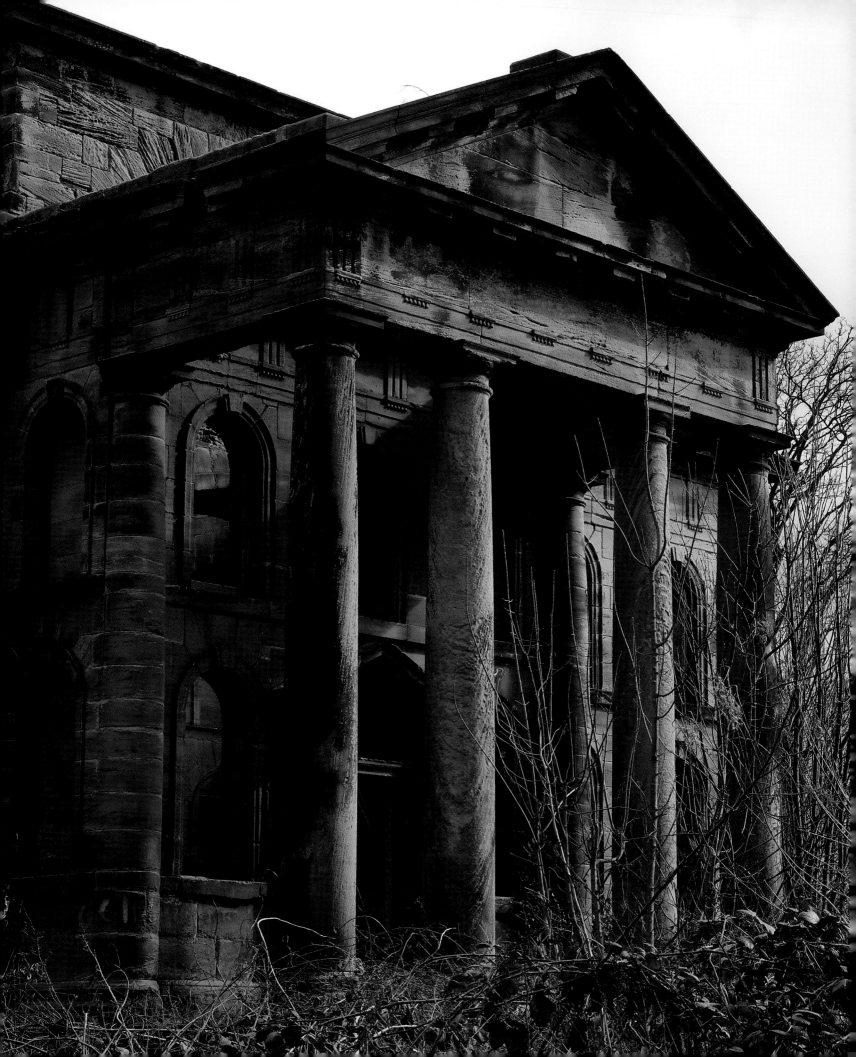

SEATON DELAVAL HALL
Northumberland

Sir John Vanbrugh, wine merchant, soldier-turned-playwright and designer of Castle Howard in North Yorkshire and Blenheim Palace in Oxfordshire, left his mark on Northumberland, too. Situated a little way north of Newcastle, Seaton Delaval Hall was one of his last and most original works; for a century and a half, it has also been one of the most evocative preserved ruins in England. Built for the well-travelled Admiral George Delaval, the house combined all of Vanbrugh's heroic spirit of architecture with a dramatic setting looking towards the sea at Whitley Bay.

Vanbrugh was working on the house when he died in 1726. By that time he had endowed it with all the energetic dignity of the Baroque and the varied skyline of a sixteenth-century mansion house. The central pedimented section contains the main hall on the north side and a south-facing saloon; the lower wings, small palaces in their own right that extend forward to form a deep forecourt, contain stables on one side and kitchen and bedrooms on the other. Some of the service rooms can be found in the semi-basement level under the hall.

The painter John Piper described a visit to Seaton Delaval Hall in *Buildings and Prospects* (1948): 'Vanbrugh the man of the theatre was at least as operative here as Vanbrugh the architect. In his last work he created a rich stage which, when the footlights were turned down and the smart audiences gone, would adapt itself to any kind of bad acting and if necessary would carry on with the play itself.' The north and south elevations of the stately main block seem to be the settings for two different plays: one smiling, and the other fierce.

The Delavals who inherited the house in the eighteenth century, especially the children of the Admiral's nephew, were famous for their theatricals, for their practical jokes and parties, and for their 'tilts, Tournements, Gamblings and Bull-batings'. In 1822 the scene of all this japery was sadly struck by a major house fire that left the central range as a roofed ruin; only the wings have been inhabited since. The remains of the basement-level servants' rooms are particularly evocative, a warren of earth-floored spaces that would once have been full of activity and life. In the grounds of the house lies another remnant of the past, a mid-eighteenth-century domed mausoleum built with an almost Vanbrughian sense of bravura. It stands now as a ruin, and has all the air of a piece of leftover scenery from an opera.

Seaton Delaval Hall passed by descent to the Astley family (the Lords Hastings), who kept the building in repair. In 2009, with its long-term future in doubt, it was acquired by the National Trust, with local support and fundraising carrying the day. It is probably one of the most important pieces of architecture in the Trust's portfolio, despite its semi-ruined state; perhaps the Piranesian drama of the great hall makes it all the more mysterious and engaging to a modern audience. The hall itself is open to the roof, and the effects of the fire can be seen in the half-burnt plaster statues still in their Classical niches.

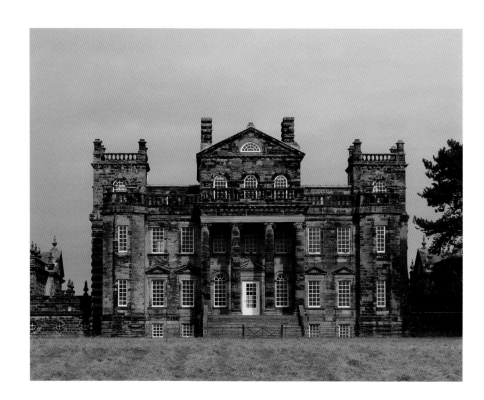

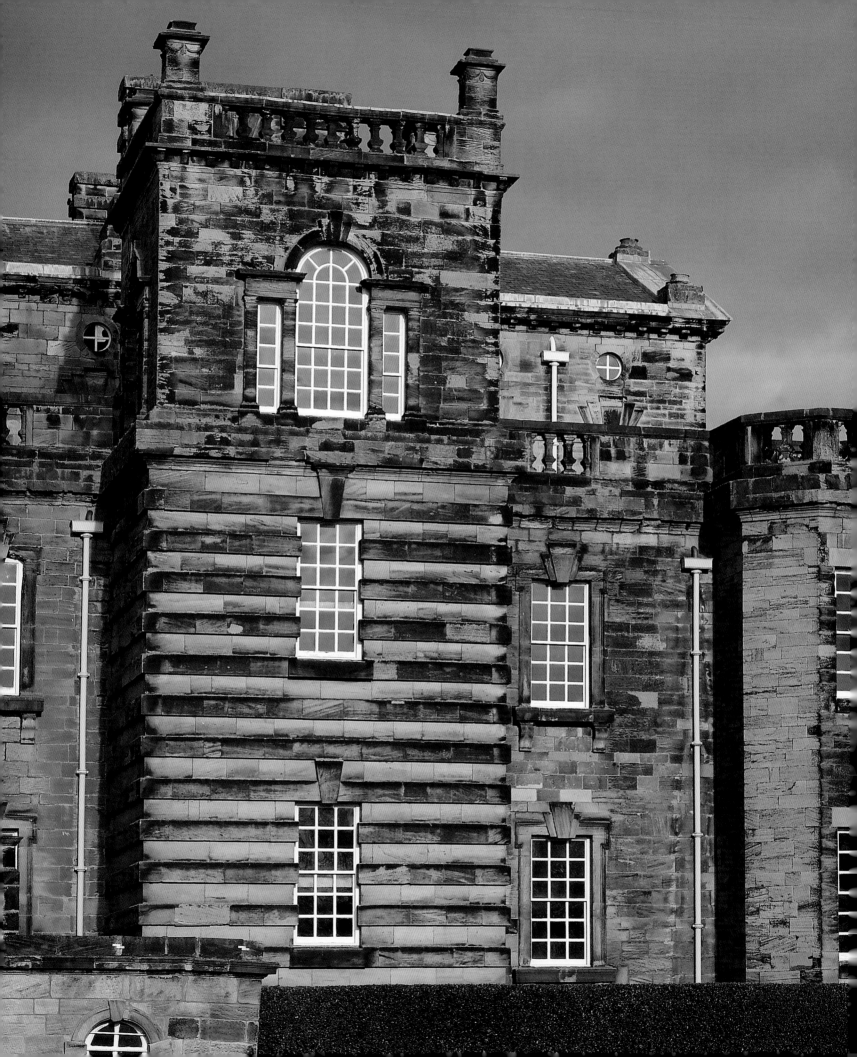

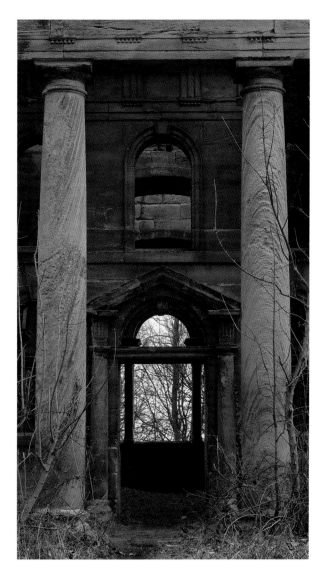

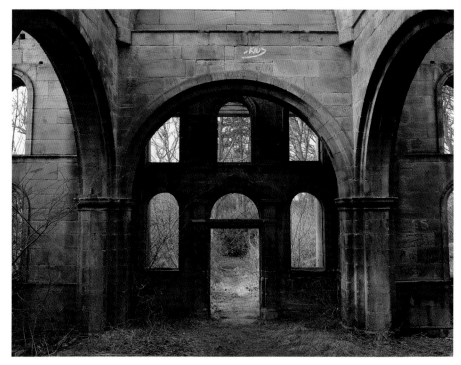

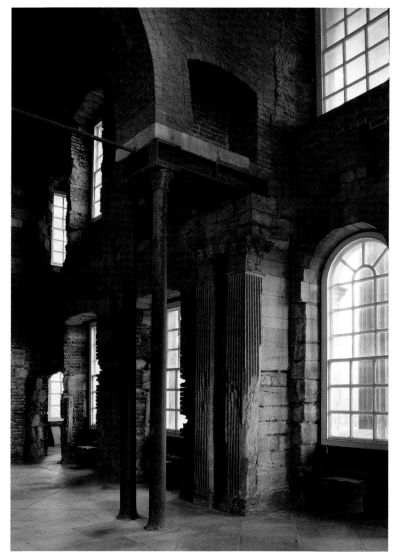

Above
The shell of the mausoleum, which lies some 500 metres (1600 feet) to the east of the house.

Right, top
The mausoleum's vaulted interior echoes the drama of the main house.

Right
Seaton Delaval Hall was badly damaged by fire in 1822. This room is the saloon, once magnificently decorated in stucco work created by Italian craftsmen.

Opposite
There is an awesome simplicity to the burnt-out but roofed and preserved interior spaces of the house.

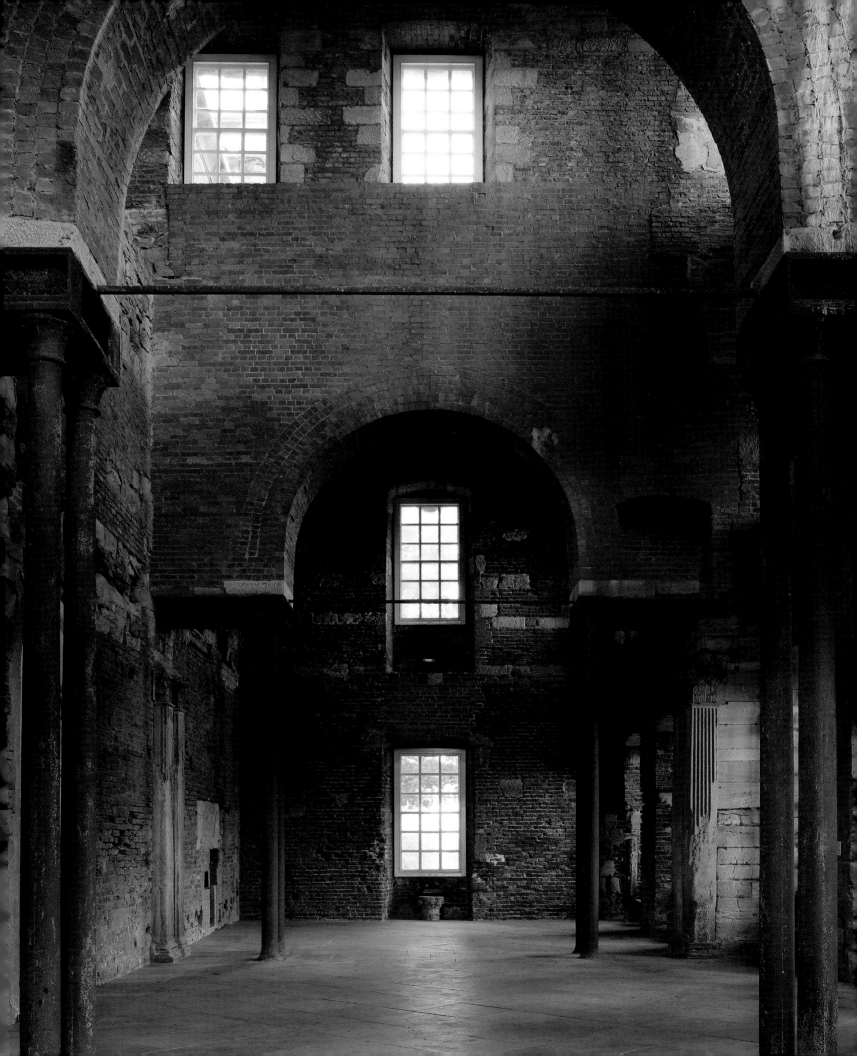

Left
Vistas inside the
house suggest
the elegance of
Vanbrugh's initial
design: (top left)
a view of the axis
between the two
staircase towers;
(top right) the stucco
figures of the arts
in the great hall;
(bottom) looking up
one of the staircase
turrets.

Opposite
A fire-damaged
stucco herm (a type
of Classical sculpture
consisting of a head,
and sometimes a
torso, above a non-
figurative base) still
frames the main
fireplace of the
great hall.

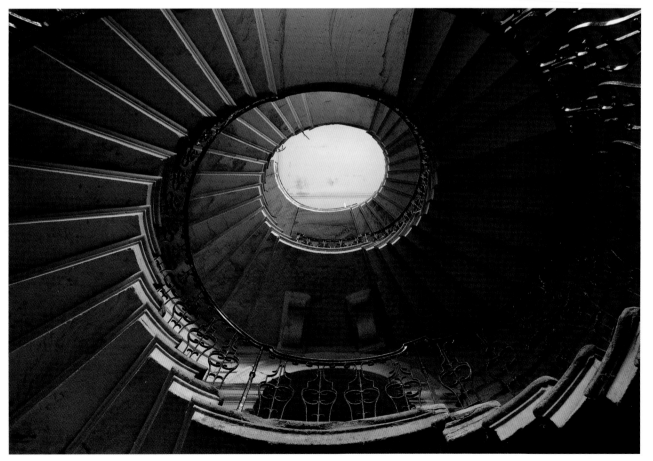

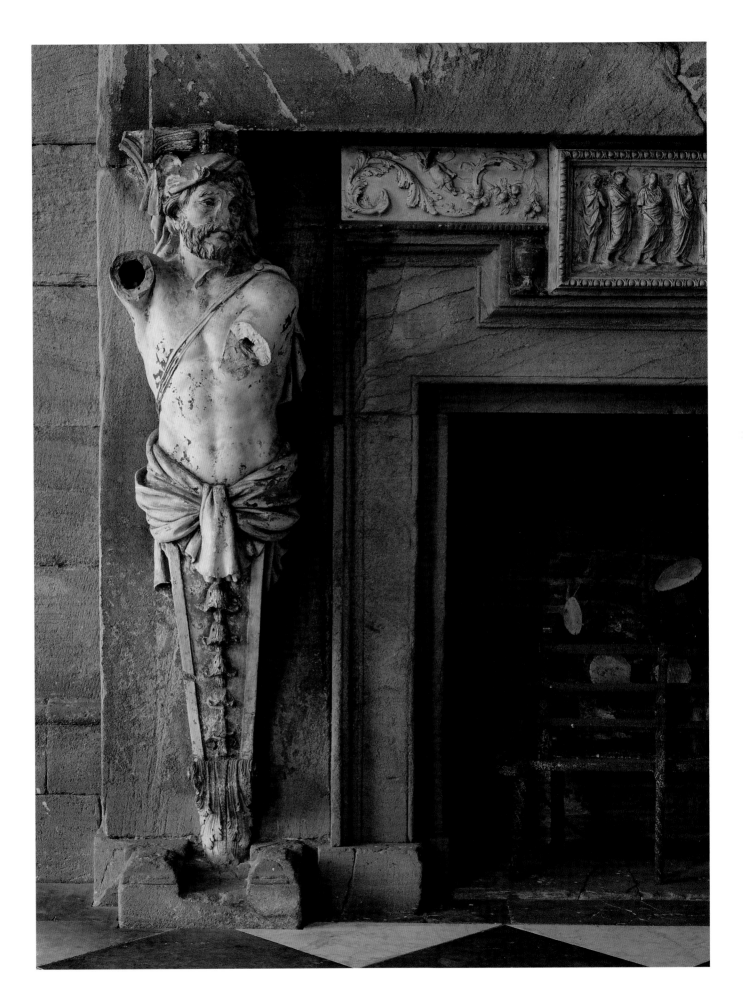

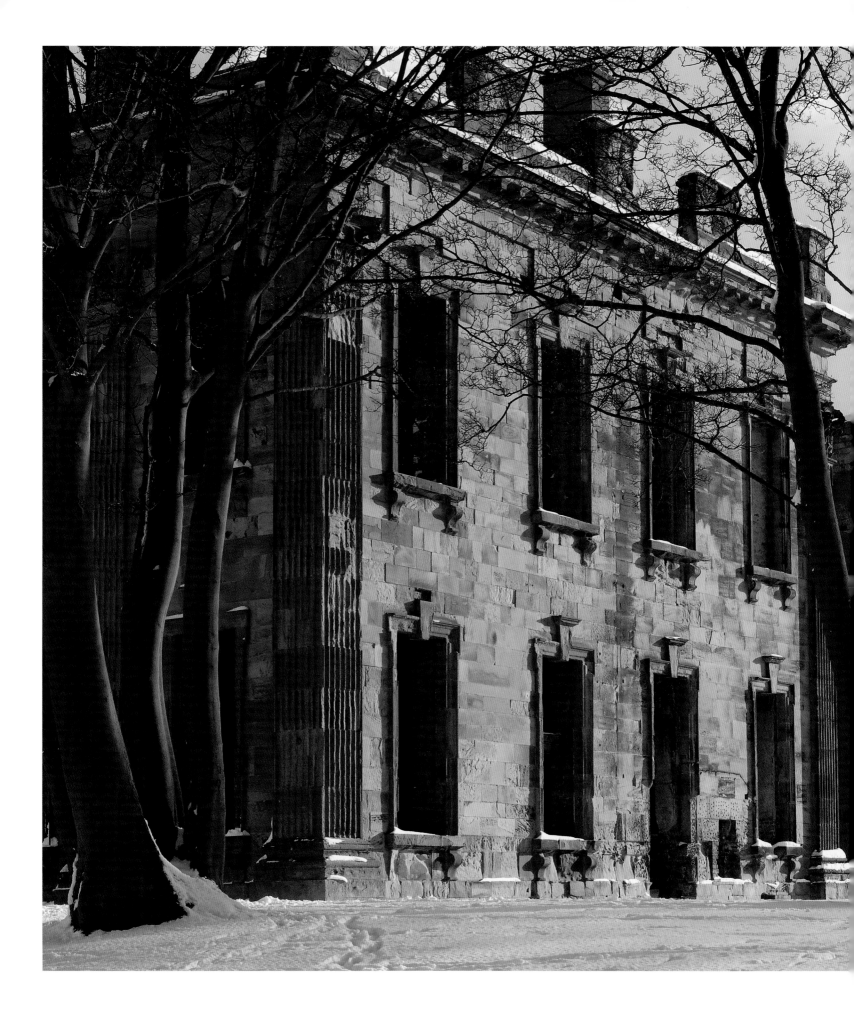

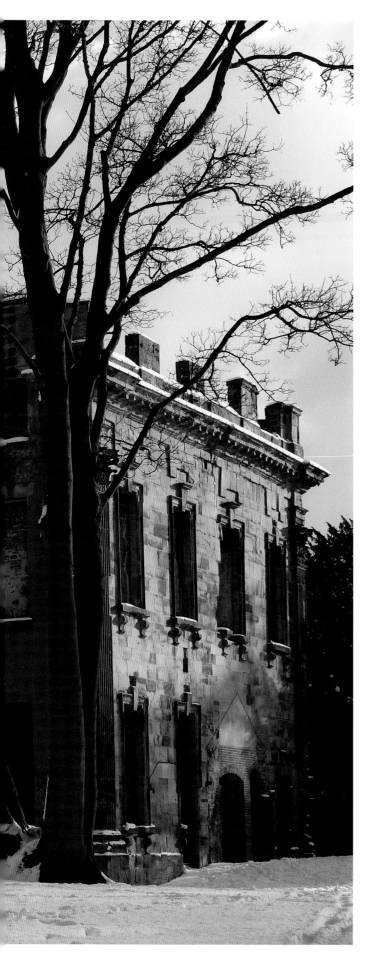

Although Sutton Scarsdale Hall is just a shell, the Italianate glories of the house continue to shine through.

SUTTON SCARSDALE HALL
Derbyshire

The roofless shell of Sutton Scarsdale Hall, visible from the nearby M1, is one of the most haunting monuments to the rise and fall of the English country house. Built in the 1720s by Francis Smith of Warwick around an older building, the house was the lavish project of Nicholas Leke, 4th Earl of Scarsdale. Leke died in 1736, and the house was eventually sold to pay his debts.

The first owner after Leke was an MP, Godfrey Clarke, who purchased the house around 1740. Towards the end of the eighteenth century it passed from the Clarke family, by marriage, to the Marquis of Ormonde, and was later bought by Richard Arkwright of Cromford Mill. Arkwright was the son of Sir Richard Arkwright, the famous inventor of the cotton-spinning frame; at his death in 1843, Arkwright junior was believed to be the richest commoner in England. The main Arkwright family seat was at Willersley Castle, to the south-west.

In its early eighteenth-century glory, Sutton Scarsdale Hall represented the tastes and desires of the generation of English aristocrats schooled on the Grand Tour, a circuit of Europe that focused on the great Classical monuments of Italy. The interiors of the house were once crowned by exuberant Baroque plasterwork by the stuccadore Francesco Vassalli, who also worked at Hagley Hall, Worcestershire, and Castle Howard, North Yorkshire.

The cause of the house's current state of ruin has nothing to do with war or sudden calamity. In 1919, with the surrounding area becoming increasingly industrialized, the house was sold to a group of businessmen, who proceeded to strip it of all valuable materials. Today, some of the panelled interiors can be seen in pristine condition in the Philadelphia Museum of Art. Another interior was reputedly acquired by newspaper magnate William Randolph Hearst, and later bought by a film company.

In 1946 the remains of the house were earmarked for demolition. Thankfully, they were saved from such a fate by the intervention of Derbyshire landowner and aesthete Sir Osbert Sitwell, who acquired the ruins and 2.5 hectares (6 acres) of land around them for £900.

In 1920 Sir Osbert's brother, Sacheverell, had planned to purchase one of four Venetian mantelpieces still in situ; by the time he had made arrangements for its removal, however, it had fallen to the ground and smashed to pieces. Sir Osbert's nephew, Sir Reresby Sitwell, gave the ruins to the state in 1970, and they are now maintained by English Heritage.

It is interesting to note that in 1946 James Lees-Milne, the first historic buildings secretary of the National Trust, assessed the Sutton Scarsdale ruins for the Trust and decided: 'Classic ruins in England [are] not as satisfactory architecturally as Gothic ruins. They lack picturesque gloom.' This judgement could so easily have consigned the structure to oblivion.

In 1972, in *Ruins: A Personal Anthology*, Michael Felmingham and Rigby Graham described the remains of the house as 'haunted … at night by the bursting flares and fires of industry, and by day by the sense of waste and tragedy implicit in the pattern of spoiled farmlands, broken trees, and small black houses.' There is still a stirring, quiet dignity to this astonishing wreck, the distant hum of the motorway probably the only thing stopping a moneyed dreamer from aspiring to re-roof it.

Right, from top
Every aspect of Sutton Scarsdale Hall suggests Italy: the giant Corinthian-order pilasters; the semi-circular pediments over the doors; the rhythm of the Classical detailing.

Opposite
The crispness of the house's surviving exterior detail contrasts with the Gothic detailing of the adjoining church of St Mary's, which dates from the thirteenth century but was rebuilt by the Leke family in the late fourteenth and early fifteenth centuries.

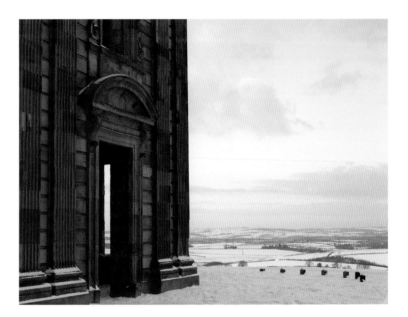

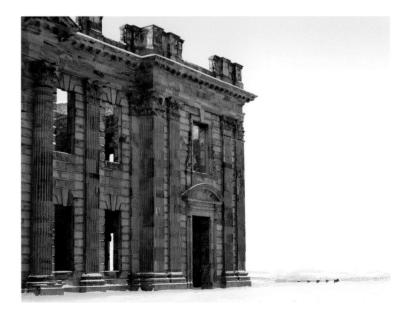

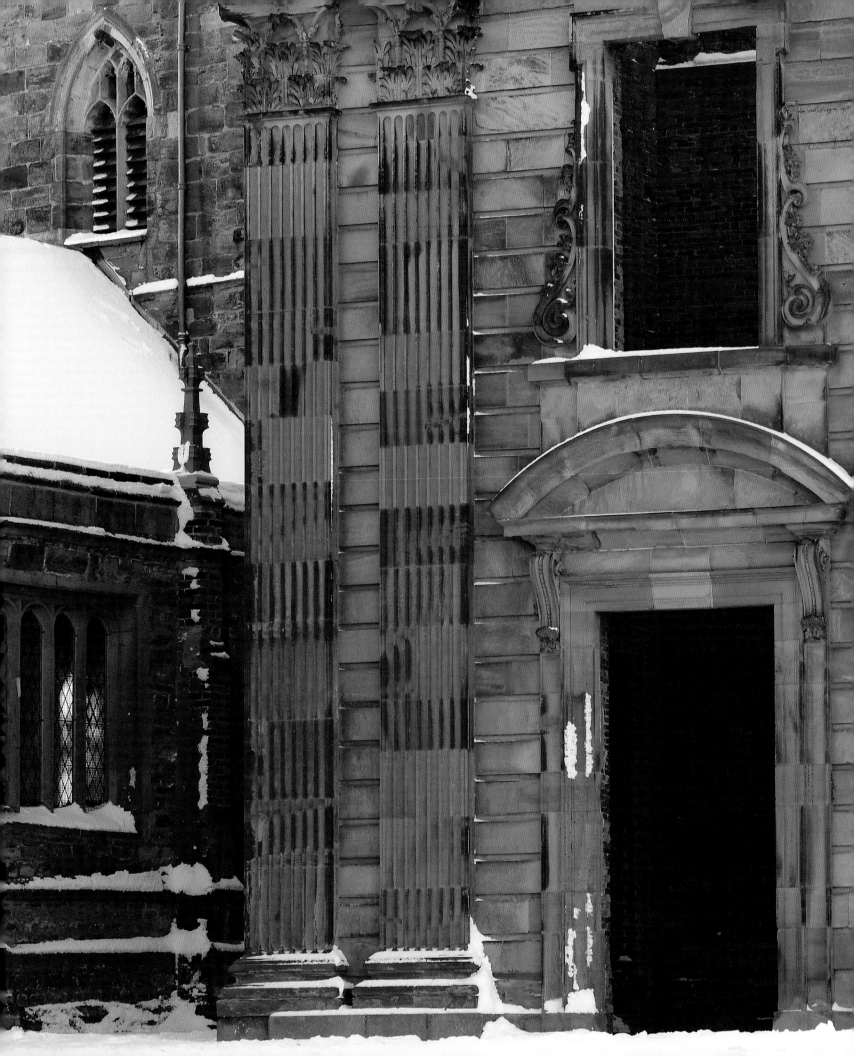

Laid bare: the rooms of the house were stripped of panelling and chimney pieces in the early twentieth century. Several of the interiors can be seen in the Philadelphia Museum of Art, where they provide a backdrop to the museum's collections of eighteenth-century English painting and furniture. The remains of a series of stucco overmantels, one featuring the figure of Aurora (opposite), the Roman goddess of the dawn, hint at the former richness of the rooms, now mostly bare brick and open to the skies.

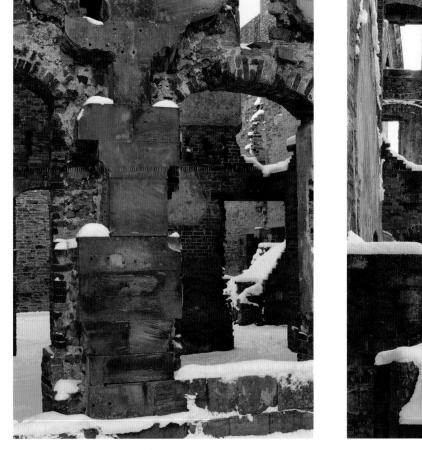

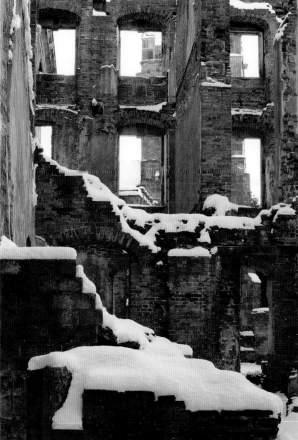

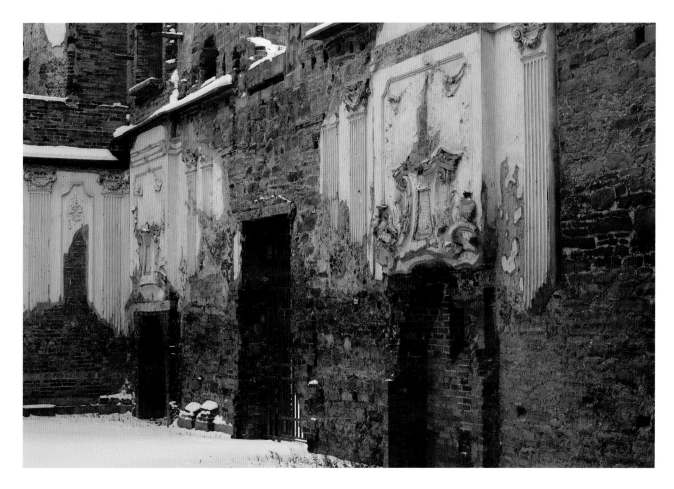

WITLEY COURT
Worcestershire

The porticoed and majestic ruins of Witley Court are among some of the most memorable sights in England. The house was the grand home of the Earls of Dudley, and represents the story of the buildings and estates into which the great industrialists of England poured their wealth. All too often the world of country houses is seen only as the story of landowning.

The core of Witley Court was in fact a Jacobean house built for the remarkable Foley family of Dudley, who made their fortune in the iron industry, first as nail makers and then as ironmasters; during the Civil War the family supplied cannon to Cromwell's navy. Classicized in the early eighteenth century by both the first and the second Lord Foley (each 'of the first creation', as it is described), the house became the seat of a large landed estate as, successively, the peers bought up adjacent manors. The first Lord Foley commissioned a fine parish church (attributed to the architect James Gibbs). Still in use today, the church is gloriously decorated with glass and paintings bought by the second Lord Foley from the chapel at Cannons, the now-demolished stately home built for the 1st Duke of Chandos, the contents of which were auctioned off to satisfy the duke's debts.

In the early nineteenth century the third Lord Foley (of the second creation) employed the architect John Nash to remodel Witley Court. Nash designed two great porticoes, one for the north side of the building and one for the south, transforming the presence of the hitherto relatively plain Classical house. He also added a new dining-room and library.

In 1836 the Foleys, by then running out of money, sold the estate to William Humble Ward, 11th Baron Ward of Birmingham, heir to the income of 200 mines in the Black Country (coal, iron, limestone and fireclay), as well as iron-smelting works, chemical factories and a railway-construction enterprise. Ward was made Earl of Dudley in 1860 (reviving a title that had belonged to the cousin from whom he had inherited his wealth), just as he completed a major renovation of Witley with the architect Samuel Dawkes. The work was in the Italianate style made popular by Queen Victoria and Prince Albert at Osborne House on the Isle of Wight,

with interiors in exuberant white and gold, a style inspired by that associated with Louis XIV and Louis XV. The gardens were designed by William Andrews Nesfield; the vast conservatory was entered through the Michelangelo Pavilion.

Ward died in 1885, and the house passed to his son, the 2nd Earl of Dudley. The new Lord Dudley, who had inherited his father's enormous wealth as well as the house, used Witley Court as the setting for a series of lavish house parties, many of which were attended by Edward, Prince of Wales (later Edward VII). The house became Lady Dudley's home on her separation from her husband, and in 1920, after her death, Lord Dudley sold Witley Court to a new owner, Sir Herbert 'Piggy' Smith, a talented carpet trader from Kidderminster. Smith installed electricity in the house, and reduced the number of domestic staff.

The devastating blow came in September 1937, when a fire tore through the house. The insurance would not cover a quarter of the cost of rebuilding, so the house was sold on, and the estate broken up. In 1954 an antiques dealer bought the ruins, stripping the house of its remaining lead, marble chimney pieces and garden statuary. It seemed likely that the whole house would be swept away.

But so impressive did the ruins still seem that, in 1964, a building preservation order was issued; six years later, the house and garden were scheduled as an ancient monument. The Department of the Enviroment took the ruins into its care in 1972, and the work of preserving them is now carried on by English Heritage.

When Christopher Hussey saw the ruins in 1945, he wrote in *Country Life* that 'The buildings and gardens of Witley Court are more pictorially romantic now than ever in their well-kept prime. ... Here in peaceful Worcestershire is a classic ruin to be enjoyed dry-eyed for its beauty alone, in which we can recapture something of the pleasing awe with which our forefathers discovered vestiges of the ancient world.'

Opposite
The ruins of Witley Court glimpsed through the restored Perseus and Andromeda fountain. The gilded dome in the background belongs to the parish church, which remains intact and in use.

Pages 132–33
The stately south-facing Ionic portico added by John Nash to an older structure. The house was burnt out in 1937, but neither restored nor demolished. It represents one of the greatest preserved country-house ruins in England.

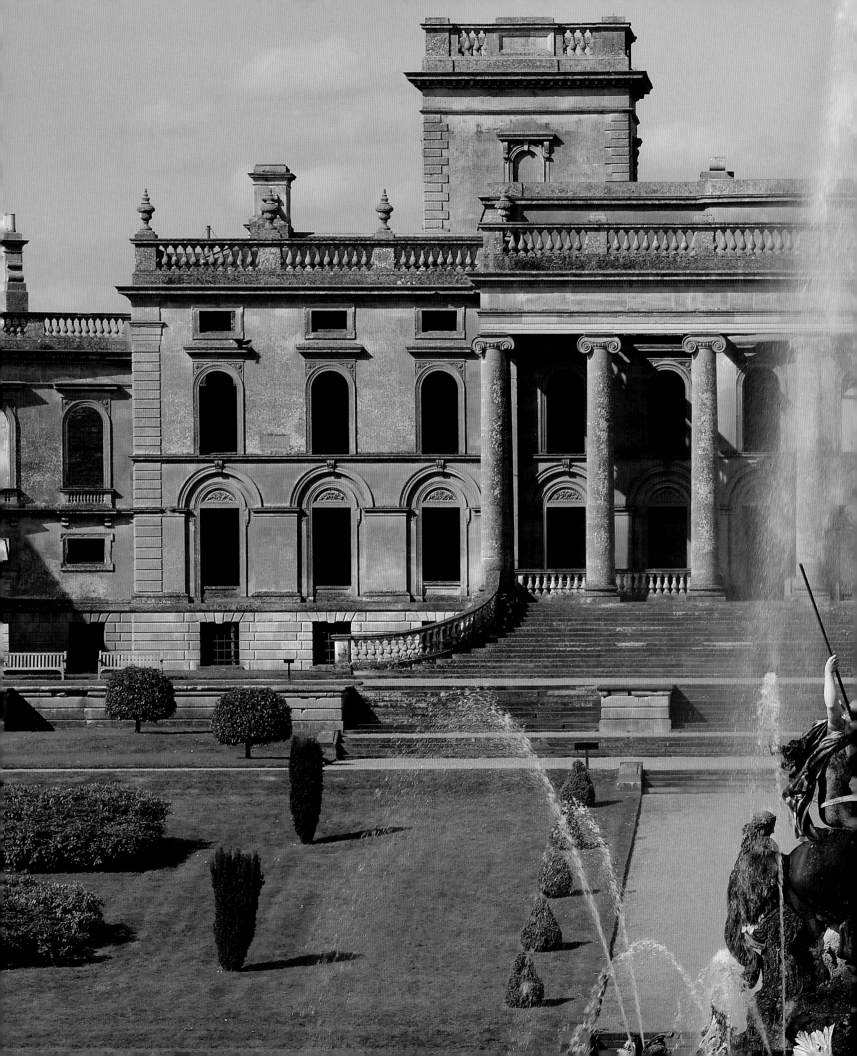

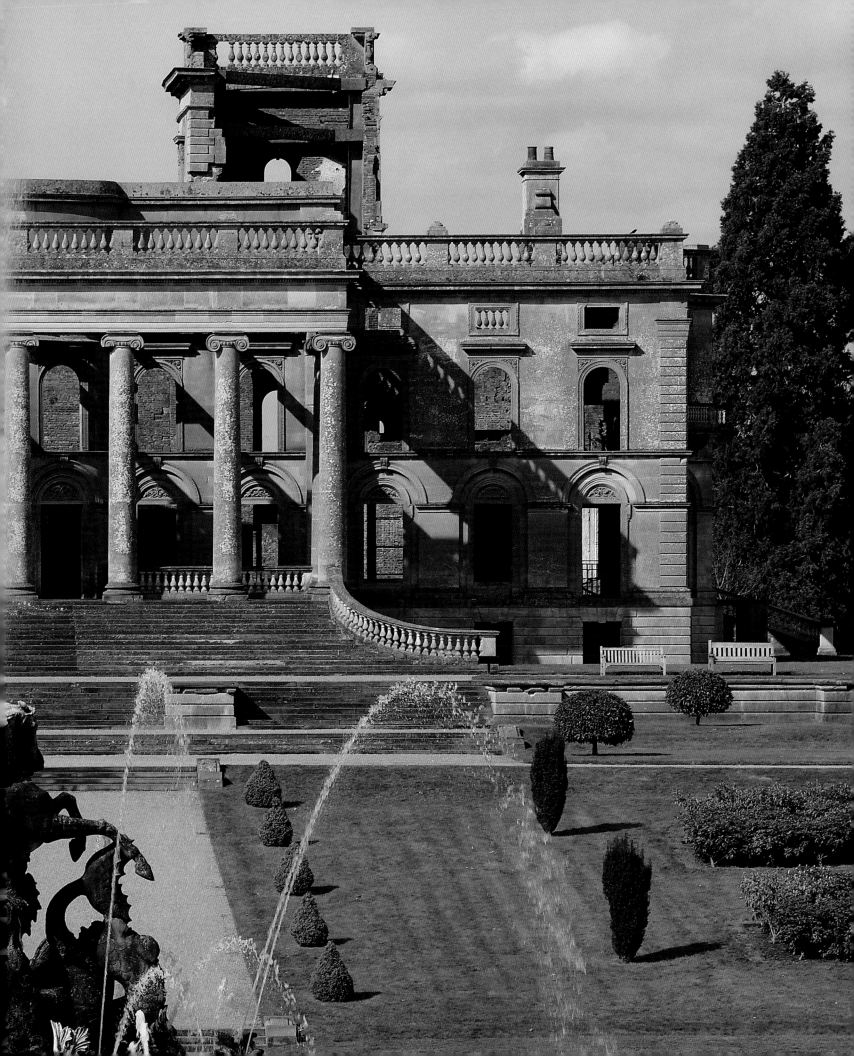

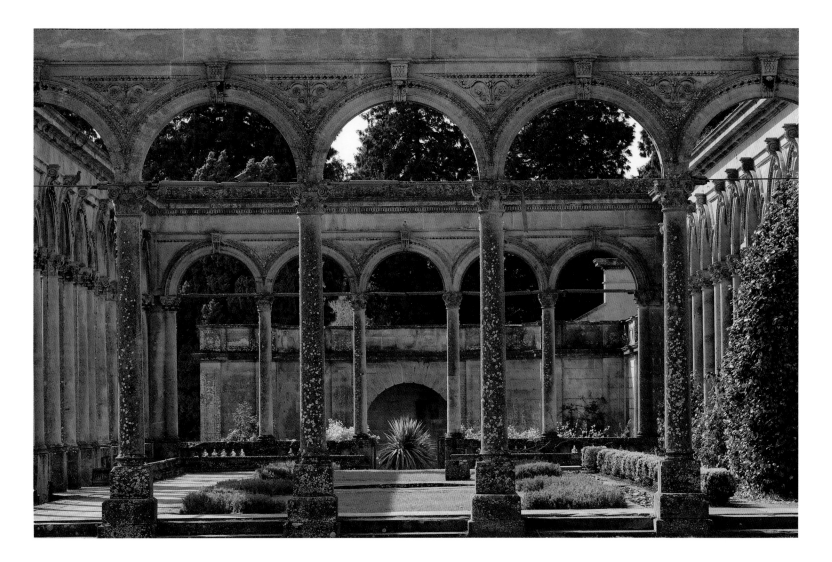

Above
The arcaded former orangery is reminiscent of a Renaissance Florentine cloister.

Right
The bare brick walls reveal the structure of the house, and provide a visual and textural contrast to the pale stonework.

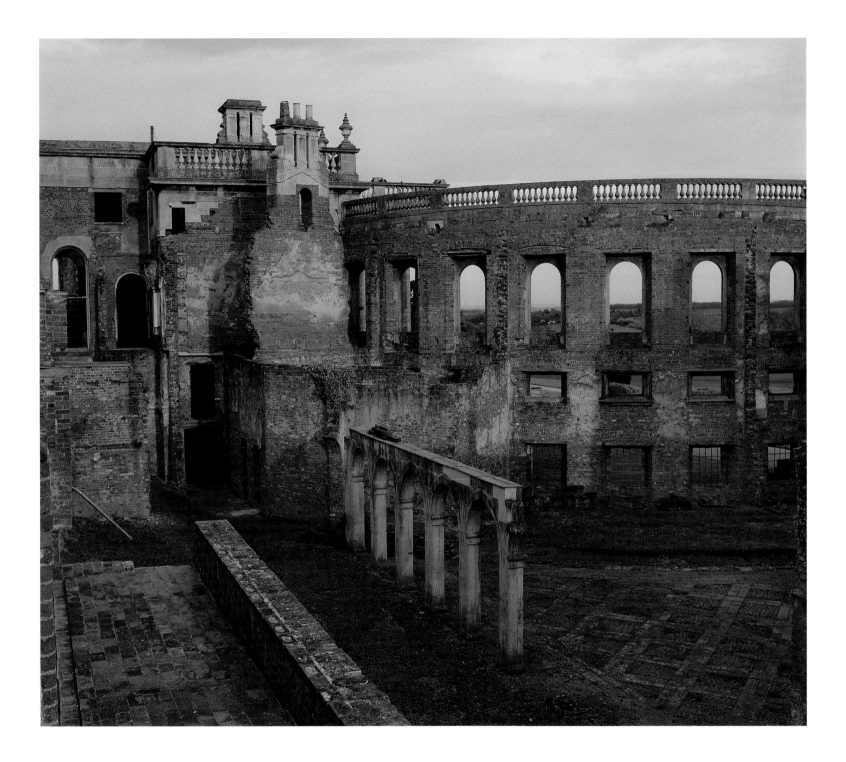

From certain angles
the scale of Witley
Court is as dramatic
and affecting as a
major Classical ruin
in Rome. Here, the
screen wall can be
seen across the former
service courtyards.

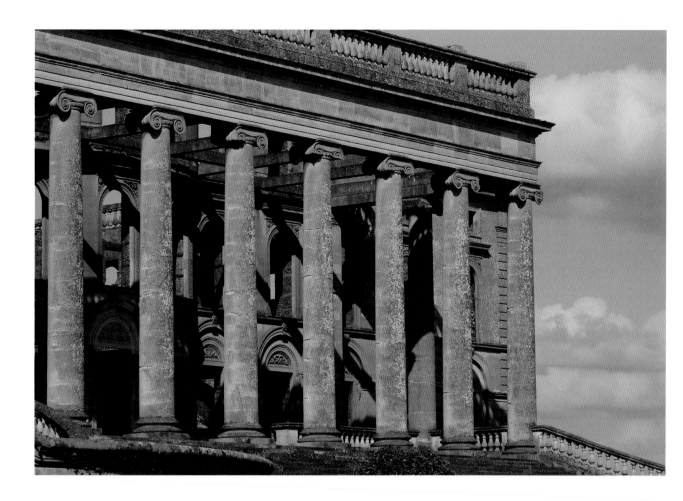

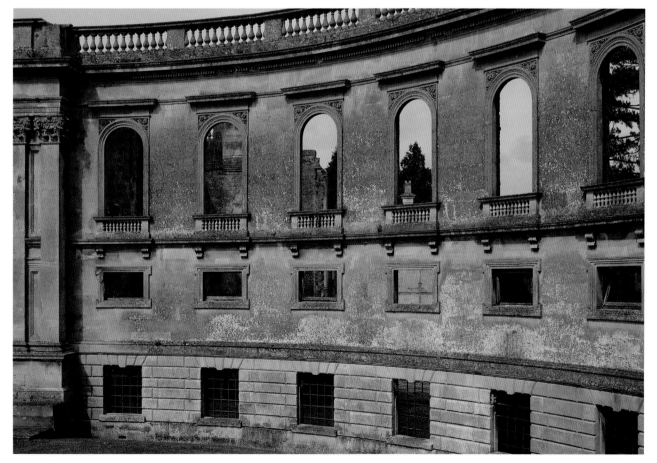

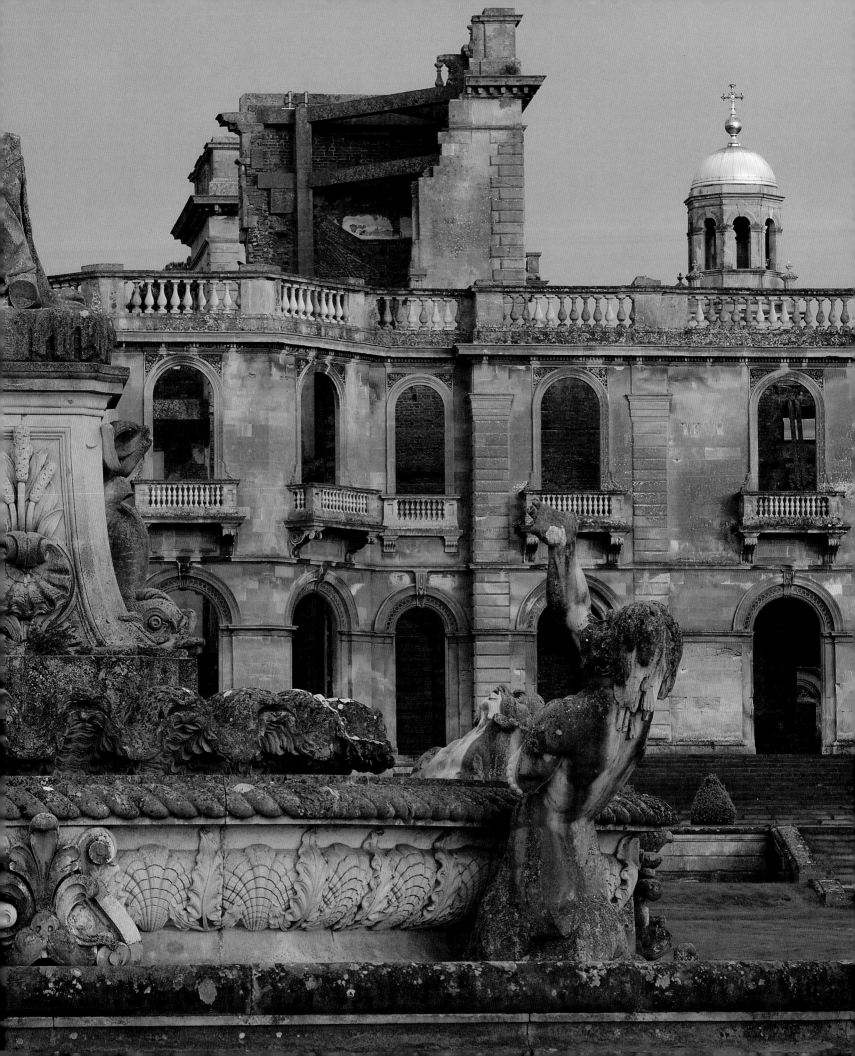

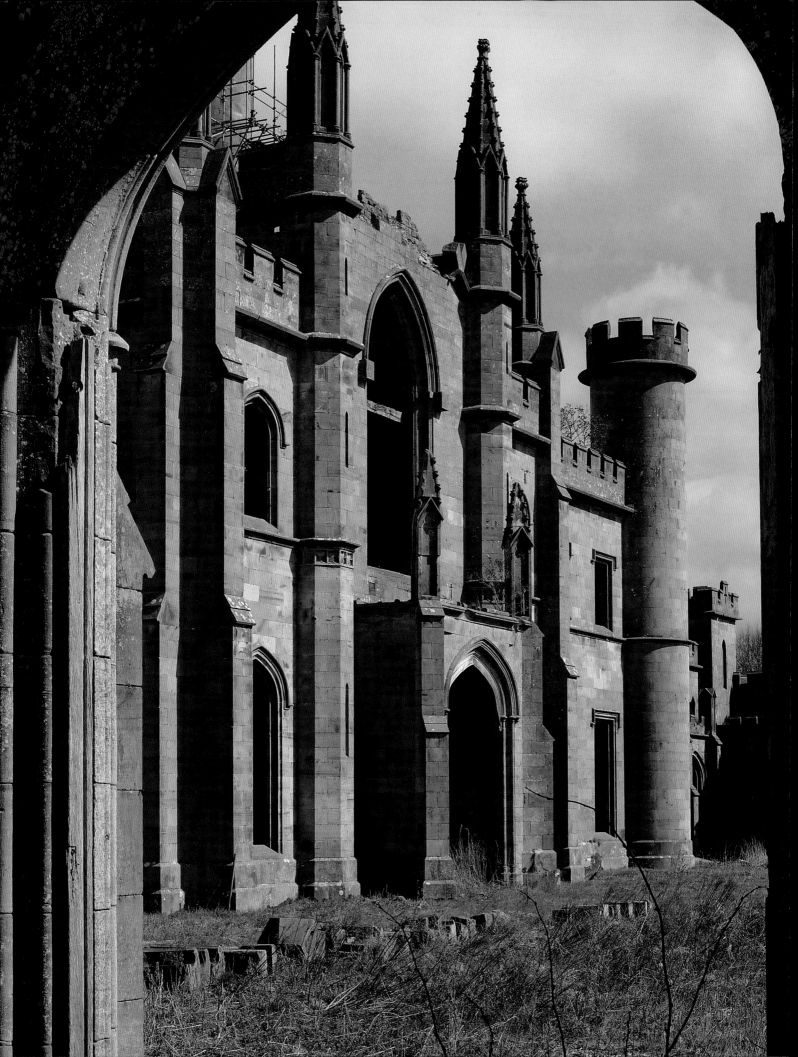

LOWTHER CASTLE
Cumbria

The dramatic Gothic Revival shell of Lowther Castle can be seen from nearby Penrith. If that were not the case, it is possible that the late James Lowther, the 7th Earl of Lonsdale, would have demolished the house entirely in the late 1950s.

Lord Lonsdale was an idealistic young man, descended from a family of landowners with a reputation for excessive grandeur. Returning home from the turmoil of the Second World War, in which he had served as an army officer, he was convinced that the old order must be changed. However, although he wanted to demolish the house, he appreciated that the people of Penrith were attached to their view of the romantic castle in the distance. He decided instead that the vast house – not properly occupied by his family since 1936, used by the military during the war, empty after a major sale of its contents in 1947 and riddled with dry rot – should not be reoccupied as a home. Thus, in 1957 he removed the roofs and floors, left the walls, carefully preserved the façades, and surrounded the house with dense ranks of chicken sheds, pig pens and forestry.

Lowther Castle was not an ancient medieval castle but a huge, early nineteenth-century mansion built to suggest the romance of an ancient family seat; it succeeded a Classical house of the 1690s, which itself had replaced a peel tower of the twelfth century. Lowther Castle, completed by 1811, was designed by Robert Smirke, at that time an assistant to George Dance the Younger. Smirke would later design the British Museum.

The Lowthers have lived in this area for a millennium, and trace their origins to a Viking called Dolfin. In 1283 they received a formal grant from Edward II, and in the family archives there is a royal pardon of 1314 to Hugh de Lowther, absolving him of 'homicide, felony, robbery, theft' as long as he supported the king in the impending wars with Scotland. Like so many of the great landed families, the Lowthers spent centuries extending the family home while planning even grander rebuildings, commissioning designs from a series of renowned architects, from the eighteenth-century neoclassicist Robert Adam to the youthful Smirke.

What is so noteworthy about the story of Lowther Castle is how much its unravelling tells us about the changing status of the country house at the end of the Second World War. In a way, the house is a monument to two conflicts: the war itself, which caused so much upheaval and destruction, to whole societies as well as to individuals; and the succeeding political battle in the mid-twentieth century to create a more equal society.

Today, with the ruin listed and protected, one of Lord Lonsdale's sons, Jim Lowther, who now runs the estate, has become convinced of the importance of the history of the site and the need to repair and use the colossal ruin in some constructive way. Lowther has already started to stabilize the ruins, and plans to convert the stable range and the former sculpture gallery, which still have roofs, into a visitor attraction. There, the public will be able to view paintings and furniture associated with the family and the house, while also being free to explore the ruins at its core; the atmospheric, overgrown Edwardian gardens; the wood; and the wider parkland. The site is scheduled to open to the public in April 2011.

Lowther is very enthusiastic about the potential for the project, and at the time of writing, the chicken sheds, which had covered the south lawns, had just been removed. 'My father knew I would have to do something about [the house],' he says, 'but was determined that it would be "after his time". I want to share the experience of this place with a wider public, but I also want to keep some of the wild Piranesian character of the ruin as it is.'

The architectural impact of Lowther Castle is undeniably romantic, as it was always intended to be. The remarkable outline of the house has largely been preserved intact, although, apart from the sculpture gallery and the stables, the building itself is only a shell. This once-great Gothic Revival house has now become, through its ruination and current revival, a truly Gothic folly to be enjoyed by visitors to the park and gardens.

Early nineteenth-century Lowther Castle was made yet more romantic and haunting when it was part-dismantled in 1957.

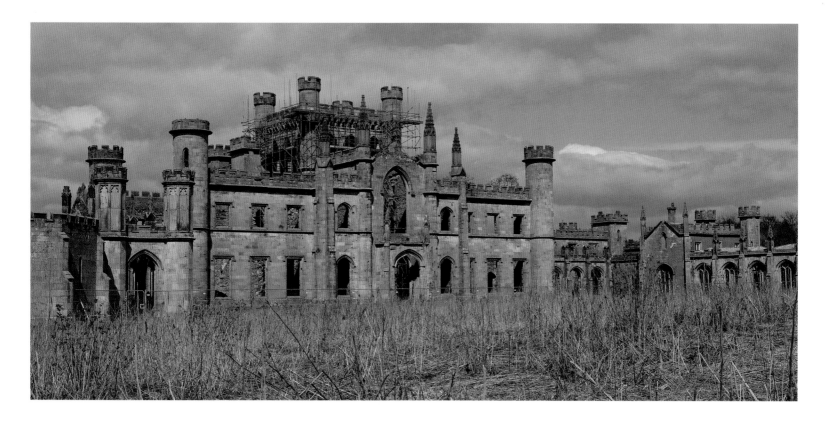

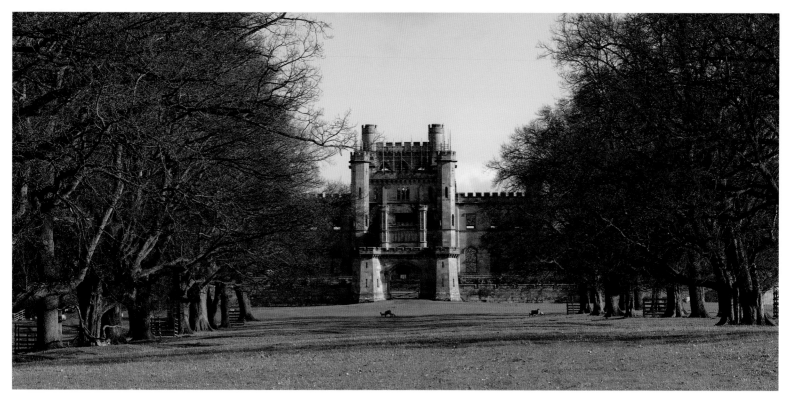

Top
The house's original Gothic Revival splendour relied partly on its symmetrical arrangement. The sculpture gallery can be seen to the right of the main complex.

Above
The gatehouse at the front of the building adds to the drama of the castle-like design. It is a bold architectural statement.

Opposite
The decorative Gothic vocabulary of the house's architect, Robert Smirke, was expressed in both square-headed and arched windows.

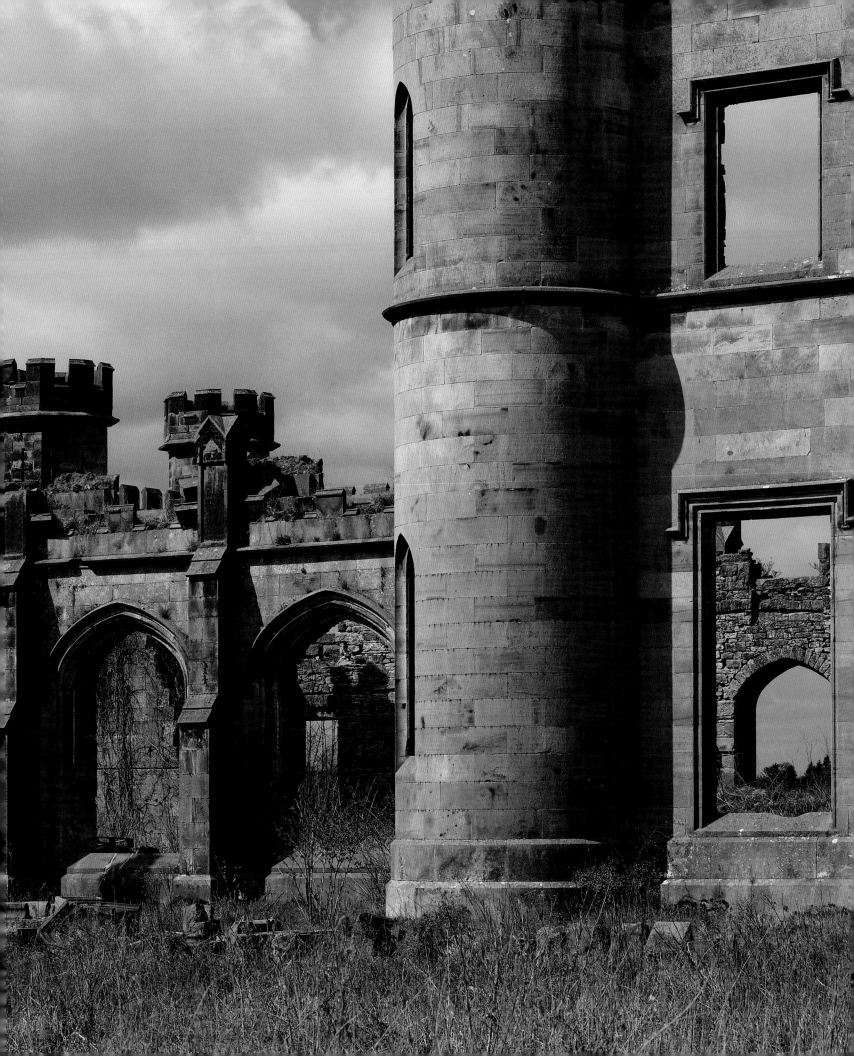

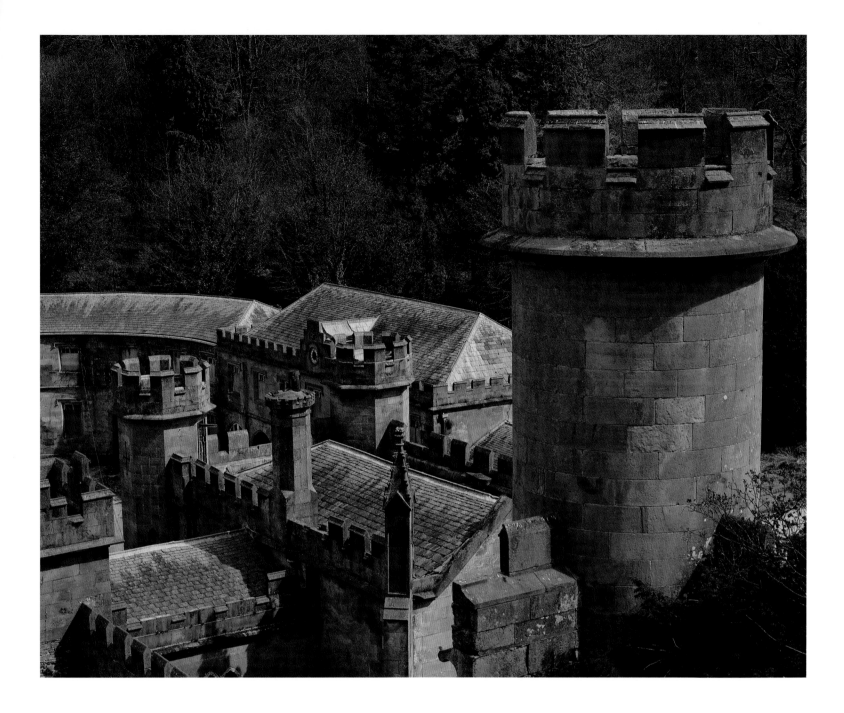

The view from the
central tower over the
stable range and across
the varied roofscape
of the service wing,
once home to armies
of servants.

Right
The cloister-like
sculpture gallery,
in which stood a
collection of Classical
sculptures.

Far right
The interior of the
stables. Together with
the sculpture gallery,
the stables will form
part of a new visitor
attraction.

Right, bottom
Ironically, the modest
service wing remains
more intact than the
main residence.

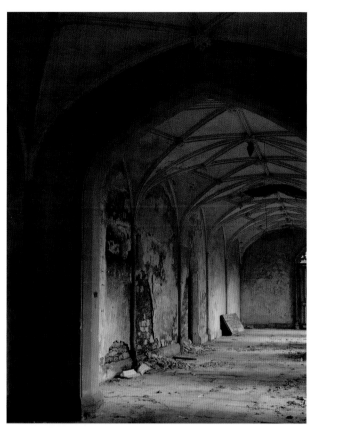

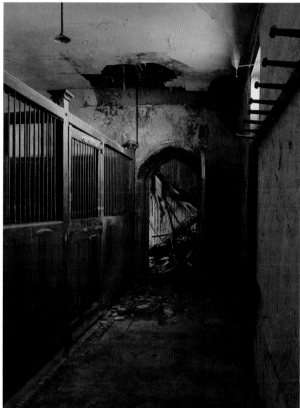

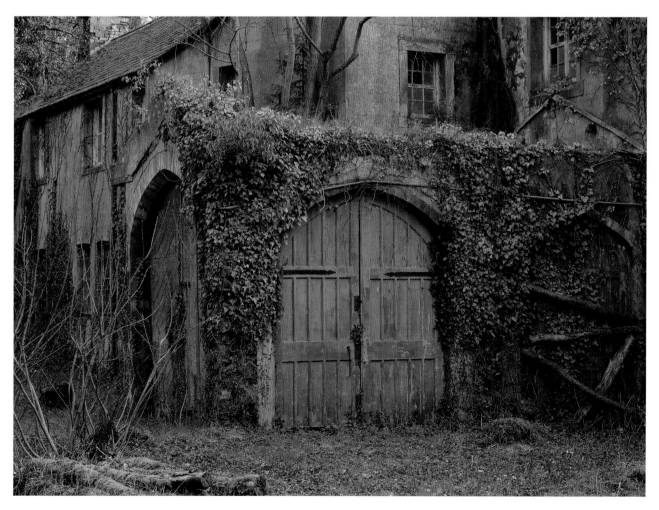

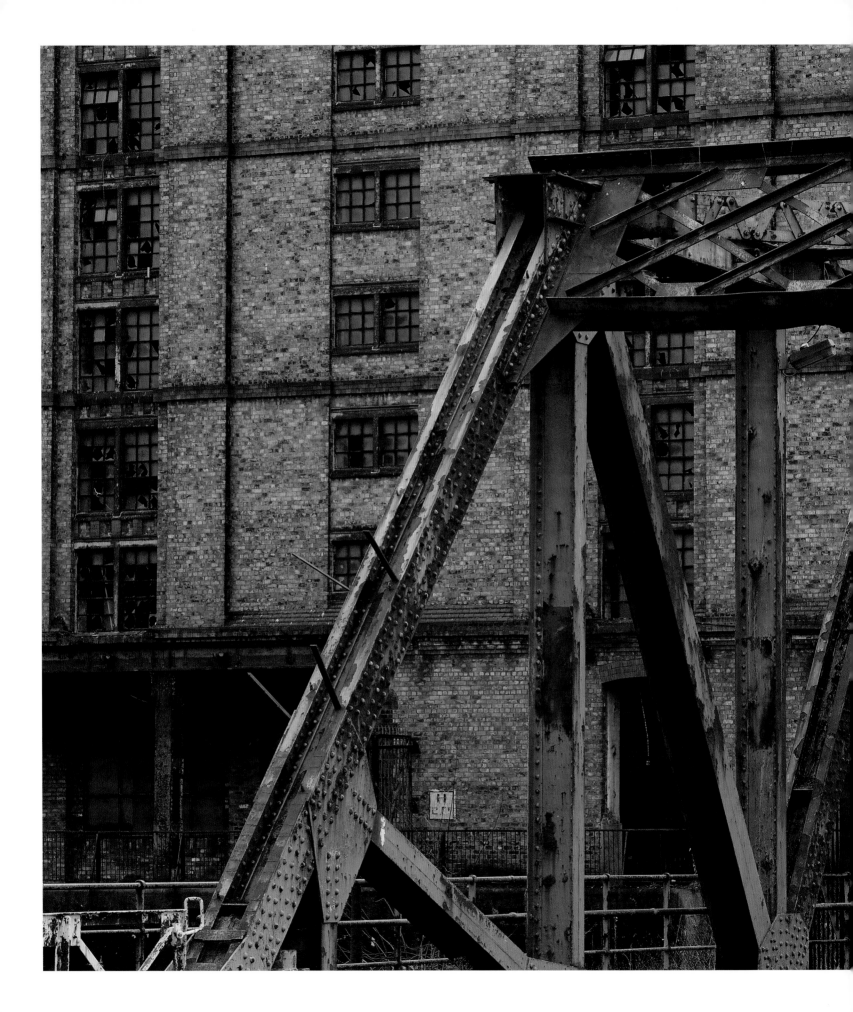

INDUSTRIAL RUINS

The Industrial Revolution defined the nature of many English towns and cities for a century or more, but from the middle of the twentieth century a series of major changes to the world of industry left much of the earlier built industrial infrastructure redundant. England (and the United Kingdom) was once characterized as the 'workshop of the world', and with the advantage of the capital and marketplace created by the British Empire, goods from English factories found a ready market around the world. From the 1840s to the 1870s the factories of England were part of one of the greatest industrial-boom economies in history.

By the late twentieth century, however, the well-established heavy manufacturing industries, in particular, had been largely replaced by new service and technological industries. Neither nationalization under Labour after the Second World War nor the free-market policies of the Thatcher years seem to have slowed the decline of industry within England's borders. Thus the country is left with the ruined shells of textile mills, engineering workshops, car factories, boatyards, vast warehouses and much else besides – constant and dramatic reminders of a sudden change in the national culture, as significant as the dissolution of the monasteries or the Blitz.

Such buildings are rarely isolated, either. From the late eighteenth century industrial buildings tended to be focused in specific areas, close to the appropriate means of transport – historically, first canals and harbours, and

Pages 144–45
The docks of English
trading ports reached
their prime in the
early twentieth
century, and then
fell into a decline.
In many cases their
warehouses have
been converted to
other uses, but some,
as here in Liverpool,
still stand empty
and decaying, visible
reminders of the
tides of economic
and industrial history.

then, from the 1840s, railways – and surrounded by the terraces and tenements in which their workers lived. Factories and warehouses are part of a deeply human story, one that links us all, either as makers or as consumers.

The decline of British industry is complicated. A changing world marketplace, centralization during the Second World War and, for certain industries, nationalization after the war, followed by waves of modernization and, ultimately, economic redundancy, have all contributed to the disuse of industrial buildings. Witness, for example, the sudden decline of the coal industry in the north of England in the 1970s and 1980s, or the dramatic collapse of shipbuilding from the 1970s onwards. The nature of the global market has taken so much manufacturing to other parts of the world.

The redundancy of many of England's industrial buildings is therefore surprisingly recent, but decay sets in quickly. And despite major redevelopments of such buildings in the past twenty years, often for housing or offices, the great industrial and trading bases of London, Liverpool, Manchester, Stockport, Blackburn, Birmingham, Stoke-on-Trent, Hull, Sheffield and Newcastle, to name but a few, still have a significant number of disused buildings belonging to what are sometimes called the 'smokestack industries', many of which date to the late nineteenth or early twentieth centuries, or even later.

In *Industrial Ruins: Space, Aesthetics and Materiality* (2005), Tim Edensor has written an eloquent and beguiling defence of the industrial ruin, dismayed by the conventional response that these are urban wastelands that should be swept away or redeveloped as soon as possible. He sees the ruins of industry as a by-product of the capitalist system, important reminders of the 'fluidity of the material world', and compares them to the industrial and commercial architecture of today ('retail sheds and assembly-kit industrial units'), which can be easily dismantled and removed.

For Edensor, industrial ruins often represent places of exciting allegorical significance, reflecting the nature of change in modern society; they also provide a contrast to the zoned, modern, planning-led cities of today, which favour a manicured version of town and landscape, even offering a place of refuge from such places. It is certainly true that the buildings that survive from England's industrial past represent the story of generations of human labour. They are also highly evocative spaces, suggestive of the rapid rotations of modern life, and much-loved by film-makers and artists for this very reason.

In an interview for this book, Marcus Binney, of Save Britain's Heritage, argued that the old factories and warehouses are

> absolutely key to the identity of a place and to the story of the people of
> that place. The industrial buildings are often very distinct types, creating
> a unique landscape; in Stoke-on-Trent, for instance, there were once
> 2000 bottle kilns, and now there are barely fifty, the others swept away.
>
> When we held an exhibition on industrial buildings under threat
> of demolition called *Satanic Mills* in 1979, the catalogue sold out in days.

There had been some who argued that there was no purpose in preserving buildings that had been part of what was now seen as an oppressive working life, but in the localities of these buildings themselves, local attitude was precisely the opposite; they wanted to see them saved as part of their own story.

When major urban sites find new uses, they often bring a great richness to the environment. The conversion of the Albert Dock in Liverpool is one of the pioneer redevelopments of a once-great industrial and commercial area.

The preservation of the well-constructed industrial building must be a cultural imperative in a country that derived so much of its wealth from the manufacturing industries. It is perhaps surprising that not more have been successfully converted into industrial museums, as in the case of Quarry Bank Mill in Cheshire; the various industrial sites along the Ironbridge Gorge in Shropshire; the Gladstone and Etruria mills in Stoke-on-Trent; and the Crossness Pumping Station in south-east London. Not all can be, of course, but surely nor can too many be demolished or left simply to decay. It is also surprising how few, with the exception of the stone-built Cornish tin mine engine houses, are regarded as acceptable 'preserved ruins' in the landscape.

Battersea Power Station in London: once a temple of power, now a roofless shell.

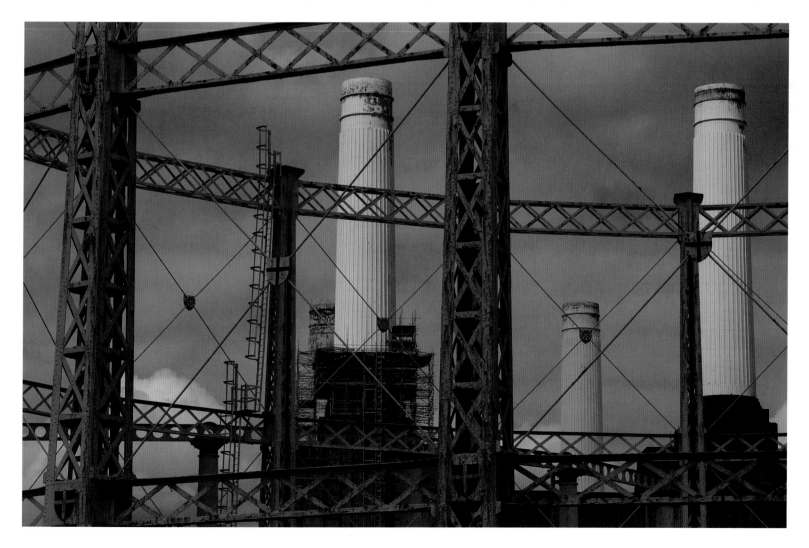

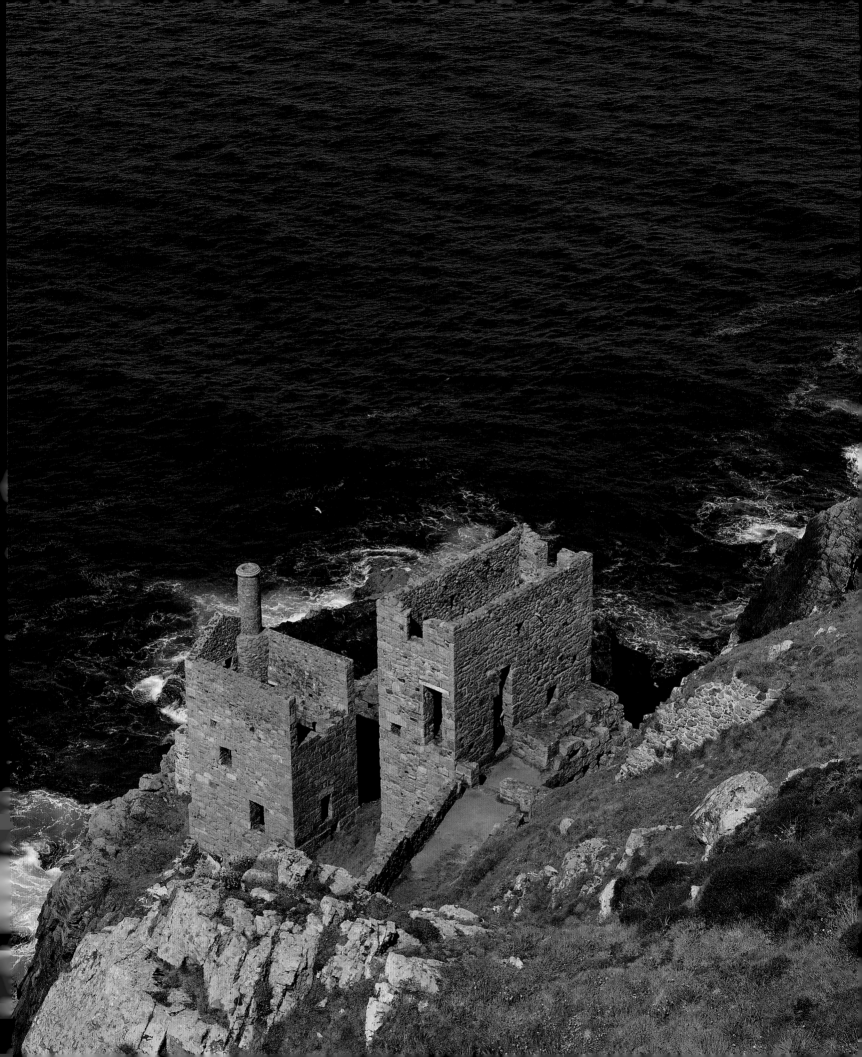

BOTALLACK MINE
Cornwall

It used to be said that if you visited any great mining operation around the world, you would find a Cornishman there, so great was the fame of the Cornish tin- and copper-mining industry. It is this same industry, practiced for centuries in the western reach of England, that has left the nation with some of its most enigmatic industrial ruins: the engine houses of the north Cornish coast. Among the most evocative are those of Botallack and Levant, perched on the extremely dark and brooding cliffs around St Just – part of a series of roofless, grey buildings that stretch out along the coast here.

Seeing the granite hulks of the engine houses silhouetted against the sky, rock and sea, with the crash of the waves and the roar of the wind all around, one can easily imagine the intensity and danger of the industry in full flow. Although mines were being worked here in the eighteenth century, the engine houses and their adjoining shafts that we can see today were built in the early nineteenth century, at the height of the industry. At that time there were some 600 engine houses at work in Cornwall, and thousands of men, women and children employed in hard, physical labour.

At first glance, we might take these roofless but solid-walled buildings, with their essentially Classical proportions, to be ancient churches or castles. But the tall chimney stacks perhaps betray their origins and tell of the curiously desolate flavour of the area, part wasteland, part nature reserve (in the spring the ground is covered with thrift and campion).

The engine houses once accommodated the steam engines with which the mines were worked. Pumping engines kept the mines drained, while 'whim' engines were used to haul ore and waste rock out of the mine. The rugged cliffs here, made up of dark slate and volcanic rock, contain near-vertical 'lodes' of tin and copper ore (cassiterite and chalcocite, for tin and copper respectively, as well as chalcopyrite and bornite, both copper ores).

The thought of building the seemingly perilously perched engine houses at Botallack is extraordinary. But while the logistics of scaffolding and transporting materials of immense weight are one thing, the realization that the mining operation descended to a depth of 600 metres (2000 feet) below the seabed, and then worked its way out under the sea for up to 2.5 kilometres (1½ miles), is quite another. Teams of miners would hand-drill shot holes for blasting with gunpowder, and then work the narrow 'stopes' with hammer and 'picker'. The last tin mine to close on this coast – at Geevor, in 1991 – is now open to the public, while the restored steam engine at Levant Mine is worked at certain times of the year.

As you take the steep path down towards the Crowns engine houses at Botallack, it is difficult not to be moved by the natural drama of the setting and the human drama of industry in such an inhospitable location. The vertiginous quality of the site and the sounds of the sea and wind give a feeling almost of terror; there is something of the sublime here, too. It is hard not to think that the generations who worked these mines deserve to be recalled and remembered.

The curiously stately Count House, where the workers were paid monthly, was also the place where the shareholders came to dine. Today this is in spruce repair, while all around it many of the other structures are in an admittedly attractive state of ruin. The fact that anything remains at all is a result of practical construction. The engine houses, for example, had to weigh more than the loads imposed by pumping. They also had to be strong enough to absorb the vibration of the working engines.

The practice of tin mining at Botallack, mentioned in the seventeenth century by English topographer John Norden, is thought to date back to at least Roman times. Scientists at the University of Oxford have gone one step further, arguing that bronze in ancient Greece may have been formed using copper imported from Cornwall.

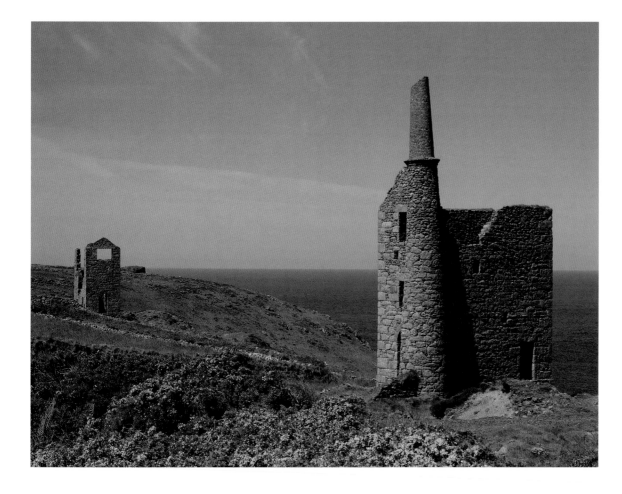

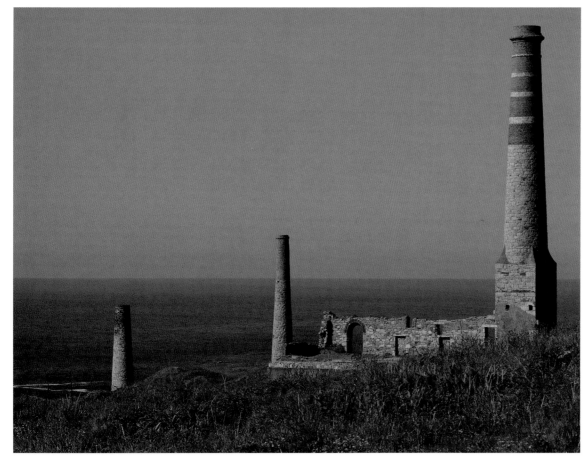

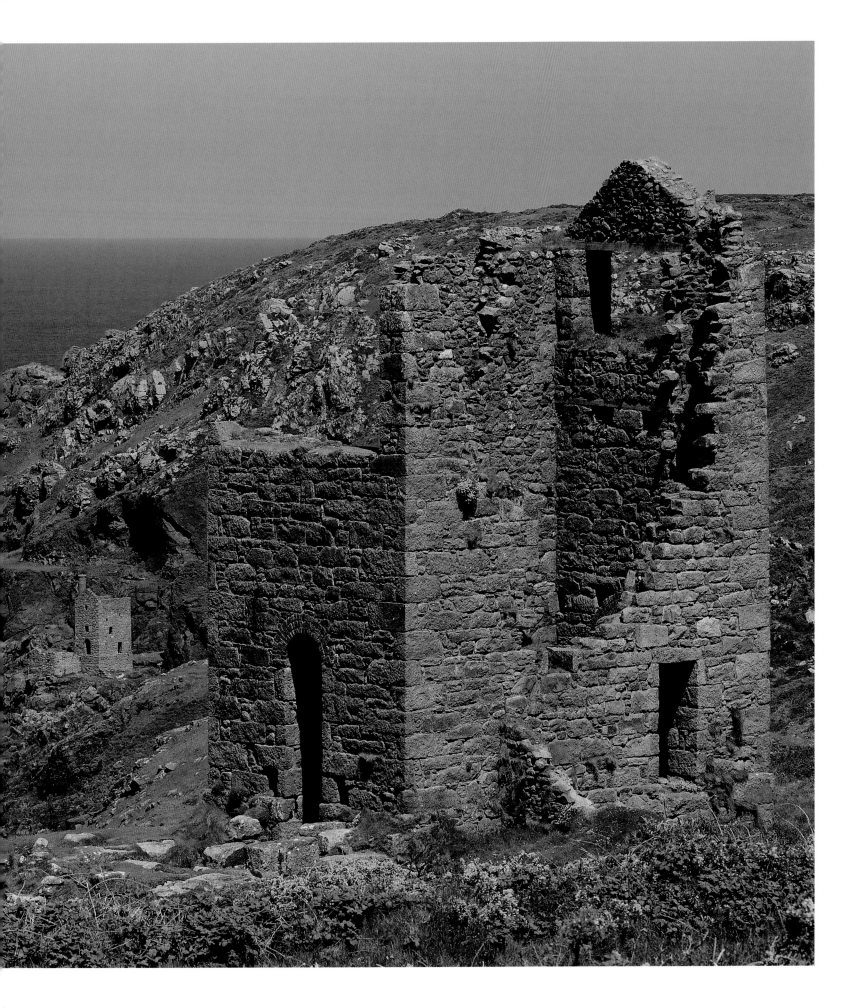

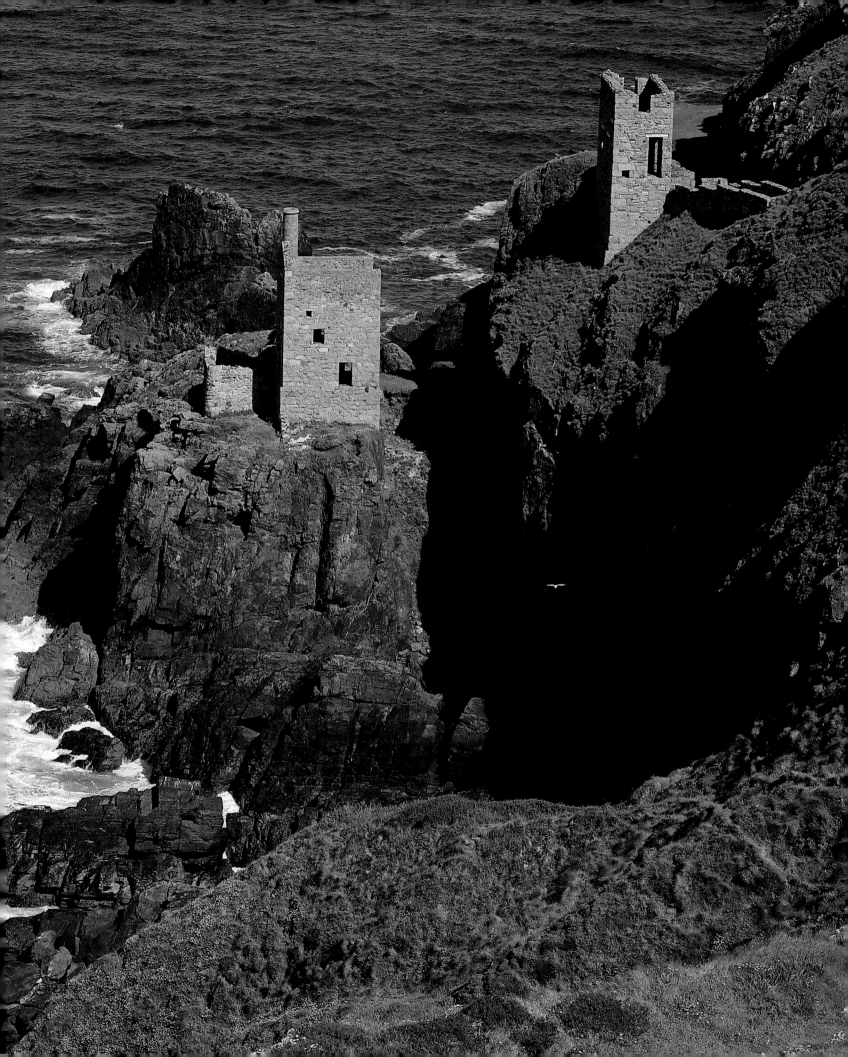

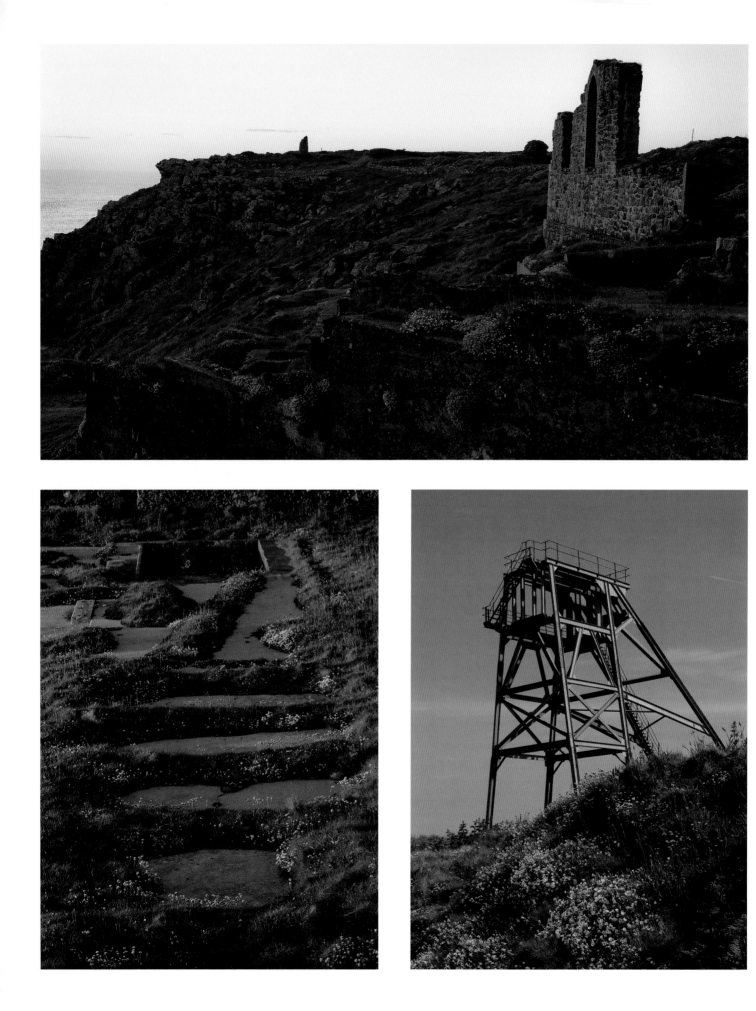

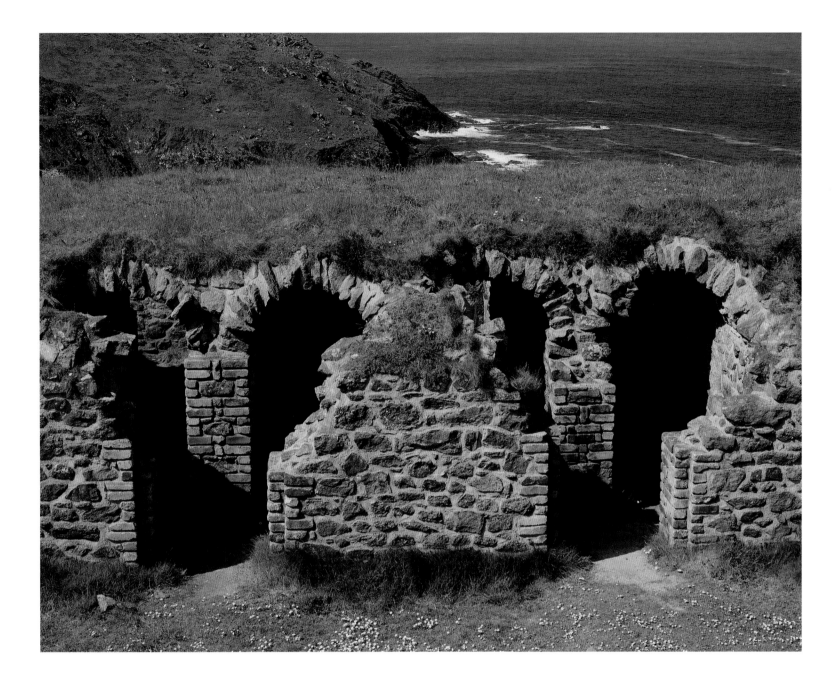

Opposite
Remnants of
different waves of
industrial work at
Botallack, including
(bottom right) the
steel headframe at
Allen's Shaft, which
survives from a
period when tin
mining was briefly
revived in the 1980s.

Above
The remains of the
calciners, used to
convert arsenic, a
by-product of tin
smelting, into a
saleable product.

TEMPLE WORKS
West Yorkshire

In terms of architecture, Temple Works in Holbeck, Leeds – also known as Temple Mill – is surely one of the very finest monuments to the industrial age. Built between 1838 and 1840, originally as a flax mill, it was sited close to water both to provide a source of energy for the steam-powered engines and to enable access by boat. It was designed by local engineer James Combe and artist and Egyptologist Joseph Bonomi the Younger, and was deliberately modelled by the latter on Egyptian temples; the building that housed the mill offices (constructed 1840–43) was based on the Temple of Horus at Edfu and the now-destroyed Temple of Antaeopolis. Bonomi, the son and brother of famous architects, had travelled to Egypt in the 1820s and drawn many of the great temples from life.

The main part of Temple Works is a massive factory building of extraordinary dramatic presence, inspired by the Typhonium at Dendera, near Luxor. Behind the great dark-stone façade, and beneath what was once a sheep-grazed grass roof (which helped to maintain the relative humidity needed to work the flax), is one vast space; at just under 1 hectare (2 acres) in extent, it is believed to have been the largest single room in England when built. Uniquely, this space meant that preparation spinning, thread twisting and cloth weaving could all take place on a single floor. Sixty-five glazed domes in the roof allowed daylight in, while the iron columns that appeared to support the ceiling were in fact a way of draining rainwater from the roof. A basement contained power-transmission and ventilation systems. Few buildings express so vividly the pride and invention of the Industrial Revolution in England in the mid-nineteenth century. In many ways, its industrial and commercial vigour reflected the might of the principal empire of the modern world.

The man behind the construction of Temple Works was one John Marshall, the son of a linen draper, who went on to revolutionize the manufacture of linen. Marshall was also considered to be one of the most liberal industrialists of his age. Many women and children worked in his mill, but overseers were not permitted to use corporal punishment, as was then

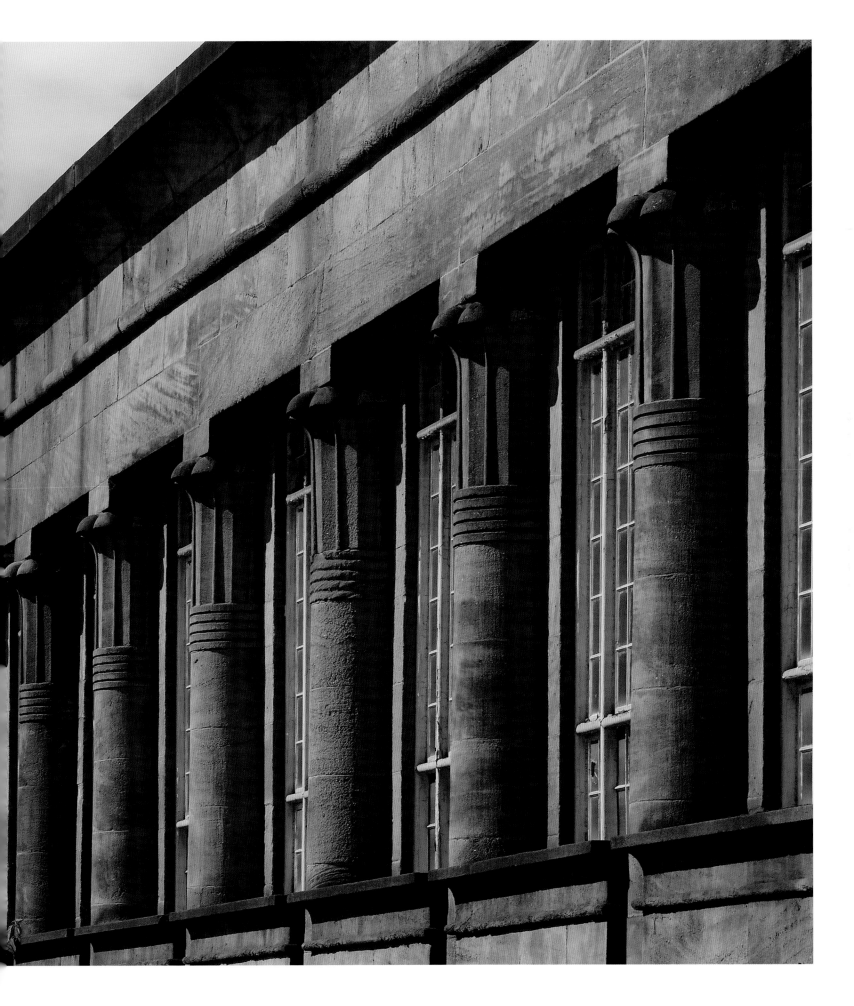

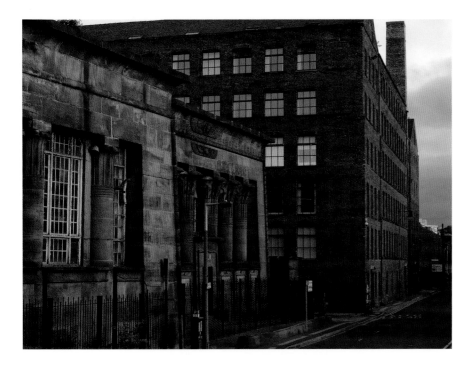

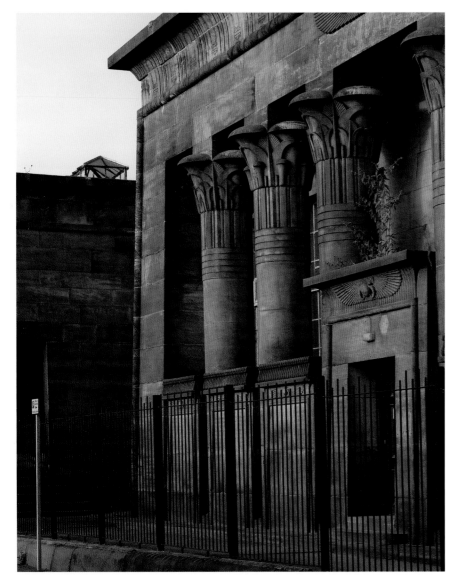

common, and the children were given free lessons on Monday afternoons. There were also baths for the millworkers to use. Marshall, MP for Yorkshire between 1826 and 1830 and founder of the Leeds Mechanics' Institute, left a fortune of around £2 million at his death in 1845.

Marshall's factory was probably the model for one erected by a philanthropic industrialist in Benjamin Disraeli's novel *Sybil* (1845): 'On the banks of his native Mowe he had built a factory which was one of the marvels of the district; one might almost say of the country: a single room, spreading over nearly two acres, and holding more than two thousand work-people.' The narrator goes on to describe the air-conditioning, the drainage system and the housing provided for the millworkers.

Temple Works' recent history has been all too uncertain. Since it closed as a parcel-distribution centre, it has stood empty and decaying. There are proposals for a major redevelopment, including an arts centre, shops and flats, but at the time of writing they were as yet unrealized. Meanwhile, the main building is deteriorating, and part of the great façade is now swathed in scaffolding.

Left, top
The Temple Works mill offices stand close to an earlier factory building.

Left
The columns of the mill offices combine a feeling of power with architectural details sourced from ancient Egyptian temples.

Opposite
The details, columns and capitals of the mill offices were modelled on ancient Egyptian examples observed by the offices' designer, Joseph Bonomi the Younger, who had travelled widely in Egypt. The capitals were designed to resemble the bud of the papyrus flower, while the decorative panels recall the winged scarab beetle.

Pages 156–57
The powerful façade of the main factory building at Temple Works, inspired by the Typhonium at Dendera, near Luxor, was designed to evoke the might of ancient Egypt. This elevation was photographed before the collapse of some of the columns in December 2008.

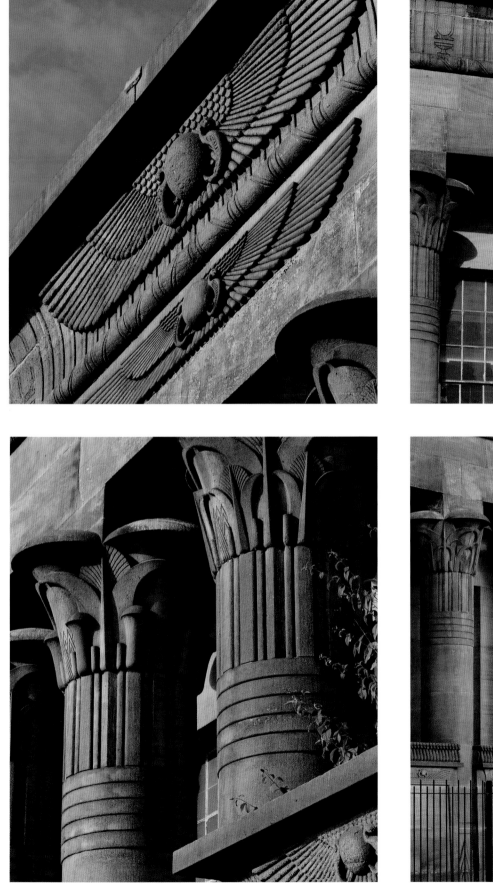

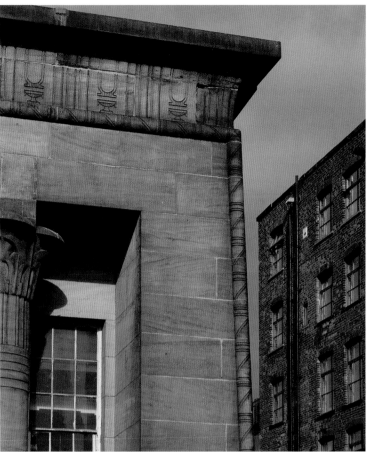

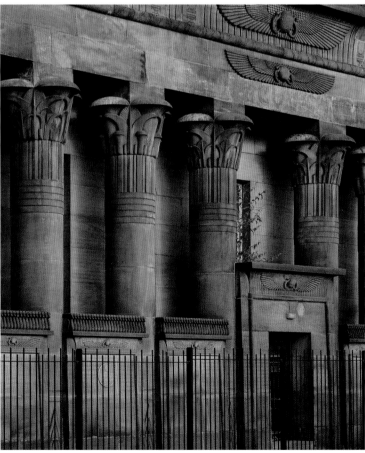

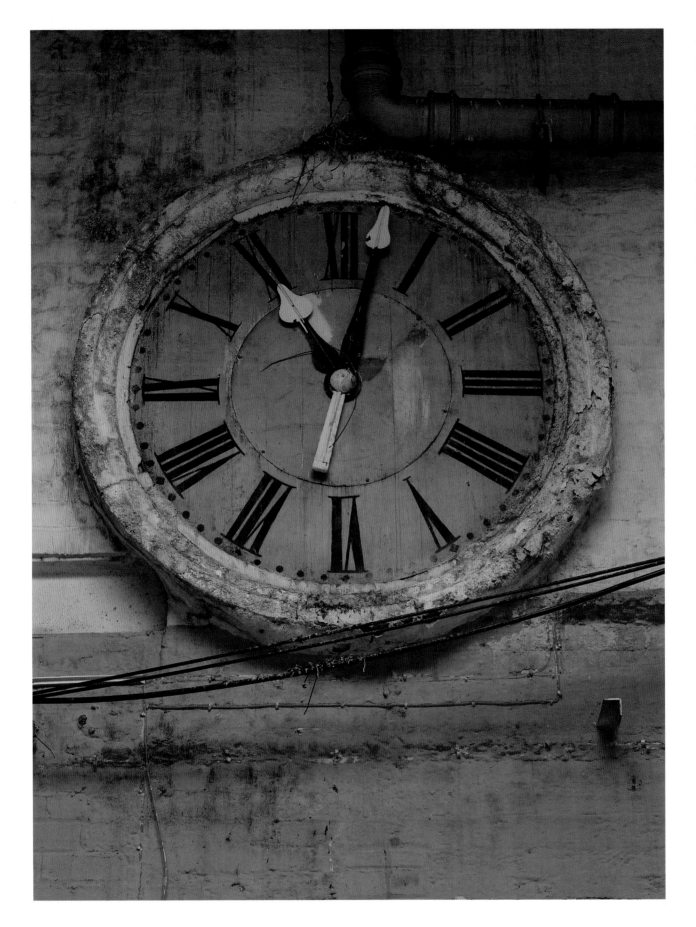

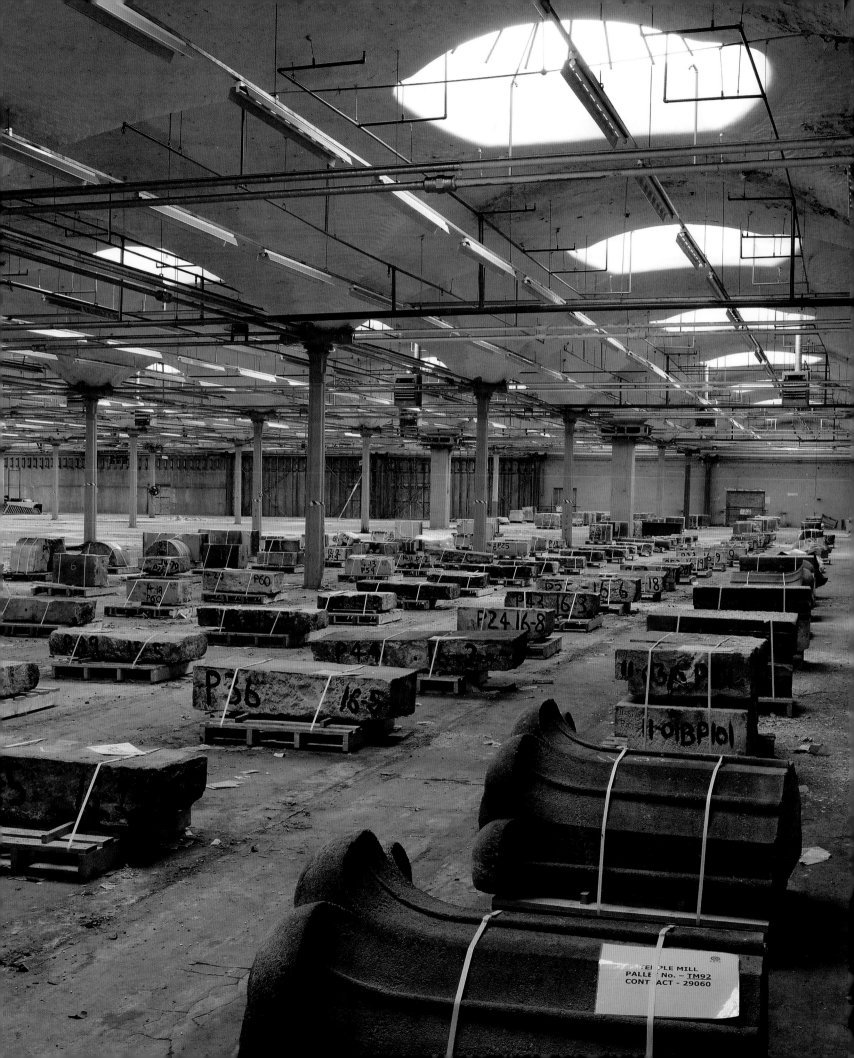

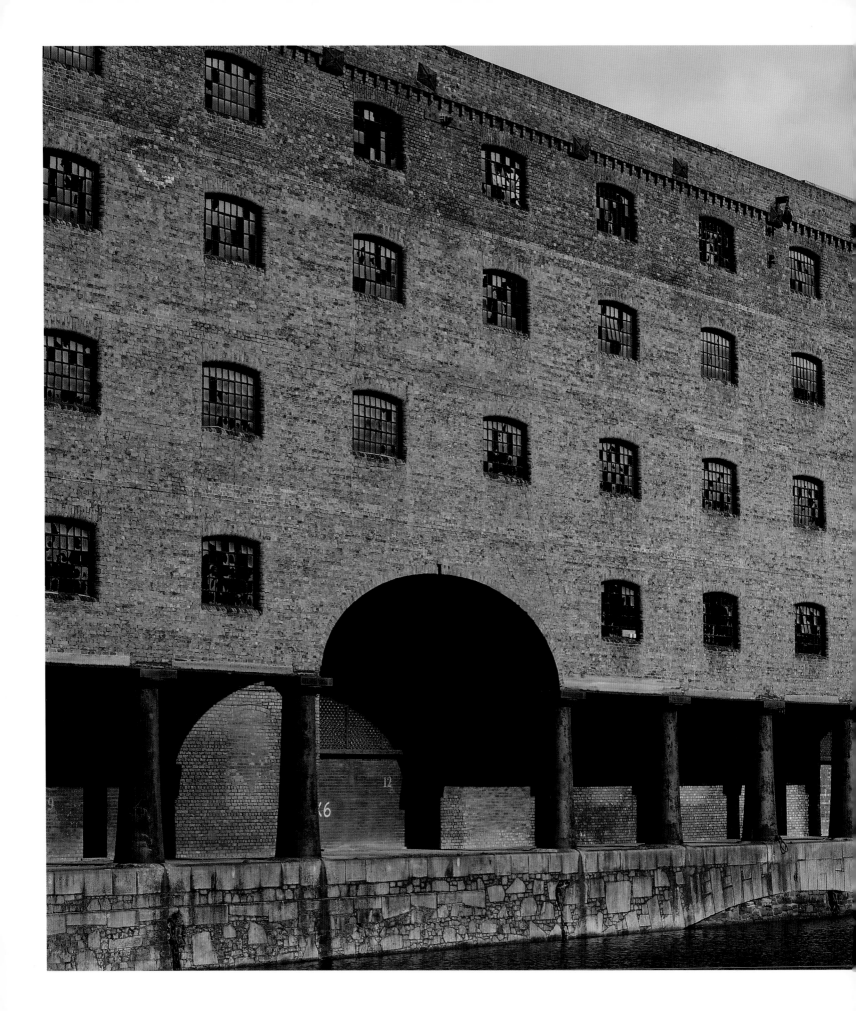

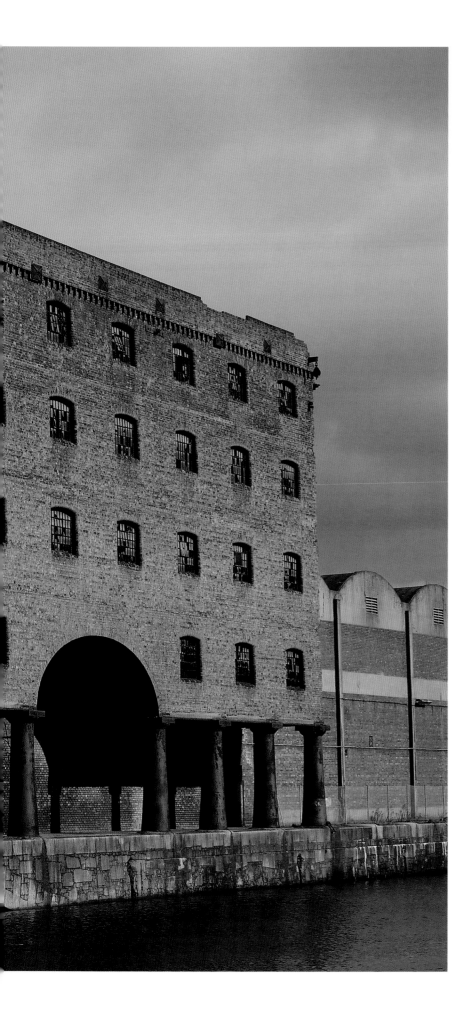

WAREHOUSES
Stanley Dock, Liverpool

Liverpool was once a major centre of shipping and trade, and the warehouses required for this trade were some of the largest ever built. The huge neoclassical ranges of Stanley Dock, constructed in the 1850s, are dwarfed by the Tobacco Warehouse of 1901, one of the biggest brick buildings in the world in terms of area when it was built. It was designed by Anthony George Lyster, the dock's engineer, and featured 'Free Renaissance' brick detailing by John Arthur Berrington, an architectural draughtsman in Lyster's office.

This gargantuan warehouse is perhaps not a ruin in the conventional sense – it is neither roofless nor in a tumbledown state – but it is a ruin in the sense that it can no longer serve the purpose for which it was built. Indeed, it is but one of many such warehouses that belong to another era, a time when intense commerce helped to define this great city. All the Stanley Dock warehouses were directly connected to the Leeds and Liverpool Canal.

Proposals for the redevelopment of Stanley Dock are now being explored, while many of the warehouses of the former Liverpool docklands have already been converted to other uses. Albert Dock, for instance, designed and built in the 1840s, now includes hotels and such art galleries and museums as Tate Liverpool and the Mersey Maritime Museum.

The scale of the Stanley Dock Tobacco Warehouse is difficult to comprehend. It is fourteen storeys high, and features forty-two bays divided by seven loading bays; its construction took 27 million bricks, 30,000 planes of glass and 81.3 million kilograms (80,000 tons) of steel. It was large enough to accommodate 70,000 hogsheads of tobacco, each of which weighed 450 kilograms (1000 pounds).

In the 1980s, with trade into and out of Liverpool a thing of the past, the Tobacco Warehouse, like so many other vast warehouses in the Liverpool docks, was closed down. The ground floor is now the location of a popular Sunday market, but much of Stanley Dock stands empty.

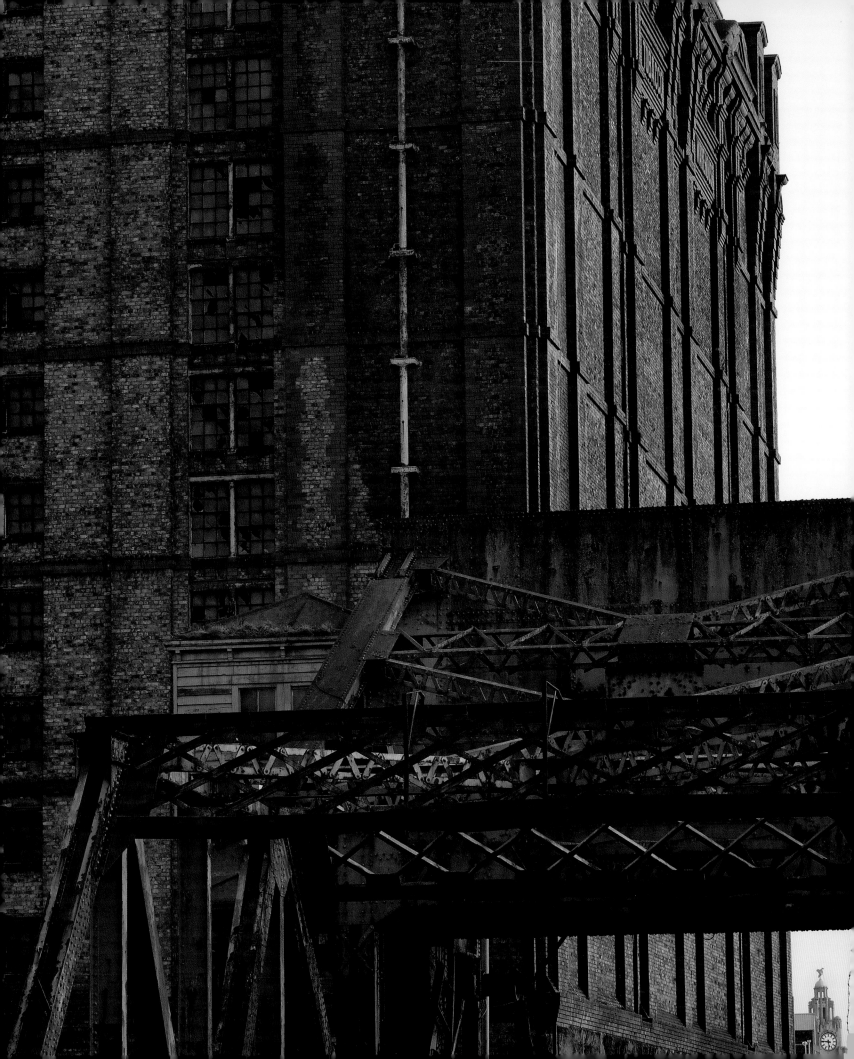

Pages 162–63
Neoclassical grandeur: built in the 1850s, this warehouse stands on the north side of Stanley Dock. Such huge commercial structures illustrate Liverpool's extraordinary history as a port: it has been estimated that in the early nineteenth century, some 40 per cent of the world's trade passed through the city.

Opposite
The towering mass of the Stanley Dock Tobacco Warehouse. At the time of its completion in 1901, it was said to be one of the largest brick buildings ever constructed.

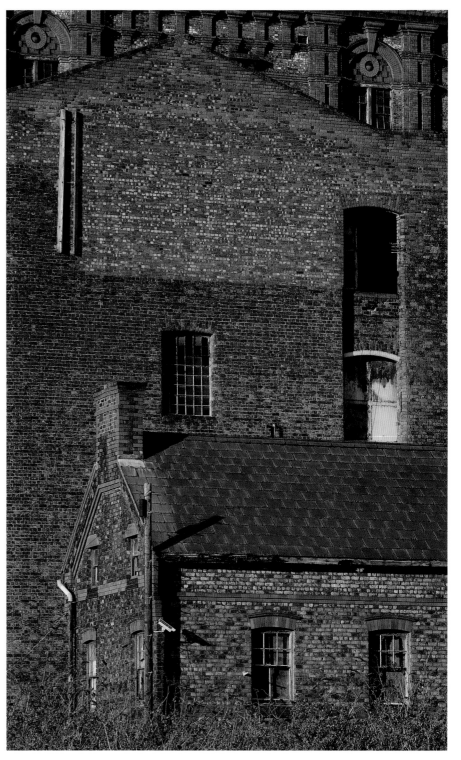

Left and above
Windows, cabins and walkways suggest the intensity of the working lives of Liverpool dockworkers in the nineteenth and early twentieth centuries.

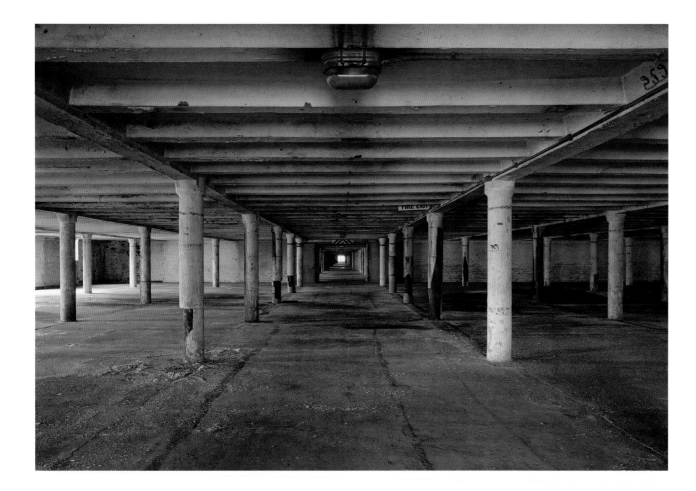

Left
The vast storage
areas of the Tobacco
Warehouse (top) are
contrasted with the
curious intimacy
of the circulation
spaces (bottom, left
and right).

Opposite
The cast-iron Doric
colonnade of the
warehouse on the
north side of Stanley
Dock, remarkable
for its atmosphere
and patina.

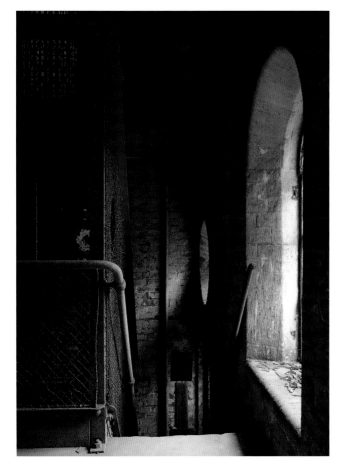

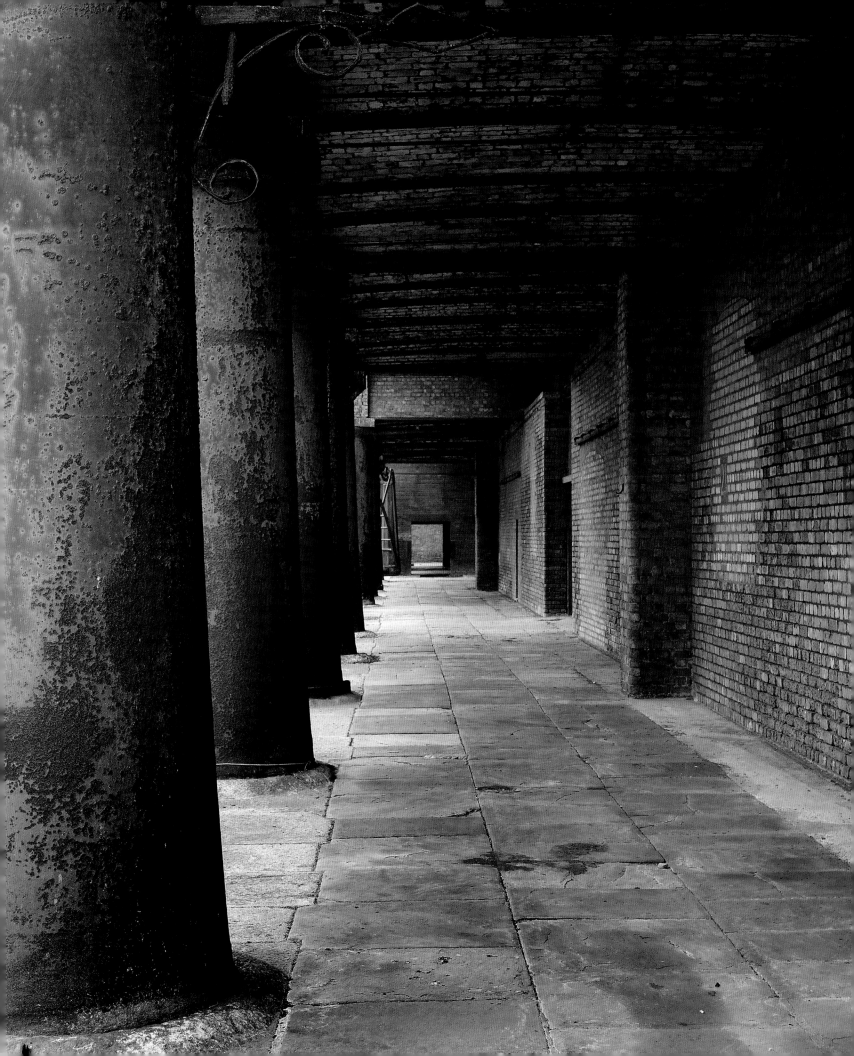

BATTERSEA POWER STATION
London

Anyone who has spent any time in London will be familiar with the towering presence of Battersea Power Station, one of the greatest and most architectural of England's industrial-era ruins. Admirers of Pink Floyd will certainly know the building from the cover of the band's famous album *Animals* (1977), which shows a pink inflatable pig floating past the chimneys of the power station, emphasizing the building's iconic status.

Currently roofless, the vast building was, in fact, two power stations: the first, Station A, was built between 1929 and 1935, while the second, Station B, built to the east of the first, was constructed between 1937 and 1941. Each station consisted of a long boiler house with a chimney at either end supported by a washing tower, in which water and alkali were used to remove sulphur from the gases produced; each station also had its own adjacent turbine house. The site on which the stations were built, formerly a reservoir, was chosen because of its proximity to the Thames: water was needed for the production of steam, of course, but the river also provided a convenient means of delivering coal.

A whole team of architects and engineers, led by architect J. Theo Halliday and engineer Sir Leonard Pearce, was involved in the design of Battersea Power Station. However, a storm of protest against the construction of such a large industrial complex so close to the centre of London prompted the London Power Company to appoint Sir Giles Gilbert Scott as consulting architect to remodel the exterior of the building. Scott, who was from a great dynasty of ecclesiastical architects, was the designer of Liverpool Anglican Cathedral. He also later designed the Bankside Power Station, now home to Tate Modern.

The austere, almost Art Deco classicism of Scott's brick exterior turned a necessarily industrial building into an admired landmark (the structure of the building is, in essence, a steel frame clad in brown brick). The detailing of the brickwork helped to humanize the awesome scale; Scott also worked on the chimneys, transforming them into great Classical columns in the Doric style of ancient Greece. Battersea was enthusiastically celebrated as a 'temple of power'.

The scale of operations was vast: more than 1 billion kilograms (1 million tons) of coal was burnt every year to provide west and south London with electricity, around one-fifth of all London's energy needs. However, amid concerns over pollution and a shift in national policy towards the use of oil, gas and nuclear power for the generation of electricity, Battersea found itself redundant. Station A was closed in 1975, while Station B suffered the same fate in 1983.

Initial plans to demolish Battersea Power Station were opposed, and in 2007 the building's listing status was upgraded to Grade II*, which prevented its wholesale demolition (however, the roof was removed from the boiler houses in the late 1980s, meaning that the power station can fairly be described as a ruin in all senses). Since the closure of Station B, several development proposals have received planning consent, but none has been realized. At the time of writing, an ambitious plan to restore the power station as part of a residential, hotel and office development had just been approved by Wandsworth Council. If the plan goes ahead, the chimneys will have to be rebuilt, but the power station itself will be used to generate green energy.

In recent years the site has been used for a variety of cultural events; it even provided the setting for the Battle of Bosworth in the film version of *Richard III* co-written by Sir Ian McKellen (1995). In 2010 Battersea Power Station took on a political role when it was used as the backdrop for the launch of the Conservative Party's election manifesto.

Opposite
The Art Deco-inspired architectural refinement of Battersea Power Station is still immediately evident despite its roofless state.

Pages 170–71
One of the greatest early twentieth-century landmarks in London, Battersea Power Station has become a symbol of post-industrial England.

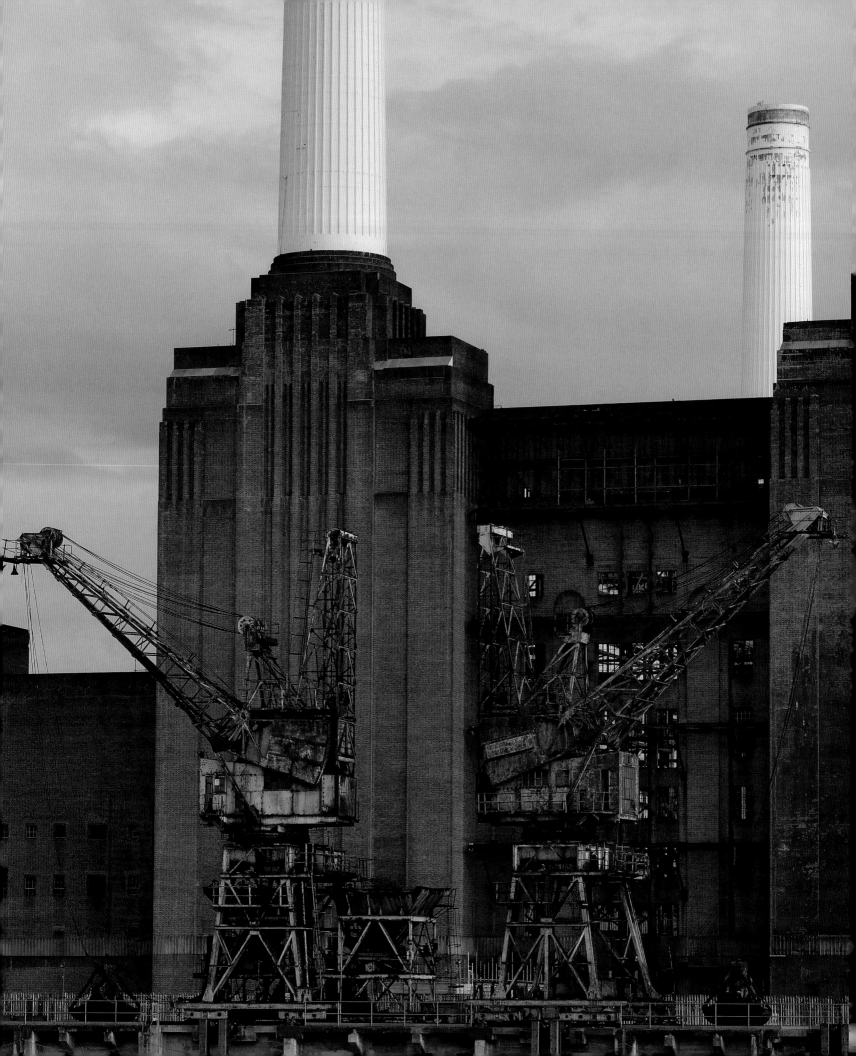

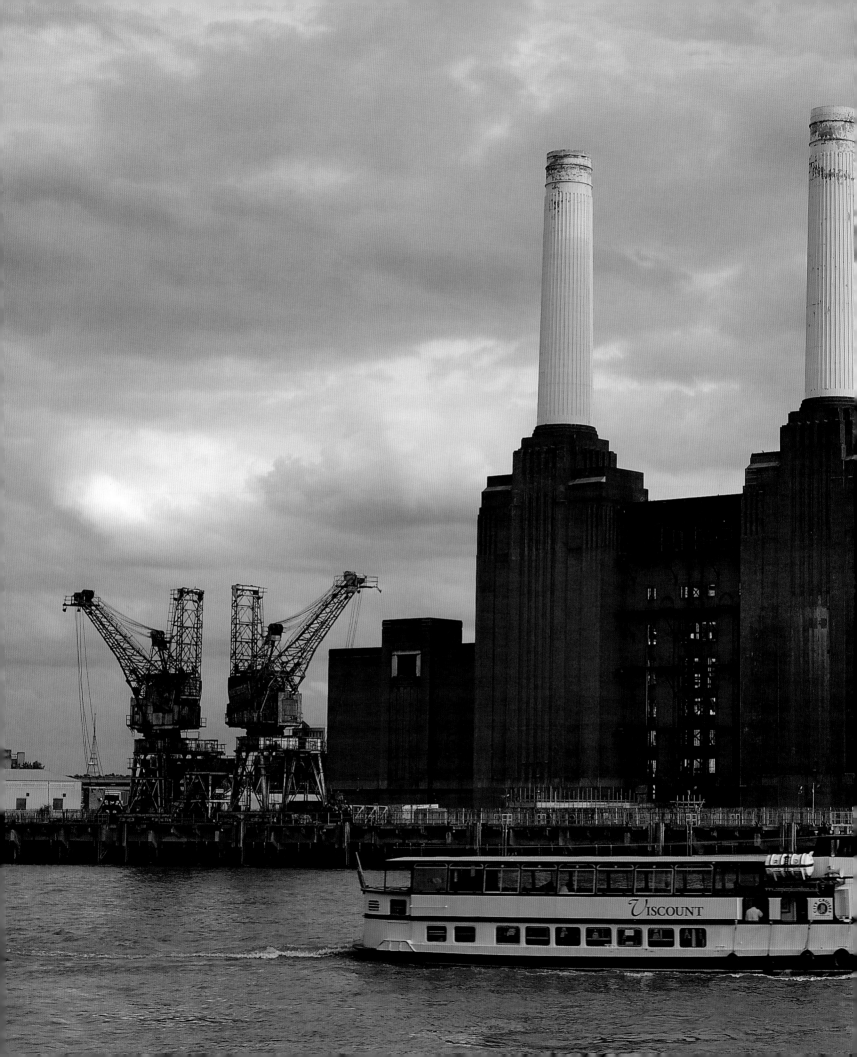

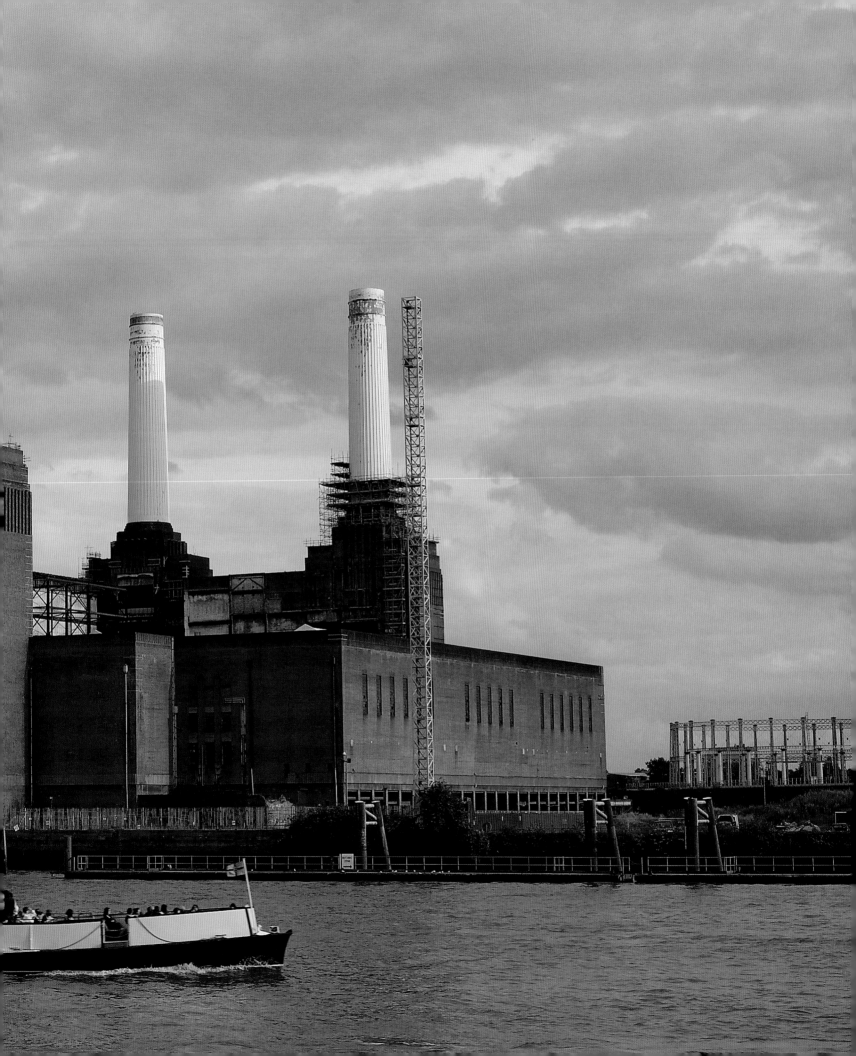

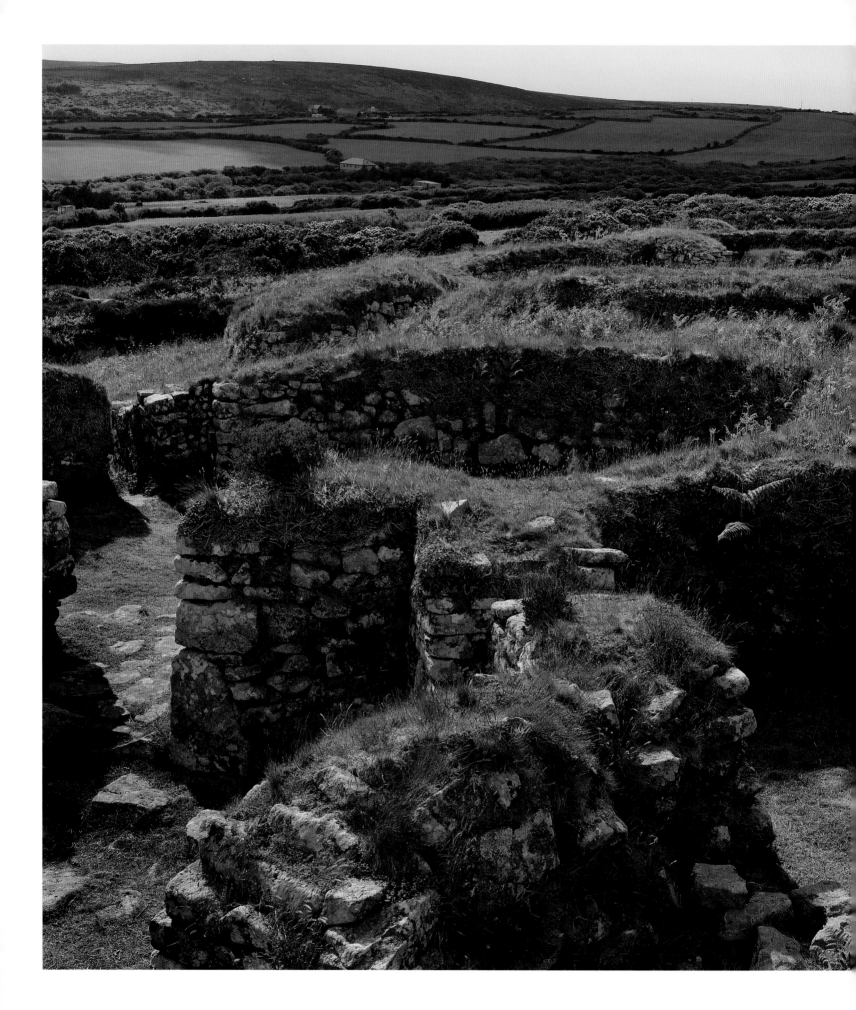

VILLAGES AND TOWNHOUSES

The English landscape is richly textured with evidence of the activities of past peoples: we live with history around us. The presence of previous generations can be felt in high streets and in old villages, but also in the shapes and names of old field patterns, as explained in detail by such twentieth-century scholars as William Hoskins and Oliver Rackham.

The passing of time is perhaps felt most acutely when looking at the sites of former villages, often no more than fields marked by curious bumps and lumps. Some of these villages were abandoned in the late fourteenth century, in the aftermath of the Black Death; indeed, there are hundreds of sites associated with this calamity. Others were deserted in the sixteenth century, as landlords turned their land over to pasture and cleared village after village, bringing to an end the system of smallholdings that had so completely characterized the medieval world.

Some ancient villages were cleared away in the eighteenth century by landlords with a taste for landscaping, agricultural improvement and, sometimes, sheer privacy, moving the houses of their tenants to the other end of the drive (as happened at Stowe in Buckinghamshire, for example). *The Deserted Village* (1770) is a moving poem by Oliver Goldsmith about a village he once knew that had been depopulated to extend one man's parkland ('space for his lake, his park's extended bounds'). The village in question is supposedly modelled on Nuneham Courtenay in Oxfordshire: 'Sweet smiling

village, loveliest of the lawn / Thy sports are fled, and all thy charms withdrawn, / Amidst thy bowers the tyrant's hand is seen / And desolation saddens all thy green.' Goldsmith's poem vividly challenged the concentration of power in the hands of landlords, which continued right up until the twentieth century: 'Ill fares the land, to hastening ills a prey, / where wealth accumulates, and men decay. / Prince and lords may flourish, or may fade / But a bold peasantry, their country's pride / When once destroyed can never be supplied.'

In the nineteenth and twentieth centuries, some villages died because the industries they supported either collapsed or moved away (such as in the cases of certain mining or railway-construction communities). In a few cases they were sacrificed to the needs of the nation, bulldozed for new motorways or reservoirs, or – during wartime in particular – turned into firing ranges or places in which to train combat troops.

Sometimes, villages are abandoned because of the threat posed by the forces of nature, such as those communities that are slowly being swept into the sea. Occasionally some buildings survive, often the churches, either strangely isolated from the village or, in some cases, the only substantial survivor among the ruins – if ruins there be.

Since the end of the Second World War there have been surprising cycles in the fortunes of urban communities in particular, as they try to recover from the blight of war damage or struggle to survive in areas where industry has come to an end. The sight of boarded-up terraces in England's major cities is one that stirs odd emotions, since it seems to represent the death of a community.

The 1960s and 1970s saw large areas of older terraced housing demolished to make way for tower blocks, which may not have solved the housing issues as neatly as was hoped. A similar struggle continues today. Since 2003, attempts by government to break the economic decline of some of the industrial cities of the Midlands and the north of England have centred on the urban-regeneration 'Pathfinder' scheme. Although the £2.2 billion project has seen some genuine refurbishment of run-down housing stock, it has also been responsible for the demolition of a large amount of nineteenth-century terraced housing, often in the face of considerable local opposition. These are ruins that could so easily be homes.

Pages 172–73
A lost community: these stout walls belong to a late Romano-Celtic village in Cornwall abandoned more than 1500 years ago.

Opposite
Modern wastelands: deliberately depopulated nineteenth-century terraced housing on the edge of Liverpool.

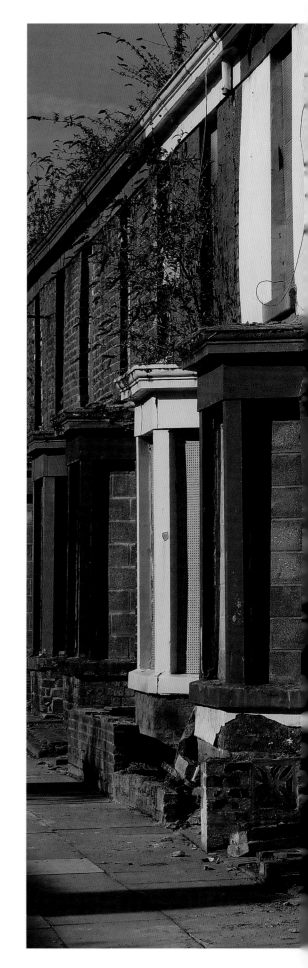

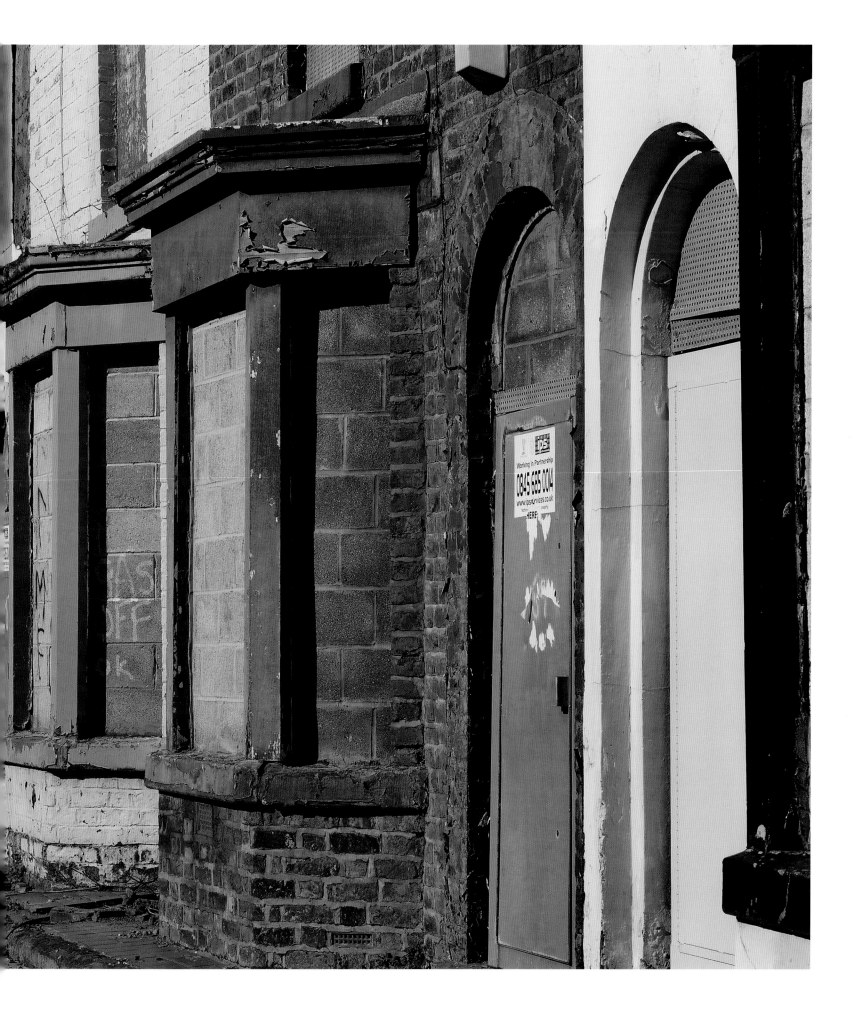

CHYSAUSTER
Cornwall

As you drive around west Cornwall, there is a palpable sense of the great age of many of the field patterns visible on elevated ground. Only a few miles outside Penzance, near the villages of Gulval and Newmill, in an area bordering moorland rich in wild flowers and birdlife because it is no longer disturbed by agriculture, lies a remarkable cluster of circular stone enclosures. If you were to stumble on them without seeing the signs, you might at first suppose that they were pens for livestock, but even then you would pause for thought: why are the walls so thick, and why are there so many small enclosures?

The stone structures at Chysauster are in fact examples of a type of 'courtyard house' built in the very south-west of Britain from 500 BC to AD 400. This period encompasses the years of the Roman occupation, which is possibly when these particular houses were erected; it is also possible that the inhabitants were connected to the Dumnonii tribe. Most such surviving villages are associated with Iron Age hill forts, which provided a certain amount of protection and no doubt a degree of government. Many, as at Chysauster, are surrounded by an ancient field system, with some evidence of the growing of crops. It is likely that there was also stock breeding at Chysauster, while such activities as weaving and corn grinding have been suggested by some of the archaeological remains.

Recognized as ancient structures in the nineteenth century, and excavated by archaeologists as early as 1873, the houses at Chysauster were put into the guardianship of the state by the landowner in the 1930s. Further excavations were carried out, and a total of nine houses were cleared of earth and vegetation. Today the site is managed by English Heritage, and, happily, the current grass-cutting regime stimulates a healthy growth of wild flowers and grasses, so that the wildness of the setting remains appealing, as does the strangeness of the archaeological remains themselves. In one corner of the village is an underground, stone-walled passage known as a 'fogou', which is thought to have been used for food storage, as a refuge or even for religious purposes.

Each courtyard house is built on top of a bank of earth, which provided a level base for construction, and some have terraced garden enclosures as well. The standard house consisted of three main enclosures (probably covered by some sort of roof) set around a central courtyard (probably paved). Evidence from similar settlements suggests that the roof coverings were turf or thatch, with smaller enclosures roofed in stone; in some of the houses, a stone with a hole in it set in the ground is thought to be a socket into which a timber upright was inserted to support a pyramidal roof.

The main entrance to each house faces away from the prevailing south-westerly winds that rush off the sea, and the sheltered and protected nature of the site is felt immediately. The individual enclosures are not so much rooms as openings contained within the exceptionally thick outer walls of each house. Two of the houses seem to form one single property, and you cannot help but wonder whether it was the home of an extended family.

To stand among these ancient houses – evidence of a settled, interdependent agrarian community of some 2000 years ago – is an extraordinary and poetic experience. The simple, stout structures are eloquent symbols of the ancient tradition of the security of a human home.

The entrance to a domestic enclosure within one of the courtyard houses at Chysauster.

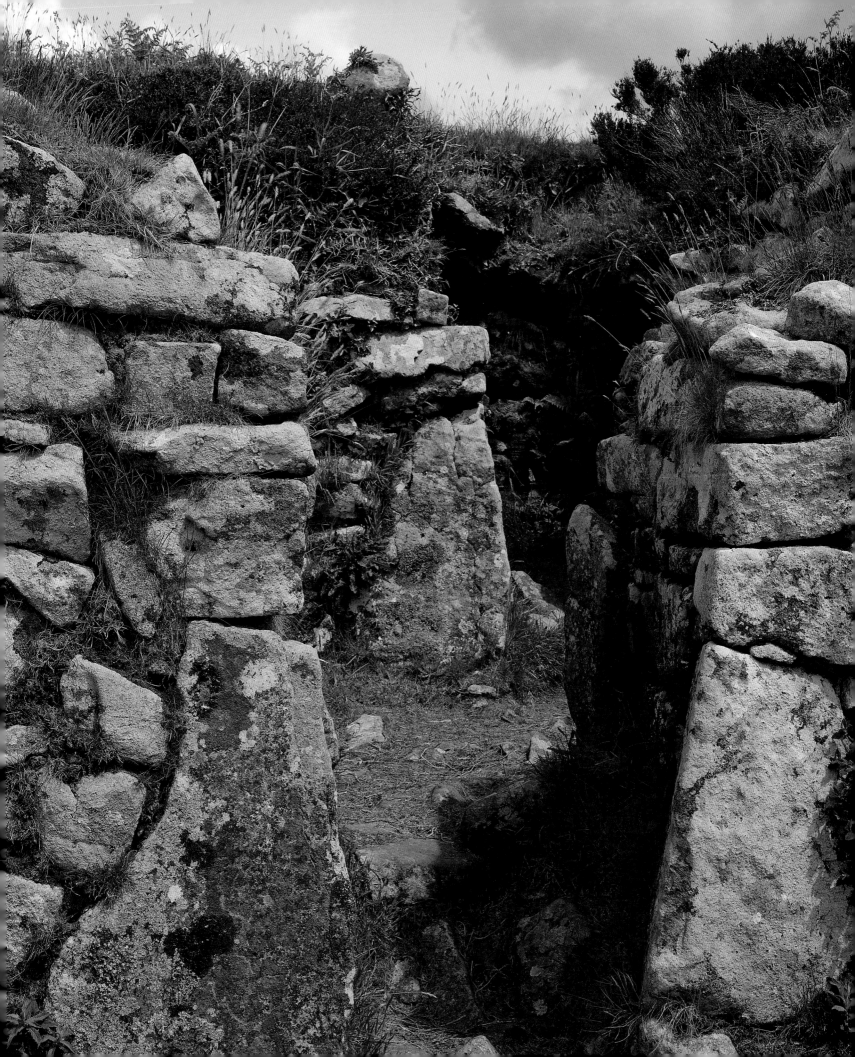

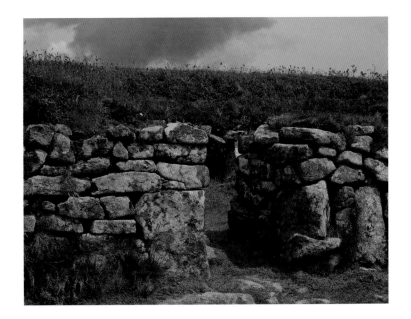 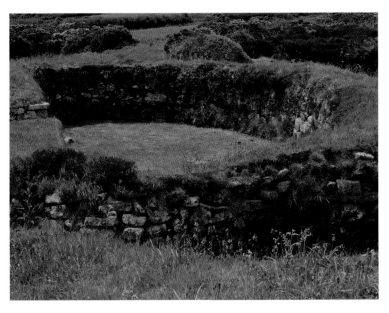

The simply constructed, thick-walled enclosures (or rooms) of each house were built around a central courtyard, which also provided access to stables for livestock. The houses, of a type found nowhere else in England, were built on circular plans, with a main, round room opposite the entrance and a long, narrow room to one side. The rooms were probably roofed with turf or thatch, with stone used for smaller enclosures, while the entrance to each house was arranged so that it faced away from the prevailing south-westerly winds. Today, the houses form a series of moving, abstract shapes that symbolize the story of the family home lying at the core of a community.

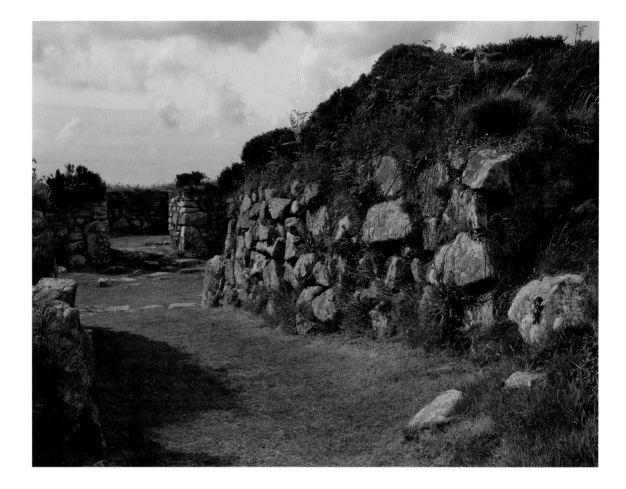

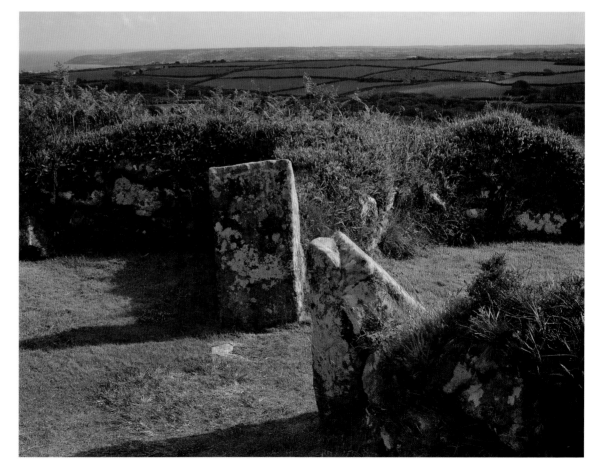

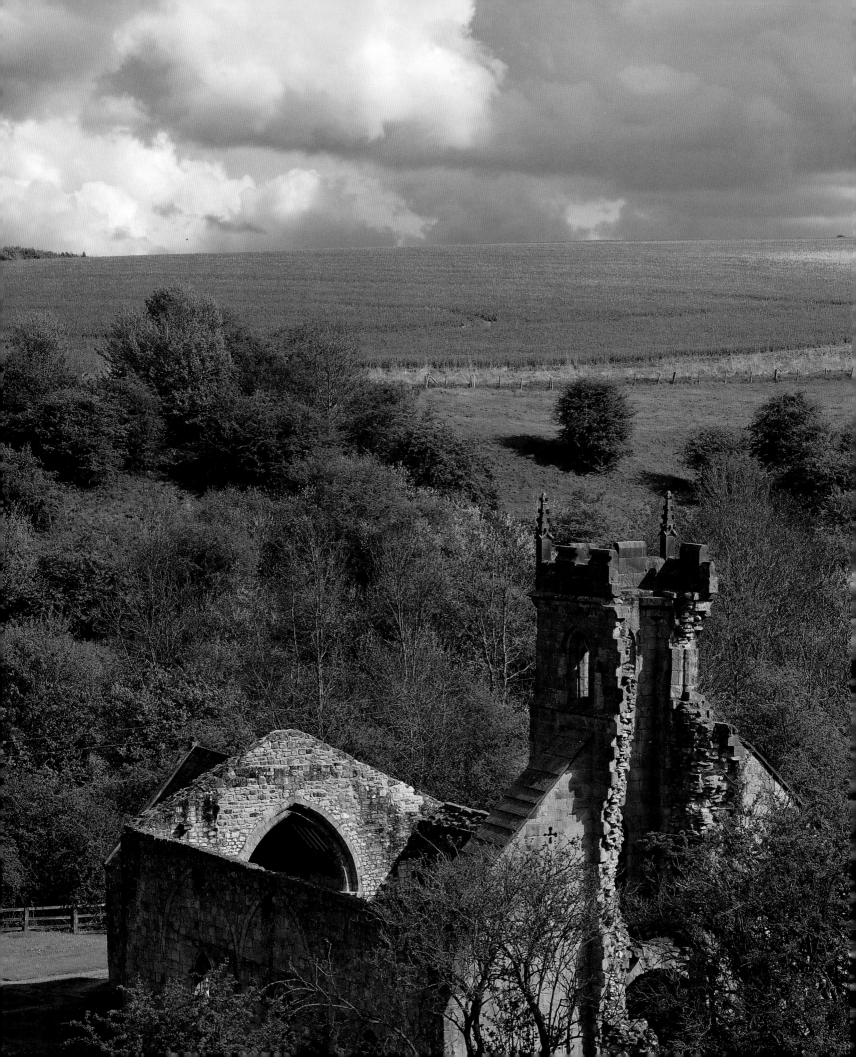

WHARRAM PERCY
North Yorkshire

There are a number of reasons why village settlements in England have been abandoned over the centuries. Some are dramatic, such as an attack from the sea, or the depredations of the Black Death. Just as often, however, they are more prosaic, driven by the economic decisions of others. In particular, they are often the consequence of decisions made by landowners, who enjoyed considerable feudal power over the lives of ordinary agricultural workers.

One village affected by such decisions is Wharram Percy in North Yorkshire, although little of the lost settlement is visible above ground today. The site of the former village can be found in a small valley not far from Malton, approached by long, winding paths worn into the chalk, and framed in summer by tall grass, cow parsley and buttercups. It is a quiet, remote place, which rewards a visit for its sense of human history. The topography suggests how sheltered and protected the site was; the houses were mostly ranged on rising ground.

This 'secret' little valley is curiously sensuous in character. The ground, now grazed by cattle, is rough; the lumps and shapes in the earth are evidence of the chalk walls of the medieval longhouses that once stood here, clustered around a manor house. The scar of a road can still be made out, and the presence of a millpond is more evidence of an early settlement, although there is no visible trace of the mill it once served.

What can be seen of the medieval village, just beyond a small farmhouse from the 1840s, is the ruinous church of St Martin, which continued to be used by the inhabitants of nearby Thixendale until 1870. Ironically, the church remained largely intact until shortly after the Second World War, when thieves stripped the lead from the roof. By 1954 much of the roof had fallen in, and in 1960 part of the tower collapsed. The church now stands as a picturesque memorial to the long-lost village.

Wharram Percy, now in the care of English Heritage, has the curious distinction of being one of the most studied of England's lost medieval villages. Perhaps this very fact tells us something about our modern obsession with the past, the drive to know and understand something that has left only a barely visible trace on the landscape.

Despite this interest in the village, the actual cause of its abandonment remains uncertain. Historians now believe that, by the end of the fifteenth century, the once-thriving settlement had dwindled in population, with the Black Death of 1348–49 playing only a relatively small role in this decline. The end finally came between 1488 and 1506, when it seems that the remaining four families were moved on by the landowner in order to create pastures for sheep, the keeping of which was then more profitable than the growing of crops. The church remained in use for almost four centuries, and farming continued here, too. Indeed, with the archaeologists having completed their work, farming continues here today, although the area around the millpond is not grazed, and the grass is allowed to grow tall.

Opposite
Wharram Percy is one of the most studied of England's abandoned medieval villages. Like so many other similar settlements, it appears that the village was cleared for pasture; only the semi-ruinous church of St Martin and a nineteenth-century farmhouse remain.

Below
The sixteenth-century windows of the church, inserted into an earlier arcade.

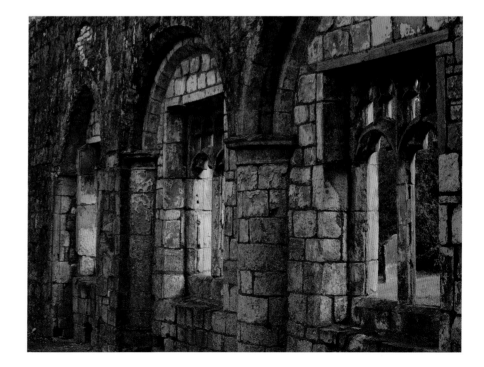

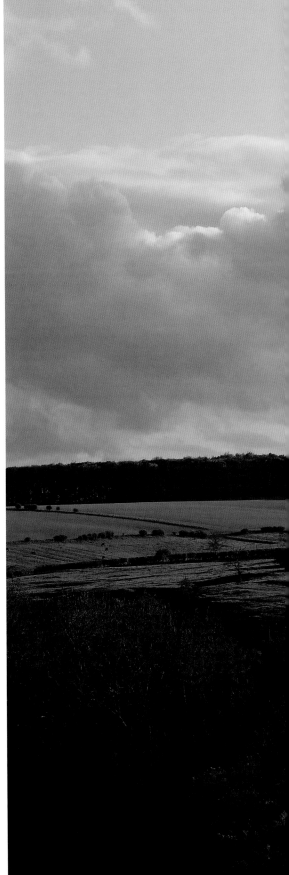

Above
A single farm track
leads through an
area once dense
with houses.

Right
The millpond that,
in the Middle Ages,
served a busy
watermill.

Far right
As the sun sets in the
west, shadows reveal
the skeletal traces of
the houses that once
stood in these fields.

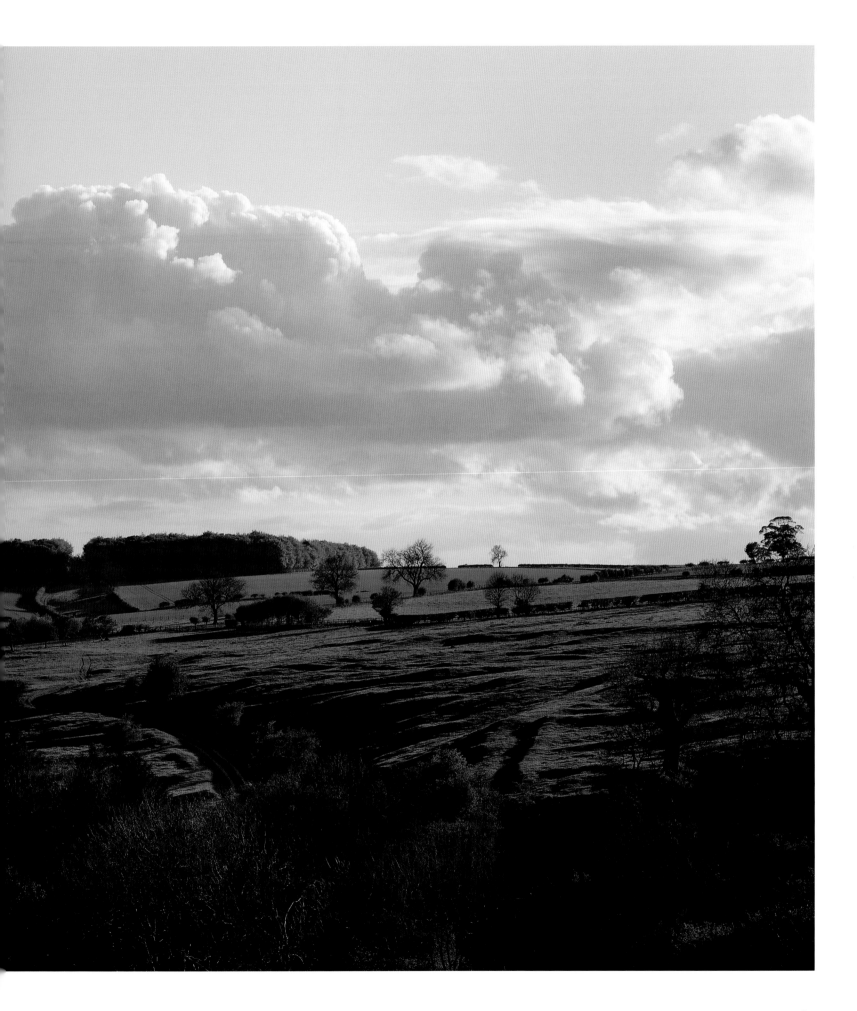

BOARDED-UP TERRACES
Liverpool

All over England one can find pockets of abandoned urban housing, sometimes made uninhabitable by accident, and sometimes by design, the windows and doors boarded up to deter vandals. In many ways such places are some of the most evocative of urban experiences, and speak immediately of past communities and changing ways of life. They are sometimes the casualties of economic blight or even well-meant modern planning, cursed by their proximity to new roads, or bought and boarded up for future regeneration or even demolition.

Terraced housing was one of England's great inventions: rows of neat, uniform houses built in single blocks divided vertically. It was an architectural treatment that could be applied to the houses of the rich and the poor alike. From the early nineteenth century, with the Industrial Revolution in full flow, it was also the typical approach of speculative landlords and builders keen to provide the mass housing demanded by rising urban populations. Such housing often entered a rental market.

From the mid-nineteenth century, terraced houses were usually built using mass-produced bricks transported into the area by rail, thereby eroding the traditional colours that reflected the nature of the local building materials, such as stone dressing or bricks made with local clay. The architectural style of terraced houses is largely Classical in character, with touches of Italianate or Gothic Revival in the detailing, depending on the aesthetic decisions and economic confidence of the developer.

For more than a century terraced housing was the scene of so much of English life, including the daily rituals and social interactions that help to define a nation. In the 1960s many of the terraces in England's industrial cities were considered outmoded and unsanitary, and were demolished by local authorities looking to high-rise tower blocks to help relieve the pressure of housing an increasing population. The social engineering represented by such intervention is a much-debated topic today.

The late seventeenth- and early eighteenth-century houses of London's Spitalfields, home to different

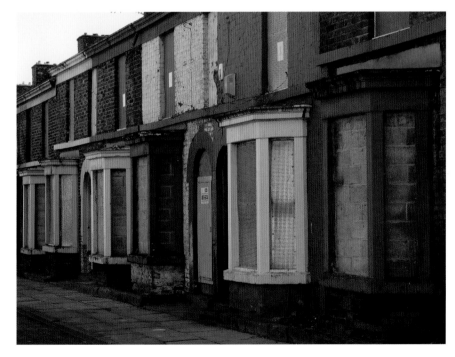

Opposite, top and above Nineteenth-century terraced housing in the Edge Hill district of Liverpool, in an area designated for renewal. The yellow-brick houses shown opposite were demolished in July 2010, shortly after they were photographed for this book. The abandonment and destruction of Victorian housing stock are done in the name of progress, but wipe out the history of a working people.

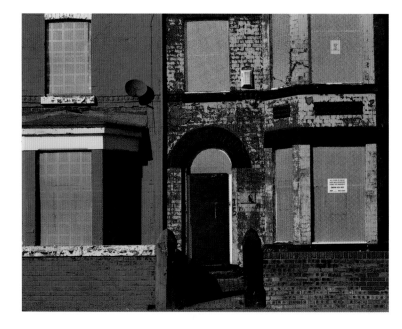

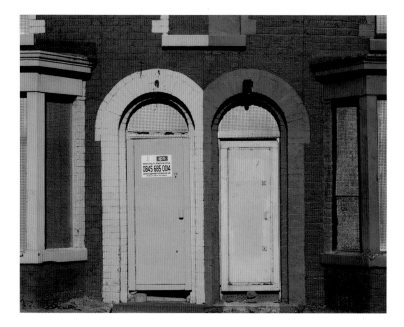

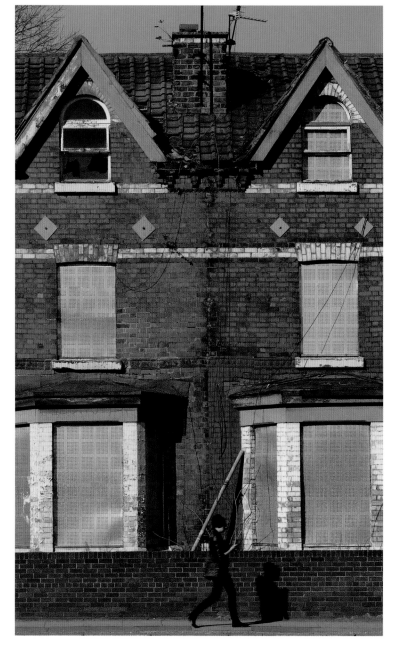

generations of migrant populations, were the setting
for one of the great conservation battles of the 1970s.
Houses that had been homes, flats, workshops and
even small factories, in a stream of constant adaptation
and continual use, were being destroyed for new
commercial developments. Yet Spitalfields is now
regarded as one of the capital's finest historic quarters.

The terraces shown on these pages, in different
areas of Liverpool, stand for the history of the many
urban communities that have had to struggle with
declining economic forces and social change. The
terraced house seems to symbolize the intimacy of the
English urban community in its very shape and form;
empty terraces suggest the loss of this urban intimacy
and a failure to 'live well' with the past.

Above
Nineteenth-century
terraced houses on
Liverpool's Prescot
Street and Edge Lane,
boarded up against
vandals and squatters.

Opposite
As you move closer
to the docks in
Liverpool, you can still
find rows of boarded-
up and abandoned
Georgian terraced
houses, such as these
on Duke Street. The
graffiti painted on the
house on the right is
an eerie comment on
England's depopulated
urban areas.

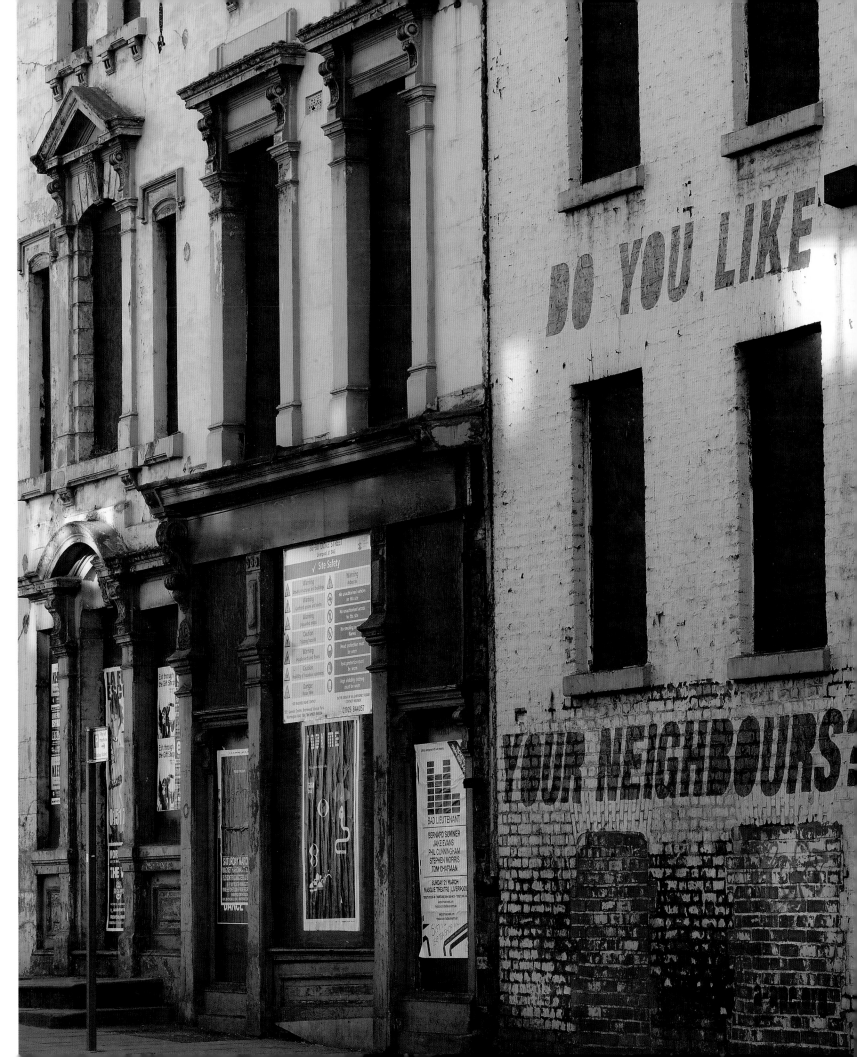

Select Bibliography

The books listed here have proved to be invaluable sources of both inspiration and information. In addition, I have made much use of the *Oxford Dictionary of National Biography*, published by Oxford University Press; the *Buildings of England* series, compiled originally by Nikolaus Pevsner and now published by Yale University Press; the relevant guidebooks for each ruin, many of which were written by John Goodall; and such websites as heritagegateway.org.uk, english-heritage.org.uk and nationaltrust.org.uk.

Peter Ackroyd
Albion: The Origins of the English Imagination, London (Chatto & Windus) 2002

John Ashurst, ed.
Conservation of Ruins, London (Butterworth-Heinneman) 2007

Clive Aslet
Landmarks of Britain: The Five Hundred Places That Made Our History, London (Hodder & Stoughton) 2005

Brian Bailey
The National Trust Book of Ruins, London (Weidenfeld & Nicolson) 1984

Owen Barfield
Poetic Diction: A Study in Meaning, London (Faber & Gwyer) 1928

Julius Bryant
Turner: Painting the Nation, London (English Heritage) 1996

Olive Cook and Edwin Smith
Abbeys and Priories, London (Thames & Hudson) 1960

Alexander Creswell
The Silent Houses of Britain, London (Macdonald) 1991

Tim Edensor
Industrial Ruins: Space, Aesthetics and Materiality, Oxford (Berg) 2005

Michael Felmingham and Rigby Graham
Ruins: A Personal Anthology, Feltham (Country Life Books) 1972

Robert Ginsberg
The Aesthetics of Ruins, New York (Rodopi) 2004

John Harris
No Voice from the Hall: Early Memories of a Country House Snooper, London (John Murray) 1998

William Hoskins
The Making of the English Landscape, London (Hodder & Stoughton) 1977

Christopher Hussey
The Picturesque: Studies in a Point of View, London (G.P. Putnam's Sons) 1927

Haidee Jackson
Ruins in British Romantic Art from Wilson to Turner, Nottingham (Nottingham Castle Museum Press) 1988

Henry James
English Hours [1905], Oxford (Oxford University Press) 1981

Simon Jenkins
England's Thousand Best Houses, London (Allen Lane) 2003

David Lowenthal
The Past is a Foreign Country, Cambridge (Cambridge University Press) 1985

Rose Macaulay
Pleasure of Ruins, London (Weidenfeld & Nicolson) 1953

Thomas McCormick
Ruins as Architecture: Architecture as Ruins, Dublin (William L. Bauhan) 1999

Adrian Pettifer
English Castles: A Guide by Counties, Woodbridge (Boydell) 1995

James Richards, ed.
The Bombed Buildings of Britain: A Record of Architectural Casualties: 1940–41, Cheam (The Architectural Press) 1942

Mary Roberts
Ruins and Old Trees Associated with Remarkable Events in English History, London (Harvey and Darton) 1843

Tim Tatton-Brown
The Abbeys and Priories of England, London (New Holland) 2006

Michael Thompson
Ruins: Their Preservation and Display, London (British Museum) 1981

Christopher Woodward
In Ruins, London (Chatto & Windus) 2001

Patrick Wright
On Living in an Old Country, London (Verso) 1985

Paul Zucker
Fascination of Decay: Ruins: Relic, Symbol, Ornament, Ridgewood, NJ (Gregg Press) 1968

Acknowledgements

JEREMY MUSSON

To my godchildren, Harry, Madeline, Patrick, Jamie, Chloe and Jossie

I thank all of those who have made this project possible. I am deeply grateful to Hugh Merrell and Claire Chandler for having faith in the idea, and to the team at Merrell – Nicola Bailey, Mark Ralph and Alenka Oblak – and the book's designer, Dennis Bailey, for their patience, for their meticulous design and editing, and for producing a book of such elegance. I would like to thank in particular Paul Barker, my collaborating photographer, whose vision of England expressed through pictures is what first inspired this book.

In writing a book of this kind, an author is dependent on the advice, kindness and encouragement of a large number of people, especially family and friends. My thanks go to those who drove me to some far-flung sites, and put me up and fed me on my travels so I could get to the more distant ruins, as well as to those who drew my attention to relevant books and places. I am particularly grateful for the opportunity to visit properties that are privately owned, or held by charities or other organizations; I am equally grateful to English Heritage and the National Trust, for granting me generous access to the properties in their care, and for the excellent job they do in protecting and managing these precious sites. My thanks also go to the Church of England and the Churches Conservation Trust.

I would especially like to thank the following people for their ideas, hospitality and practical support: Charlie Bain-Smith, Matthew Beckett, Marcus Binney, Dawn Carritt, George Carter, Robin Cormack, Alexander Creswell, Ptolemy Dean, Hugh Dixon, Martin Drury, the Duke of Devonshire, George Eccles, Martin Gayford, Leslie Geddes-Brown, John Goodall, John Harris, Kate Jeffreys, Simon Jenkins, Anna Keay, Alice Magnay, Pepe Messel, Thomas Messel, Mary Miers, Georgia Musson, Miranda Musson, Roger Musson, Rosemary Musson, Sophie Musson, William Palin, Ken Powell, the Revd Ben Quash, John Martin Robinson, Lady Sitwell, the late Sir Reresby Sitwell, Gavin Stamp, Sir Roy Strong, Simon Thurley, Hannah Tunstall-Behrens, Peter Tunstall-Behrens, Angus Wainwright, Lady Wakefield, Sir Humphry Wakefield and Steve Waters.

Special thanks are due to Christopher Woodward, whose thoughtful book *In Ruins* was a particular inspiration. For their help and support, I am especially grateful to the librarians of the Cambridge University Library and the London Library, and to Justin Hobson and Helen Carey of the Country Life Picture Library. I must also acknowledge the brave new world of factual bloggers, who throw up such interesting material for the curious traveller.

Finally, for their early encouragement of the project and enthusiastic responses to my requests, I am very grateful to the custodians and private owners of each of the sites featured in this book, especially Chris Fowler of Fountains Abbey, Heather Ongley of Cowdray Ruins, Grant Lohoar at Orford Ness, George Bailey at Bodiam Castle, Francis Thyer of Glastonbury Abbey, Paul and Janet Griffin of Wothorpe Towers, Jim Lowther of Lowther Castle, and the Western Heights Preservation Society.

PAUL BARKER

To my wife, Tracey, whose contribution to this book can never be overstated; and my son, George, to whose generation England's architectural heritage will pass

The majority of the people and organizations that I would like to thank have already been mentioned by Jeremy. To his list, however, should be added the following individuals: Kate Thompson, Jimmy Gringe and John at Stanley Dock; Chris Griffiths at Liverpool City Council; Catherine Atkinson at Seaton Delaval Hall; Cath Trumper at Whitby Abbey; Paul Wells and Chris Townley at Drop Redoubt Fort; and Duncan Kent at Orford Ness.

Index

Main entries for each ruin shown in **bold**;
page numbers in *italics* refer to illustrations.

Front jacket
Whitby Abbey, North Yorkshire (pages 38–43)

Back jacket, clockwise from top left
Fountains Abbey, North Yorkshire
(pages 30–37); boarded-up terraces, Liverpool
(pages 184–87); Battersea Power Station,
London (pages 168–71); Dunstanburgh Castle,
Northumberland (pages 68–73)

Frontispiece
Dunstanburgh Castle, Northumberland
(as above)

First published 2011 by

Merrell Publishers Limited
81 Southwark Street
London SE1 0HX

merrellpublishers.com

Text copyright © 2011 Jeremy Musson
Photographs copyright © 2011 Paul Barker,
 unless stated otherwise (see left)
Design and layout copyright © 2011 Merrell
 Publishers Limited

British Library Cataloguing-in-Publication data:
Musson, Jeremy.
English ruins.
1. Ruined buildings – England – Pictorial works.
2. Abandoned buildings – England – Pictorial
works.
3. England – Antiquities – Pictorial works.
I. Title II. Barker, Paul, 1952–
720.9′42-dc22

ISBN 978-1-8589-4543-9

Produced by Merrell Publishers Limited
Designed by Dennis Bailey
Project-managed by Mark Ralph
Indexed by Vicki Robinson

Printed and bound in China